Methods & Theories of Art History

Published in 2005 by Laurence King Publishing Ltd 361–373 City Road London EC1V 1LR United Kingdom

Tel: +44 20 7841 6900 Fax: +44 20 7841 6910 email: enquiries@laurenceking.com www.laurenceking.com

Copyright © 2005 Anne D'Alleva.

Previously published in the United States as Look! Again, Art History and Critical Theory.

All rights reserved. No part of this publication may be reproduced or transmitted in any form or by any means, electronic or mechanical, including photocopy, recording or any information storage and retrieval system, without permission in writing from the publisher.

A catalogue record for this book is available from the British Library.

ISBN 978-1-85669-417-9

Printed in China

Editor Elisabeth Ingles
Picture Research Sally Nicholls
Design Andrew Lindesay

Front cover: Jean-Auguste-Dominque Ingres, *Oedipus and the Sphinx* (detail), 1808, reworked c.1827. Oil on canvas. 6ft 2in x 4ft 9in (1.89 x 1.44m), Louvre, Paris,

Anne D'Alleva

Methods & Theories of Art History

Contents

Introduction How to use this book	1
Chapter 1 Thinking about theory	5
What makes theory "theory"?	5
Is theory pure, universal, and impartial?	8
Positivism, or the theory of anti-theoretical positions	10
Thinking through theory	11
Conclusion	16
■ Jargon	8
■ What's the difference between theory and methodology?	13
A place to start	16
Chapter 2 The analysis of form, symbol, and sign	17
Formalism in art history	17
Iconography and iconology	20
Panofsky's iconography and iconology Iconography and	
iconology since Panofsky Practicing iconography and	
iconology Semiotics	
The founding semioticians: Saussure and Peirce Systems and	28
codes Interpreting codes and signs Semiotics and art history	
Practicing semiotic art history	
Word and image	43
Conclusion	44
■ Are works of art puzzles? Are art historians detectives?	34
■ Do we "read" works of art?	39
A place to start	45
Chapter 3 Art's contexts	46
The history of ideas	46
Marxist and materialist perspectives on art	48
The critique of capitalism and historical materialism Ideology	
and cultural hegemony Marxism and art Materialist and	
Marxist art history Practicing Marxist art history	

Feminisms	60
A brief history of the women's movement The beginnings of	
feminist art history Current issues in feminist art history	
Essentialism and feminist art history Practicing feminist	
art history	
Sexualities, LGBTI Studies, and Queer Theory	70
LGBTI Studies Queer Theory Gender performativity, a key	
queer idea LGBTI/Queer art history Practicing Queer/LGBTI	
art history	
Cultural Studies and postcolonial theory	76
Race and postcolonial theory Subaltern Studies Art history,	
Cultural Studies, and Visual Culture Practicing art history	
informed by Cultural Studies/postcolonialism	
Conclusion	86
■ So what's normal—or normative?	71
A place to start	87
Chapter 4 Psychology and perception in art	88
Art history and psychoanalysis	88
Basic Freud Freud on art Freud's critics Basic Lacan	
Lacan on art Lacan's critics Psychoanalysis and contemporary	
art history The gaze	
Reception theory I: the psychology of art	109
Reception theory II: reader response theory and	113
the aesthetics of reception	
Practicing reception theory/psychoanalytic art history	
Conclusion	120
■ Jungian archetypes	93
■ Object relations theory and the nature of creativity	96
■ The anxiety of influence	110
A place to start	121
Chapter 5 Taking a stance toward knowledge	122
Hermeneutics	122
The hermeneutic trio The hermeneutic circle Hermeneutics	
and art history Practicing hermeneutic art history	

Structuralism and post-structuralism	131
Culture as structure Binary oppositions Intertextuality and	
the death of the author Post-structuralism Foucault's history:	
knowledge is power Structuralism, post-structuralism, and art	
history Practicing structuralist and post-structuralist art history	
Deconstruction	143
Art history and deconstruction Practicing deconstructive art	
history	
Postmodernism as condition and practice	149
Defining modernism(s) Adding the "post" to modernism	
Challenging master narratives Fragmentation, pastiche, and the	
simulacrum Modernism, postmodernism, and art history	
Practicing postmodernist art history	
Conclusion	157
A place to start	158
Chantage Writing with the own	450
Chapter 6 Writing with theory	159
The kind of paper you're probably writing now	159
Learning how to write with theory	163
The place of theory in research	165
Which comes first? How do you know which theory (or theories)	165
Which comes first? How do you know which theory (or theories) to use?	
Which comes first? How do you know which theory (or theories) to use? Writing the paper	165 169
Which comes first? How do you know which theory (or theories) to use? Writing the paper Crafting a theoretically driven argument Integrating theory	
Which comes first? How do you know which theory (or theories) to use? Writing the paper Crafting a theoretically driven argument Integrating theory Supporting your points/providing evidence	169
Which comes first? How do you know which theory (or theories) to use? Writing the paper Crafting a theoretically driven argument Integrating theory	
Which comes first? How do you know which theory (or theories) to use? Writing the paper Crafting a theoretically driven argument Integrating theory Supporting your points/providing evidence Creativity, imagination, and truth	169 172
Which comes first? How do you know which theory (or theories) to use? Writing the paper Crafting a theoretically driven argument Integrating theory Supporting your points/providing evidence Creativity, imagination, and truth	169
Which comes first? How do you know which theory (or theories) to use? Writing the paper Crafting a theoretically driven argument Integrating theory Supporting your points/providing evidence Creativity, imagination, and truth	169 172
Which comes first? How do you know which theory (or theories) to use? Writing the paper Crafting a theoretically driven argument Integrating theory Supporting your points/providing evidence Creativity, imagination, and truth	169 172 173

Introduction **How to use this book**

I want to suggest a different metaphor for theoretical work: the metaphor of struggle, of wrestling with the angels. The only theory worth having is that which you have to fight off, not that which you speak with profound fluency.

Stuart Hall, Cultural Studies and Its Theoretical Legacies (1992)

This book gives you a starting point, no more and no less, in approaching theories of art historical practice. It is neither encyclopedic nor exhaustive—I don't know how it could be and not lose its usefulness as a reference, the kind of dog-eared book that you keep in a pile next to the computer.

This book provides signposts, a set of possible orientations toward the field of art history, by presenting some of the theoretical perspectives most widely used in the discipline today. I have done my best not to over-synthesize, but to present individual arguments, controversies, and divergent perspectives whenever possible. Art-historical theory is a forum of intense, often passionate debate. These ideas it embraces aren't ever a "done deal," but are always under development and constantly changing. For that matter, art history itself, as an academic discipline, isn't a "done deal": it has changed enormously since I was an undergraduate—twenty years ago as I write this—and it will change just as much over the next twenty years.

So who, do I imagine, is going to be looking for the signposts I present here? My imagined readers are undergraduate students of art history. They are people seriously interested in the practice of art history, even if they are new to it and even if they are not intending to make professional careers as art historians. They are people who are interested in the world of ideas, who engage in intellectual, political, and artistic pursuits outside their coursework. They are people who are not content simply to memorize slides—in fact, I sometimes hope that they are people who actively resist

memorizing slides! They are people whose professors may be assigning readings in critical theory, or referring to critical theories in class, and who, therefore, want background information or suggestions for pursuing these ideas further. These descriptions may or may not fit you, but, regardless, I welcome you to the intellectual forum to which this book is a contribution.

Be warned, however, that this book is not a historiography of art history, nor is it an explanation of theories of art. Instead it addresses the multiple intersections of art history and critical theory, since some of the latter has been generated through the practice of art history and some not, over the past thirty years or so. Because this book is not a historiography, it sometimes gives little emphasis to key figures in the history of art. For example, the Swiss scholar Heinrich Wölfflin (1864–1945) may not be a central figure in current theoretical debates within art history, but if you're studying historiography then he's critically important and I would certainly hope that, in other contexts, art-history students are reading his work and grappling with the issues it presents.¹

Because of the range of approaches to be covered here. I've tried to give this book a simple, rational plan. The core of the book is chapters two through five, which present detailed discussions of different theoretical approaches to art history. Each chapter presents a group of related approaches: for example, Chapter 3, Art's contexts, discusses Marxist and materialist, feminist, queer. and postcolonial theory together, because, as I see it, all of these approaches address the contextual history of art in fundamental ways. Of course, many such groupings are possible, as the numerous cross-references clearly demonstrate, and the selection of theories presented here reflects my sense of the field. In no way do I see this book as reflecting or contributing to the formation of a canon of critical theory, a set list of the most important works. Instead, it's more like a family album—a collection of snapshots that document the field. This book is subject to change, and is written from an individual perspective, just as a family album may be put together by someone who has a particular perspective on the events depicted and may add and remove photographs at will.

Each chapter starts with a brief introduction explaining the range of theories it presents, then separate sections discuss each of them in turn. The explanation of each approach starts with a broad overview. Then, especially if this body of theory did not emerge from within art history, I discuss art historians who have taken it up.

Finally I take a work of art, or two, and develop a line of questioning according to that particular theoretical model. This helps you understand how to generate research questions and how the ideas of particular scholars and theorists might be employed in arthistorical analysis. A brief conclusion sums up each chapter and adds any final thoughts.

Two additional chapters frame this core. **Chapter 1: Thinking about theory** introduces the concept of theory and explains why theory is important to the practice of art history. **Chapter 6: Working with theory** presents some practical ideas about writing theoretically driven art-history papers. It focuses on the tento twenty-page research paper, as this is the format undergraduate art-history students confront most often.

There are many ways to read this book, depending on your level of expertise, time constraints, and goals. There's always that mythic reader who devours the book from cover to cover. On the other hand (and, perhaps, more realistically) you may read a particular chapter or section to get a basic orientation to a set of ideas that interests you—say, feminism or reception theory—and then use that to put together a reading list that will help you delve further into the field. Or you may just be looking for some ideas to frame a research topic, and so you may go straight to the sample works of art and browse the research questions for inspiration. If you're working on a paper, you may turn to Chapter 6 to get help in developing your argument.

I want to emphasize that the next step for a student interested in seriously engaging with any of the theoretical perspectives presented here is to read primary texts. If, for example, you've read the relevant section on Marxism in **Chapter 3: Art's contexts**, you should start reading works by Karl Marx and Friedrich Engels, Antonio Gramsci, Louis Althusser, and other important theorists. There are many field-specific anthologies of such texts to help you get started, and ultimately you will want to read the full-length works themselves. You should also start reading works by Marxist art historians. The works listed at the end of the chapter under **A place to start** will help you, as will the endnotes, but there's no substitute for getting out there and digging into the literature.

The act of reading itself becomes somewhat different when engaging with challenging theoretical texts, and you may find that the reading techniques you've been using in your studies aren't very helpful. To enhance active reading and critical thinking, many

study guides recommend a process called SQ3R (Survey, Questions, Read, Recite, Review).2 The reader first surveys, or skims, the reading to get an idea of the nature of the argument, paying special attention to the introduction, conclusion, illustrations or diagrams, headings and subheadings. Then the reader develops a set of questions about it. Headings and subheadings will often provide clues: a subheading such as "Freud and Ancient Egypt" might become "Why and how was Freud interested in Ancient Egypt?" Next comes reading the piece, either taking notes or annotating the text itself (underlining or highlighting alone is a relatively passive and ineffective reading method). Jot down answers to your questions, add new questions as important points emerge, and be sure you understand new terms. In the recall stage, summarize what you've read, check whether your initial questions have been answered, and pay special attention to ideas that still don't seem clear. Evaluate the strengths and weaknesses of the argument and relate it to other works you've read. As an art historian, focus on how the reading expands your engagement with artistic practices. A day or two later, review what you've learned to help consolidate it as part of your base of knowledge.

Readers who have used my previous book, Look! The Fundamentals of Art History (2003), will find both similarities and differences here. I've tried to keep the text simple and accessible—although, given the complexity of the ideas discussed here, the language is necessarily more technical. Concrete examples and practical advice about developing arguments and writing papers stand here alongside the discussion of more abstract ideas. I've tried my best to be even-handed in discussing various theories of art-historical practice, but I hope that my own viewpoints and experiences as an art historian aren't entirely lost.

In the end, this book is an introduction to the scholarly struggles—the rewarding, frustrating struggles—to which Stuart Hall so gracefully refers above. After reading it you won't be ready to bill yourself as an expert on psychoanalysis or semiotics. (Is that a relief or a disappointment?) You'll have to read much more widely to gain that kind of status, but you'll be ready to make a start. Good luck with your work.

Chapter 1 **Thinking about theory**

The master's tools will never dismantle the master's house.

Audre Lorde, Sister Outsider (1984)

And suddenly the memory revealed itself. The taste was that of the little piece of madeleine which on Sunday mornings at Combray . . . my aunt Léonie used to give me, dipping it first in her own cup of tea or tisane.

Marcel Proust, Swann's Way (1913)

Before exploring different strands of critical theory, like Marxism, feminism, or psychoanalysis, we first have to define what theory is—and answer the crucial question, why is theory important? Engaging with theory is hard work, and you may start to wonder why you're bothering, when struggling through yet another article about cultural hegemony or the sign. You'll find the answer here, I hope.

What makes theory "theory"?

Undergraduate students have often asked me this question. Why are Marx's writings considered theory? When people talk about literary theory, or critical theory, is that what we're using in art history? Why is one art historian's work considered theory and another's not?

Like "art" or "culture," theory is one of those words that we use all the time but which is actually hard to define when we stop to think about it. Theory can be defined in fairly narrow terms or more broadly, and both perspectives are useful.

To start with a relatively narrow definition, I'll turn to Merriam-Webster's Collegiate Dictionary, which includes under the term "theory" the following:

3: the general or abstract principles of a body of fact, a science, or an art <music theory>

4a: a belief, policy, or procedure proposed or followed as the basis of action <her method is based on the theory that all

children want to learn> **b:** an ideal or hypothetical set of facts, principles, or circumstances—often used in the phrase in theory <in theory, we have always advocated freedom for all>

5: a plausible or scientifically acceptable general principle or body of principles offered to explain phenomena <wave theory of light>

6a: a hypothesis assumed for the sake of argument or investigation **b:** an unproved assumption: CONJECTURE **c:** a body of theorems presenting a concise systematic view of a subject <theory of equations>

So theory is a basis for action, but also an explanation of how phenomena work. In art history, we could say that theory helps us to develop precise and penetrating lines of questioning to guide our research. Certain modes of inquiry, or theories, are recognized as valuable across a variety of disciplines: among these are semiotics, Marxism, queer theory, and psychoanalysis. Others are more specific to their disciplines—like iconography in art history.

The range of theories most commonly employed today in the social sciences and humanities is often called critical theory. The term originated in the mid-twentieth century with the Frankfurt School, a group of Marxist scholars based at the University of Frankfurt who critiqued capitalism and consumer culture (see Chapter 3). The term is used more broadly now to indicate contemporary theories useful in the investigation of history, culture, and society across a range of disciplines. These include, for example, feminism, psychoanalysis, semiotics, and structuralism. However, I think it's important to avoid creating a canon of critical theory, as if there are certain works to be considered theory and others to be excluded. Engaging with theory is not about what's trendy or what other people are doing; it's about your own intellectual, political, and creative commitments and endeavors, and about searching out and developing the tools you need to expand your thinking and do this work.

In a broader way, you could also say that "theory" is anything that helps you think better about a subject, enlarges your perspective, and helps you formulate new questions. The source may not be a text widely used and labeled as "critical theory." I included the famous passage from Proust at the beginning of this chapter as a reminder of the potentially broad nature of "theory." For the main character in Proust's novel, the taste of a cake unexpectedly lets loose powerful memories. Similarly, it's hard to say what is going to free your ideas and give you new perspectives on your work—a

song, a poem, a novel, a dance performance. For such prompts to truly work as theory, I would argue that a sustained line of questioning, a coherent perspective on your subject, must develop out of them. Theory isn't just what gives you an idea, but what gives you some real insight.

For example, I have used a rather unconventional approach to theory in my writing about a particular cultural practice in early nineteenth-century Tahiti, where judicial courts were established under the influence of English missionaries. These courts made tattoo a crime, but, paradoxically, they also used tattoo as a punishment for the crime of getting tattoos, as well as for other transgressions (Figure 1.1). 1 I was particularly interested in the class and gender dimensions of this set of practices: the elite didn't typically receive these punishments, and, among commoners, only women were marked on their faces for crimes (including adultery). The "theory" that helped me think about this situation was not, as one might expect, the work of the French philosopher and historian Michel Foucault (1926-1984) (see Chapter 5). His famous book about prisons and corporal punishment, Discipline and Punish (1977), deals with the ways in which European societies punished criminals and changed behavior using the body. As useful as Foucault was in tracing the social construction of power and the development of

 Henry Byam Martin, watercolor of Tahitian woman, 1847. Peabody Essex Museum, Salem, MA.

According to Martin, a local court condemned this woman to death for murdering her husband. Instead, the local missionary argued that her face should be tattooed with the word "murderess"—the mark of Cain to mark her crime. Under the influence of evangelical missionaries, Tahitian courts frequently punished women for adultery—only defined as a crime with the coming of Christianity—by tattooing their faces.

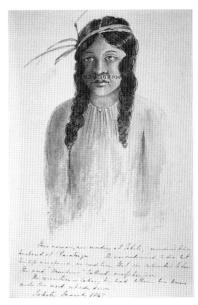

Jargon

If you are in difficulties with a book, try the element of surprise—attack it at an hour when it isn't expecting it.

H.G. Wells

When is language appropriately precise and technical, and when is it jargon—pretentious, long-winded, and obscure? That's a hard line to draw. Before being too quick to damn a piece of writing as pure jargon, make sure it's not just your own lack of familiarity or discomfort with the material that's making you experience "the jargon effect." Often,

when you're new to a discipline or theoretical approach, even basic words (such as, in the case of semiotics, sign, interpretant, or semiosis) will seem strange and unwieldy. As you keep reading, these words will become more familiar and will no longer be stumbling blocks. At the same time, some theoretical writing is convoluted: not all great thinkers are elegant writers. If this is the case, it sometimes helps to find a summary of the arguments elsewhere (e.g. the introduction to an anthology, a book review) which you can then use to guide your reading.

institutions, I also found myself turning to fiction, to Nathaniel Hawthorne's novel The Scarlet Letter (1850) and Franz Kafka's short story "In the Penal Colony" (1919). In relation to these tattooing practices, I wanted to investigate individual experience and agency—that is, the ability and opportunity to act in society—which Foucault doesn't really consider in Discipline and Punish. In fiction, I found a framework to help me discuss the individual and experiential aspects of this tattoo practice; it was important for me to consider what it may have been like for a woman or a religious resister to wear a tattoo as punishment, or for someone to inflict a tattoo as punishment. These are not abstract moral or poetic questions, but central issues in examining the reception of these tattoos and the kinds of social conditions and power structures that made punitive tattooing possible.

Is theory pure, universal, and impartial?

The short answer to that question is "no." Now I'll provide the long answer...

Let me first define the term discourse. As you read theoretical works, you'll frequently come across this word in phrases such as "art-historical discourse" or "Marxist discourse." In these contexts discourse has a very specialized meaning. You may typically define discourse as "conversation," "speech," or "communication," but it is also, more precisely, according to literary theorist Terry Eagleton,

"language grasped as utterance, as involving speaking and writing subjects, and therefore, also, at least potentially, readers or listeners." We understand discourse not as idle chitchat, but as meaningful communication that expresses and shapes cultural ideas and practices. (Keep in mind that meaningful communication can include images, gestures, or sounds as well as writing or speech.)

So language, or discourse, is not innocent or neutral; it can shape, express, reflect, or even conceal human experience and human realities in a variety of ways. Throughout his writings, Foucault emphasized that discourse is interwoven with power relations and social practices.³ This dynamic is visible both on a large scale—where, say, certain groups don't have access to governmental power and so can't make policy or law—and on a small scale: think about how families or classrooms work. The work of the cultural critic bell hooks (lower case intentional) reminds us that a revolutionary gesture is made when disempowered peoples simply speak for themselves and represent their own viewpoints and experiences.⁴

Theory is a discourse (or a web of many intersecting discourses) and as such it isn't neutral, universal, or impartial. Different theories and writers present specific points of view on the world. Any given theory emerges in a particular place and time, in response to particular events. It subsequently circulates, and is used and developed by scholars with particular motivations, working in particular places and times, with particular audiences.

The first quote that opens this chapter addresses this issue, as you will see, drawing attention to the ways that theory can reflect and perpetuate—as well as challenge—society's injustices. Poet and activist Audre Lorde (1934-1992) points out that we need new ideas and new theoretical constructs if we are going to achieve social justice. She argues that the master's tools will never dismantle the master's house because the ideas that emerge within racist, sexist, and homophobic contexts are not going to be able to change those contexts.⁵ Similarly, bell hooks challenges the racism underlying much contemporary critical theory, writing that, "racism is perpetuated when blackness is associated solely with concrete gut-level experience conceived either as opposing or having no connection to abstract thinking and the production of critical theory. The idea that there is no meaningful connection between black experience and critical thinking about aesthetics or culture must be continually interrogated."6 Theory doesn't stand outside culture, even when it critiques culture.

Positivism, or the theory of anti-theoretical positions

"Just the facts, ma'am." Detective Joe Friday, Dragnet

So what does it mean when Detective Joe Friday, the quintessential TV cop, asks for "just" the facts when talking to crime victims and witnesses? His statement implies that the facts are essential to solving the crime, but that their interpretation—the important stuff—should be left to the professionals. Facts in and of themselves don't say much; poor interpretation says less.

Positivism is a term used to describe scholarship that refuses to engage in interpretation, as if the facts can be selected and presented without interpretation—and as if interpretation is some kind of deeply suspicious activity. Positivism developed originally as a philosophical argument against metaphysics and theology; positivists recognized the sciences, which deal in "facts," as the only source of true knowledge. The French philosopher Auguste Comte (1798–1857), the founder of modern positivism, believed that human behavior follows laws, just as gravity and motion do; by discovering those laws through scientific observation, immoral and evil behavior could be eliminated without recourse to religion.7 Given the critiques of science and ideology that have appeared over the past half century, it's hard to take the position now that science is value-free or presents uninterpreted factual truth. In The Mismeasure of Man (1996) historian of science Stephen J. Gould (1941–2002) discusses the ways in which racism—to give one example—has distorted scientific practice.

In art history, positivism translates into highly descriptive accounts of artworks, including their formal qualities, history of creation, symbols and motifs, the biography of the artist, and so on. Often such detailed description is presented either as an argument against theoretically driven interpretation or as the necessary work "prior" to engaging in interpretation (strangely, the right time to engage in interpretation never seems to arrive . . .). Positivist art history—which doesn't usually identify itself as such—often claims to be more real, or more factually grounded, than theoretically informed art history. In making this claim, positivism sets up an unfortunate opposition between theory and fact, as if the two don't go together. Any of the aspects—or facts—of an artwork could form part of a theoretically informed interpretation, but they are not the end points of a theoretically informed interpretation.

Over the past thirty years or so, art historians have passionately

debated the role that theory should play in the interpretation of works of art. Some scholars have argued against the "importation" of theory into art history, as if art history has no theory and does not need it. Sometimes critics embrace formalism and often rather narrow iconographic approaches (see Chapter 2), as "native" to art history, and resist the examination of such issues as politics or reception raised by Marxist, psychoanalytic, or semiotic lines of questioning. In fact, many of the kinds of questions raised by contemporary theoretically informed art history—about context, reception, art history's institutions, power and ideology, relations of production—also have roots in eighteenth- and nineteenth-century art historical practice, even if, for a variety of reasons, they fell out of favor for a time.8 That art historians now range widely in crafting theoretical frameworks for their studies-engaging with political theory, anthropology, psychoanalysis, cultural studies, etc. reflects the interdisciplinary nature of recent academic practice.

I'm not arguing here against detailed contextual and/or visual analysis, which are both essential to good art history. It's not the "facts" themselves that are the problem but the way they are presented, what they are used to do or not do. The idea that a presentation of facts is not shaped by an intellectual position is an illusion, although that intellectual position may be less apparent if the author isn't being open about it. As Terry Eagleton shrewdly points out, "Hostility to theory usually means an opposition to other people's theories and an oblivion of one's own."

Thinking through theory

Using a theoretical approach to the practice of art history means that you channel your visual and contextual analysis into a more focused inquiry around a particular set of issues. Instead of starting from the general question "What is this painting expressing through this imagery?" you might ask "What does this painting tell us about gender relations in eighteenth-century France?" Engaging with a theoretical approach means that you pursue a particular line of questioning in depth. It means that you have to educate yourself about this line of questioning, and are prepared to engage in very in-depth formal and contextual analysis of the work. Working with critical theory in this way will make you even more aware of art history as a process of interpretation, not description.

You'll notice that a number of the dictionary definitions of theory quoted at the beginning of this chapter focus on scientific theory. When we study art history, are we trying to "prove" a theory. in the same way that laboratory experiments try to prove scientific theory? I think the answer here lies in making a distinction between two different levels of scientific practice. When you're a student, your lab experiments ask you to "prove" various theorems that are, in fact, already well tested. The point of these exercises is not, in the end, to prove the theorem, but to teach you how to engage in the scientific process and laboratory procedures. Theory in art history works more like true experimental science. Scientists have working hypotheses. or theorems, and then engage in experiments to see if those hypotheses are true. Often, that process of experimentation leads to a revision of the hypotheses and further experimentation. In art history, theory helps you frame better questions about the artworks or cultural practices you're studying, and then the process of exploring the answers to those questions helps you develop a more productive theoretical framework, one that generates further questions.

There's an important difference, though, between the sciences and art history. A scientist may, in the end, find a drug that is an effective cancer treatment, and her work then is done, or at least a phase of it reaches closure. But the interpretation of history, art, and culture is different: they express such a wide range of human ideas and experiences that there is no one result for the art historian to seek. Each person, each generation, each culture reinterprets artworks, finding in them new significance. Certainly, some arguments are more persuasive than others and some arguments do a better job of accounting for a wider range of evidence. But when we're talking about interpreting the past, or interpreting cultural practice, it's not a question of right and wrong but of looking for insight.

In wrestling with the relationships between "facts" and "theory" the ideas of the French philosopher Gilles Deleuze (1925–1995) about radical empiricism may be helpful. Empiricism, generally speaking, holds that knowledge derives from the senses alone, and stresses the importance of observation and experience in interpretation rather than theoretical constructs. Deleuze emphasizes that his radical empiricism has two key principles: "the abstract does not explain, but must itself be explained; and the aim is not to rediscover the eternal or the universal, but to find the conditions under which something new is produced (creativeness)." Empiricism allows us to analyze the state of things so that "non-pre-existent concepts" can be derived from them, an approach that he brought to bear in his own studies of literature, art, and film. The way the

What's the difference between theory and methodology?

The line between theory and methodology is often fuzzy, and they're usually spoken of together—"theory and methodology"—so that they seem to come as a unit. It helps me to think of theory as the process of formulating research questions and methodology as the process of trying to answer those questions. Theory is what helps us frame our inquiries and set an agenda for work on particular topics, objects or archives. Methodology, strictly speaking, is the set of procedures or ways of working that

characterize an academic discipline. For art history, standard methodologies include formal analysis of works of art; laboratory analysis of works of art (to determine age, identify materials, or reconstruct the artist's working process); and research into related historical documents such as contracts, letters, or journals. In some fields, interviews with artists, patrons, and others involved in artistic production are possible. Each of these methodologies has its specific procedures and theories of practice.

madeleine unleashed powerful memories for Proust's character would be a good example of this kind of process (not surprisingly, Deleuze wrote extensively about Proust). Deleuzian empiricism is not narrow or limited: it is about expansion, production, creativity, and difference, and fundamentally linked to "a logic of multiplicities." The practice of theoretically informed art history perhaps reflects, or shapes, such a logic of multiplicities.

So how do you actually engage with theory in your practice of art history? In attempting to answer that question, I feel like Glinda the Good Witch: I can point you to the right road, but you have to travel that road, and find the answer, yourself. The best general advice for art-history students first engaging with critical theory is to read widely in art history, philosophy, history, literature, political science, anthropology, sociology, and any other academic fields that capture your interest; take a range of courses; and ask your professors for advice.

In many ways, your own interests and experiences will guide your theoretical investigations. For example, you may find yourself focusing on issues of gender or class or race that will lead you to engage deeply with feminist, Marxist, or post-colonial theory. Working from those interests, you'll choose to examine works of art, artists, and arts institutions that enable you to explore such issues. Or you may be interested in a particular artist, period, art form, or culture, and from that develop related theoretical interests.

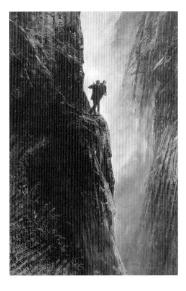

 Mark Tansey, Derrida Querying De Man, 1990.
 Oil on canvas. Collection of Mike and Penny Winton.

Tansey, the son of art historians, makes paintings about the making, and studying, of paintings. In this image, two great theorists of deconstruction, Jacques Derrida and Paul de Man, struggle on cliffs made of words. They reprise Sidney Paget's famous illustration of the fatal encounter between Sherlock Holmes and his nemesis Moriarty in Arthur Conan Doyle's 1893 story "The Final Problem."

You may be interested in portraiture, for example, and that may lead you to psychoanalytic and reception theory. As you become familiar with different theoretical perspectives, you'll also be able to see which ones will help you in answering certain kinds of questions and analyzing particular works of art, artistic practices, or institutions. Ultimately, this kind of inquiry leads to a rather open set of questions around the relationship between art, ideas, and society (Figure 1.2). Are artworks or practices necessarily vehicles for ideas in society? Can art and ideas exist in separate realms? Can they exist outside society? What do ideas—in this case, critical theory—tell us about the arts? What do the arts tell us about critical theory?

I want to emphasize the idea that theoretical analysis is not a one-way street: theory is not something simply to be applied to works of art. Rather theory, visual arts, culture, and politics are all caught up in a web of relations. Sometimes it is art that helps me think through theory rather than the other way around. For example, a performance by the artist Shigeyuki Kihara (Figure 1.3), who identifies herself as a fa'a fafine (in her Samoan heritage, a man who dresses and lives like, and considers himself, a woman) made me reconsider how I think about multiple cultural practices, gender identities, and the idea of hybridity—a widely used concept in post-colonial discourse (see Chapter 3). In the performance, a collaborator broke open the casing of a sex video and then slowly walked around Kihara, wrapping her in the shiny videotape. Kihara stood

quite still and erect, saying nothing, and only occasionally moving her arms to change her pose as the tape accumulated around her body. When the tape was at an end, she began to unwrap herself with slow, ritualized movements, finally kicking the tape to one side and walking away.

A number of Auckland's Pacific Islander artists and writers, including the novelist Albert Wendt, argue against the term hybridity to describe their work and their realities. If the work seems hybrid or contradictory or part this and part that, this is only because the viewer looking at it stands outside the artist's reality-most frequently in the position of the colonizer. 12 So on one level the gesture of wrapping in Kihara's performance referenced the use of binding to render people and objects tapu (sacred) in Samoan culture. This act claimed Kihara's person as something sacred or set apart, in distinct opposition to the kind of violence directed at transgendered people in Western cultures. At the same time, being wrapped in a sex videotape also referenced the ways that transgendered people are defined—and dehumanized—by the kind of stereotypes found in pornography and other mainstream cultural representations. Through the gesture of unwrapping, Kihara reclaimed the right to determine her own representation while simultaneously returning her body to a noa or non-sacred state. The staging of the performance (at an adult store, in a sexy outfit) refer-

enced the urban Pacific drag-queen scene, and there was something, too, of the geisha in Kihara's self-conscious and highly-stylized performance of gender: Kihara is also Japanese, and sometimes goes by the name of Dusky Geisha. But standing there on Karangahape Street watching the performance, I didn't feel that Kihara was only "part" any of these things: each was a whole aspect of her whole self as presented in the performance.

1.3 "Lala Siva," performance piece collaboration between Shigeyuki Kihara and Filipe Tohi, Auckland, 2003.

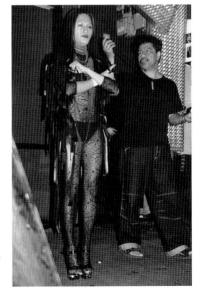

Conclusion

This chapter has defined theory and made a case for its importance in contemporary art history. The definition of theory proposed here is utilitarian, a working definition that can help you engage with these ideas. When writing this chapter, I looked at a number of theory handbooks and websites to see how they defined theory (I'll admit that I was struggling to come up with a clear, concise definition). Interestingly enough, a number of sources I consulted plunged right into the discussion of theory without defining it first, as if assuming readers knew this already. That didn't seem right to me, and so in this chapter I've tried to supply a basic discussion of theory as a common starting point for all readers. Where you, the readers, will end up is, of course, an open question.

A place to start

The guides listed below will help you get a broad understanding of the history of critical theory as it relates to the arts and culture. The readers provide helpful overviews of movements and authors, but, more importantly, they also include excerpts of primary theoretical texts.

Guides

Eagleton, Terry. Literary Theory: An Introduction. Oxford: Blackwell, 1983, and Minneapolis: University of Minnesota Press, 1996; 2nd edition, 1996.

Harris, Jonathan. The New Art History: A Critical Introduction. London and New York: Routledge. 2001.

Macey, David. The Penguin Dictionary of Critical Theory. Harmondsworth: Penguin, 2000, and New York: Penguin, 2002.

Sturken, Marita and Lisa Cartwright. Practices of Looking: An Introduction to Visual Culture. Oxford and New York: Oxford University Press, 2001.

Tyson, Lois. Critical Theory Today: A User-Friendly Guide. New York: Garland, 1999.

Readers

Fernie, Eric, ed. Art History and Its Methods: A Critical Anthology. London: Phaidon, 1995. Hall, Stuart and Jessica Evans, eds. Visual Culture: The Reader. London: Sage, 1999. Mirzoe, Nicholas, ed. The Visual Culture Reader. London and New York: Routledge, 1998. Preziosi, Donald, ed. The Art of Art History: A Critical Anthology. Oxford and New York: Oxford University Press, 1998.

Richter, David H., ed. The Critical Tradition: Classic Texts and Contemporary Trends. 2nd edition. Boston: Bedford/St. Martins, 1998.

Chapter 2

The analysis of form, symbol, and sign

The heart of this chapter deals with iconography, along with iconology—a closely associated theory of interpretation—and semiotics. Both iconography and semiotics address the meaning of works of art: what they mean and how they produce those meanings. Within the discipline, art historians developed iconography as a distinctive mode of inquiry first, but semiotics is actually older as a philosophy of meaning: its roots go back to ancient times.

As an introduction to these ideas, I'll briefly review some theories of formalism, an approach to works of art that emphasizes the viewer's engagement with their physical and visual characteristics, rather than contextual analysis or the search for meaning. Keep in mind that the methodology of formal analysis, as you practice it in your art-history courses, is distinct from the theory of formalism. The chapter closes with a short discussion of "word and image" and the sometimes knotty relationship between images and texts in art historical practice.

Formalism in art history

Art is significant deformity. Roger Fry quoted in Virginia Woolf, Roger Fry: A Biography (1940)

Formalists argue that all issues of context or meaning must be set aside in favor of a pure and direct engagement with the work of art. The artwork should be enjoyed for its formal qualities (e.g.

composition, material, shape, line, color) rather than its representation of a figure, story, nature, or idea. Although this perspective runs counter to the direction of much contemporary art history, the idea that works of art have a unique presence, and impact on us, is hard to dismiss. In fact, it's an idea with a long history: the German philosopher Immanuel Kant (1724–1804), for example, famously argued for the special character of aesthetic experience. He wrote that the poet seeks "to go beyond the limits of experience and to present them to sense with a completeness of which there is no example in nature" for "as their proper office, [the arts] enliven the mind by opening out to it the prospect into an illimitable field of kindred representations."

In art history, the theories of form and style proposed by the Swiss scholar Heinrich Wölfflin (1864–1945) were highly influential during the first two-thirds of the twentieth century. Writing at a time when sciences and social sciences were uncovering seemingly immutable laws of nature and human behavior, Wölfflin argued that a similarly unchanging principle governed artistic style: the cyclical repetition of early, classic, and baroque phases. He likened the functioning of this "law" to a stone that, in rolling down a mountainside, "can assume quite different motions according to the gradient of the slope, the hardness or softness of the ground, etc., but all these possibilities are subject to one and the same law of gravity." According to Wölfflin, the way to explore this dynamic was through rigorous formal analysis based on pairs of opposing principles (e.g. linear vs. painterly, open vs. closed form, planar vs. recessive form).

Wölfflin focused primarily on Renaissance and Baroque art, but with the rise of modern art, formalism found another champion in Roger Fry (1866–1934), an English painter, critic, and curator, and part of the Bloomsbury Group of artists and intellectuals. Fry held that artwork is irreducible to context: for him, the power of art cannot be "explained away" by talking about iconography, or patronage, or the artist's biography. Fry's personal and intellectual resistance to the growing field of psychoanalysis—which very directly addresses the relationship between form and content, whether in dreams or works of art—may have influenced his opposition to the discussion of content in art.⁴ Unlike psychoanalysts, or some earlier art historians such as Alois Riegl (1858–1905), Fry argued that artworks have no real connection either to their creators or to the cultures in which they're produced. In 1912

he organized an influential exhibition of Post-Impressionist painting in England, and his catalogue essay explains his vision: "These artists do not seek to give what can, after all, be but a pale reflex of actual appearance, but to arouse the conviction of a new and definite reality. They do not seek to imitate form, but to create form; not to imitate life, but to find an equivalent for life . . . In fact, they aim not at illusion but at reality." 5

Henri Focillon (1881–1943), an art historian who worked in France and the United States, developed a widely debated theory of formalism: the 1992 reprint of one of his most famous works, The Life of Forms in Art (1934), has renewed interest in his work. Focillon saw artistic forms as living entities that evolved and changed over time according to the nature of their materials and their spatial setting. He argued that political, social, and economic conditions were largely irrelevant in determining artistic form, and, like Fry, he emphasized the importance of the viewer's physical confrontation with the work of art. In The Art of the West in the Middle Ages (1038). Focillon traced the development of Romanesque and Gothic style in sculpture and architecture, emphasizing the primacy of technique in determining artistic form. (Of course, from a different perspective, political, social, and economic conditions could be seen as primary factors in determining the availability of materials and the development of technology, both of which shape technique; see the discussion of Michael Baxandall in Chapter 3.) For him, the key to understanding Gothic art was the rib vault, which "proceeded, by a sequence of strictly logical steps, to call into existence the various accessories and techniques which it required in order to generate its own architecture and style. This evolution was as beautiful in its reasoning as the proof of a theorem . . . from being a mere strengthening device, it became the progenitor of an entire style."6

Even after the death of Roger Fry, modern art continued to have its formalist defenders. Perhaps chief among these was Clement Greenberg (1909–1994), a prolific and controversial American art critic who championed Abstract Expressionism. His first major piece of criticism, "Avant-Garde and Kitsch" (1939), appeared in the Partisan Review, a Trotskyist Marxist journal; in it he claims that avant-garde art, unlike the kitschy popular art promoted by Stalin's regime, presented the only true road to revolutionary change. This was soon followed by "Towards a Newer Laocoön" (1940), in which he argued that the most important modernist painting had

renounced illusionism and no longer sought to replicate three-dimensional space. Each art form had to develop, and be critiqued, according to criteria developed in response to its particular internal forms. In "Modernist Painting" (1961), Greenberg developed these ideas further, contending that the subject of art was art itself, the forms and processes of art-making: modern art focused on "the effects exclusive to itself" and "exhibit[ed] not only that which was unique and irreducible in art in general, but also that which was unique and irreducible in each particular art." Abstract Expressionist painting, with its focus on abstraction, the picture plane, and the brush stroke, was ideally suited to this perspective, although Greenberg took pains to emphasize that modernism was not a radical break from the past but part of the continuous sweep of the history of art.

Early in her career, the American art theorist and critic Rosalind Krauss was an associate of Greenberg's, but she broke with him in the early 1970s to develop her own very distinctive vision of modernism. Her work often stresses formalist concerns, though through post-structuralist semiotic and psychoanalytic perspectives (see "Semiotics" later in this chapter, and Chapter 4). Her essay "In the Name of Picasso", first delivered as a lecture in 1980 at the Museum of Modern Art, is a prime example. In it, she argues against using biographical or contextual information to interpret Picasso's Cubist works, especially the collages, precisely because the works themselves reject the task of representing the world (or mimesis). According to Krauss, Picasso's collages engage in "material philosophy," that is, through their form and materials they assert that representation is fundamentally about the absence of actual presence.9 Krauss criticizes the practice of interpreting artworks primarily in terms of artists' biographies, a phenomenon that she witheringly labels "Autobiographical Picasso." ¹⁰ She further challenges the way that art history ignores "all that is transpersonal in history—style, social and economic context, archive, structure" and as an alternative emphasizes the potential of semiotics as a concept of representation. 11

Iconography and iconology

Iconography means, literally, "the study of images." At its simplest level, the practice of iconography means identifying motifs and images in works of art: a woman with a wheel in her hand represents St. Catherine, a figure sitting cross-legged with hair in a

topknot and elongated earlobes represents the Buddha. Sometimes iconographers focus on a particular element within an image, such as a human figure who is part of a larger crowd scene, or a flower motif used to decorate a capital; at other times, they focus on the image as a whole, such as the Last Supper. The process of identification may not be all that simple: it often requires extensive knowledge of a culture and its processes of image-making.

Although the terms "iconography" and "iconology" are often used interchangeably, they actually refer to two distinct processes of interpretation. Iconology, in a way, picks up where iconography leaves off. It takes the identifications achieved through iconographic analysis and attempts to explain how and why such imagery was chosen in terms of the broader cultural background of the image. The idea is to explain why we can see these images as "symptomatic" or characteristic of a particular culture. So, for example, once you've determined that a statue represents St. Catherine, then you may want to ask why St. Catherine was depicted in this particular place and time by this particular artist.

Unlike some of the theoretical approaches discussed in this book, which developed in other disciplines and have been adapted by art historians, iconography and iconology were developed first by art historians specifically for the analysis of art. In a sense, iconography, as the identification of images, has a long history: the Roman scholar Pliny (AD 23-79), for example, in his Natural History, took care to discuss the subject matter of the images he was discussing. Iconography became more systematized in the sixteenth century, when iconographic handbooks that explained different themes and allegorical personifications were published for the use of artists and connoisseurs. Somewhat later, the Italian art connoisseur and intellectual Giovanni Pietro Bellori (1615-1696), in his Lives of the Modern Painters, Sculptors, and Architects (1672), combined elements of his predessor Giorgio Vasari's influential biographical approach with iconographic analysis, as he tried to explain the literary sources of images. In the eighteenth century, the German scholar Johann Joachim Winckelmann (1717–1768) laid the foundation for the modern, systematic approach to iconography in his studies of subject matter in ancient art.12

Panofsky's iconography and iconology

Working in England, the Austrian art historian Aby Warburg (1866–1929) and his students developed modern iconographic

theory, rejecting what they saw as a purely formal approach to art in the work of scholars such as Wölfflin. Warburg argued that a given period's art was connected in numerous ways with its religion, philosophy, literature, science, politics, and social life. As his student, the art historian Erwin Panofsky (1892–1968), put it: "In a work of art, 'form' cannot be divorced from 'content': the distribution of colour and lines, light and shade, volumes and planes, however delightful as a visual spectacle, must also be understood as carrying a more-than-visual meaning." Iconography was the method that enabled scholars to retrieve content embedded in works of art. In Studies in Iconology (1939) and Meaning in the Visual Arts (1955), Panofsky defined three levels of iconographic/iconological analysis, each with its own method and goal.

In the first level, pre-iconographic analysis, the viewer works with what can be recognized visually without reference to outside sources, a very basic kind of formal analysis. In the second level, iconographic analysis, the viewer identifies the image as a known story or recognizable character. In the third level, iconological analysis, the viewer deciphers the meaning of the image, taking into account the time and place the image was made, the prevailing cultural style or style of the artist, wishes of the patron, etc. So, for example, you might look at a small plastic object and identify it as the figure of a woman. Researching further, you might identify the woman depicted as Barbie, and recognize this object as a type of doll widely circulated in the United States and beyond since the 1950s. At the third level, you might examine the ways in which Barbie dolls express certain ideas about women's roles in society and women's bodies.

Hypothetically, when you're studying a work of art, you move through these three levels in order. In actuality, it's not always that simple. Many art historians have challenged the notion of the "innocent eye" necessary for pre-iconographic analysis: semiotics and reception theory have emphasized that viewers come to art as individuals shaped by their experiences, values, and historical and cultural knowledge. For example, if you've been raised as a Christian, or are very familiar with the history of European art, it will be a real challenge to see an image of the Nativity at a pre-iconographic level. You'll immediately jump to the iconographic, and then have to step back deliberately from that informed viewpoint. Of course, if your eye is too "innocent" you may have trouble engaging in interpretation at any level. The lotus motif in Egyptian art may look

like a purely geometric pattern to you if you're not familiar with the plant and can't see the representational aspects of the image. In historical and cross-cultural analysis, it may prove to be a challenge to move from level two to level three: all sorts of gaps in the historical record or your own knowledge, as well as your own preconceptions, may complicate your work. If you're completely unfamiliar with African art and are studying a Yoruba gelede mask, you may have to work very hard to identify the different figures depicted in the mask's superstructure, and some of them you may not be able to identify with any certainty.

At its most subtle, then, iconography works to retrieve the symbolic and allegorical meanings contained in works of art. Let me take a moment here to define these terms. A symbol is something that is widely recognized as representing an idea or entity. A set of scales is, for example, a symbol for the idea of Justice. An allegory is a narrative, using a set of symbols that is widely recognized to represent an idea or entity; it may be in the form of a personification (that is, a human or animal image). So a woman holding a set of scales is an allegorical figure of Justice. It's important to remember that symbols and allegories are culturally specific, and their meanings are not always evident to every member of that culture, much less outsiders. Among the Hawai'ian people, for example, the idea of kaona, or "veiled reference," underscores this: poetry and other arts have many layers of meaning, some of which are accessible only to those who are highly trained as artists. 14

Iconology is the phase of interpretation that follows the identification of iconographies. Iconological interpretation investigates the meaning of motifs, symbols, and allegories in their cultural context. In developing his theory of iconology, Panofsky was strongly influenced by Ernst Cassirer's theory of significant form. 15 Cassirer (1874–1945), a German philosopher who fled the Nazis, argued that images represent fundamental principles or ideas (symbolic values) in a given culture, so that we can see works of art as "documents" of an artist, religion, philosophy, or even an entire civilization. 16 This idea of significant form is different from the formalist idea: the formalist idea strips away cultural meaning, while Cassirer argues that significant forms are loaded with cultural meaning. Cassirer noted that the researcher's own personal psychology, experience, and philosophy will shape her interpretation—an interesting precursor to ideas of reception and identity politics discussed in Chapters 4 and 5.

Iconography and iconology since Panofsky

Panofsky's method was widely influential in mid-twentieth-century art history, and he is still respected as a leading figure in the discipline. Although Panofsky developed his methods in relation to his pioneering studies of Renaissance art-his own field of expertise—they were widely applied to a range of periods and cultures (see, for example, the work of Fritz Saxl, Rudolf Wittkower, Ernst Gombrich, Richard Krautheimer, Jan Białostocki, and Hans Belting in the bibliography). Leo Steinberg's famous (and controversial) book, The Sexuality of Christ (1996), is a skillful and imaginative exercise in iconographic and iconologic analysis. Steinberg (b. 1920), an American art historian, first identifies Christ's penis as an overlooked icon. He demonstrates that in numerous Renaissance images, the penis of Christ is not only visible but deliberately displayed: the Madonna may reveal the infant Christ's genitals to the Magi, or the dead Christ's hand may fall over his genitals with subtle emphasis. Steinberg relates this iconography to the theological emphasis on Christ's humanization, his Incarnation as a mortal—and sexual—human being who unites God and Man.

The practice of iconography and iconology resulted in productive new developments in the field. One area of concern was the changing meaning of images over time. Polish art historian Jan Białostocki (1921–1988) used the term "iconographic gravity" to describe the ways in which images and motifs take on new meanings. In fact, Aby Warburg had earlier commented on the persistence of such themes and images in the transition from Classical to Christian art: for example, the halo, which we typically interpret as a sign of Christian holiness, was actually used in late Antiquity to indicate princely status. "Iconographic gravity" is particularly prevalent in what Białostocki called Rahmenthemen, or encompassing themes, which, like topoi in literature, persist over time as important subjects in art. 17 In Western art, examples include the triumph of Virtue over Vice, the hero, the ruler, sacrifice, mother with child, divine inspiration, and the lamentation of the beloved dead. Each of these has appeared in Greek, Roman, early Christian, Medieval, and Renaissance art—and beyond—in a wide range of historical and cultural contexts.

With the rise of the "new" art history in the late 1960s, a productive critique of iconography developed. Working at a time of dynamic intellectual and social movement, the new art historians

were engaged with emerging fields of critical theory, such as poststructuralism and semiotics, and the history of art history; they began to question the assumptions, methods, and aims of art history.¹⁸ They emphasized the role of the viewer and social context in shaping works of art: the work of art wasn't a neatly packaged message delivered by the artist to the viewer, but a complex text that could be read (or misread) in any number of ways. In particular, these art historians criticized iconographic analysis that was limited and descriptive in nature: T. J. Clark dismissed Panofsky's less skillful followers as "theme chasers," while Svetlana Alpers (b. 1936) challenged the assumption that visual symbols inevitably have or express meaning.¹⁹

At the same time, Alpers and other scholars stressed that Panofsky's method had been developed for the analysis of Renaissance art, and argued that this was what it was best suited to. In their view, applying this method indiscriminately was to suggest, falsely, that Renaissance art—especially Italian Renaissance art provided a universal model of image-making.²⁰ The debate was particularly heated with respect to seventeenth-century Netherlandish genre painting. Netherlandish art historian Eddy de Jongh and others had used an iconological approach to discuss such depictions of everyday life and objects as allegories rich in symbolic meaning.²¹ In The Art of Describing: Dutch Art in the Seventeenth Century (1983), Svetlana Alpers countered that Dutch art, unlike Italian art, was not narrative and symbolic. In her view, Dutch painters participated in a distinctive visual culture that led them to value detailed paintings of everyday life as a way of knowing the world, not as a way of presenting disguised moralistic messages. She connected painting to the production of maps, lenses, and mirrors as expressions of a distinctive Dutch visual culture. Other scholars have argued that both perspectives on Dutch painting are right—that Dutch artists deliberately created open-ended works which viewers could interpret symbolically, if they chose to, or experience as a fresh and penetrating view of the world.²²

Practicing iconography and iconology

When you begin an iconographic analysis, it can help to work your way through Panofsky's three stages, but only rarely will you systematically explain all three in your final analysis. I'll take as an example a South Asian sculpture that depicts the Hindu goddess Durga slaying the demon Mahisha (Figure 2.1).

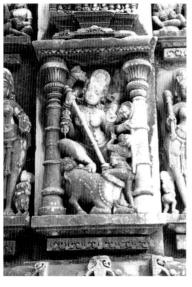

2.1 Durga defeating Mahisha, 961 CE. Stone. Ambika Mata temple, Japgat, Rajasthan, India.

- ► The basic iconographic questions are a helpful way to start learning about this work, especially if you are unfamiliar with Hindu imagery: What does this sculpture represent, on the most simple level? (A multi-armed female figure decapitating a buffalo, with a lion biting the buffalo's hindquarters and a man seemingly crouching on its head.)
- ▶ Who are these figures? How did you identify them? (The woman's multiple arms and the many weapons she holds—vajra (diamond or thunderbolt), trident, sword, bow, chopper—help you identify her as Durga, the goddess who slew the demon Mahisha in buffalo form; as she decapitated the buffalo, Mahisha emerged from its heads in human form—this is the figure on the right.)

Having accomplished a basic identification of the figure, you could then proceed to ask a series of iconological questions, designed to explore the larger dimensions of the image:

- How is this artist's depiction of the subject similar to or different from other artists' depictions at the time this was made, or at different times?
- ► Did this image inspire, or was it inspired by, literary representations of this theme or subject? How is it similar to or different from such literary representations?
- ▶ How do you account for these differences and similarities?

Are there other visual images that directly inspired this representation?

An important aspect of iconographic/iconological analysis is comparison with textual sources, and so you might search out accounts of Durga's confrontation with the demon. Here's one such text, from Chapter 62 of the Kalika Purana, a late ninth- or early tenth-century collection of religious verses that includes numerous descriptions of Hindu goddesses:

The demon started to worship Bhadra Kali and when [Durga] appeared to him again in a later age to slaughter him again, he asked a boon of her. [Durga] replied that he could have his boon, and he asked her for the favour that he would never leave the service of her feet again. [Durga] replied that his boon was granted. "When you have been killed by me in the fight, O demon Mahisha, you shall never leave my feet, there is no doubt about it. In every place where worship of me takes place, there [will be worship] of you; as regards your body, O Danava, it is to be worshipped and meditated upon at the same time."

You could also study this relief as part of the overall iconographic program of the temple it decorates. Ambika Mata is a Devi (Goddess) temple, incorporating numerous images of Durga and other female divinities. Ambika, the principal image in the shrine, is a form of the mother goddess who is associated with Durga through her lion mount. So you might want to compare this image of Durga with others from the same temple depicting Ambika.

Often, iconographic/iconological analysis is comparative, and you might compare this temple image with another Durga image made in the nineteenth century (Figure 2.2). In this image, Durga's lion is emphasized, and the demon, instead of appearing as a buffalo, is shown in its final human form. Durga still has her many arms, but she is also accompanied by her children. In a comparative iconographic analysis, you would go on

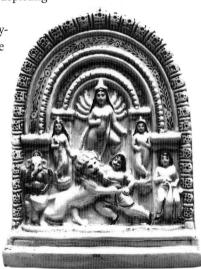

to consider the significance of these similarities and differences. From an iconological perspective, you might try to understand the different ways in which the two images were used: the small porcelain image as part of a domestic shrine, the stone sculpture in an important temple. Also, the small porcelain image was made during the time that India was a British colony—it may have been made in Europe and exported to India or produced in India by a European manufacturer; either way, the colonial situation in which it was produced is an important iconological issue.

Of course, iconography and iconology don't have to be used alone. You could take this series of iconological questions, use them to generate some ideas, and then take those ideas as a starting point for addressing issues of ideology, class, gender, or colonialism using specific contextual theories presented in Chapter 3. For example, feminist theory would probably help you to analyze the range of female imagery found at Ambika Mata.

Semiotics

They say she cannot wear the color red because it is too old for a young girl, that maybe she will be ready when she is near the end of high school. She knows that red is the color of passion, that a woman in a red dress is sultry, sensuous, that a woman wearing a red dress had better look out. Red is a color for sluts and whores they say. She is trying on yet another pink dress. They say she looks so innocent, so sweet in the color pink. Secretly she loves the color black. It is the color of night and hidden passion. When the women go dancing, when they dress up to go to the nightclub they wear black slips. They sit in front of the mirror painting themselves with makeup, making their lips red and rich. To her they are more beautiful in their black slips than they will ever be in any dress. She cannot wait to wear one.

bell hooks, Bone Black: Memories of Girlhood (1997)

Semiotics is the theory of signs. Simply put, a sign is something that represents something else. Here's an example: look out of the window and find a tree. There are all sorts of signs for that thing you're looking at. One of them is the word tree itself, four letters spelled out on the page: t-r-e-e. A different sign is the spoken word, "tree." Another sign is a drawing of a tree. A little plastic toy tree is also a sign for tree. Yet another sign is gestural: if you were playing charades and stood straight with your legs together and your arms spread out in a V-shape over your head, your team might

guess that you were representing a tree. So signs take the form of words, images, sounds, gestures, objects, even ideas—the thought "tree" generated in your head by looking out of the window is also a sign. But although almost anything has the potential to be a sign, it can only function as a sign if it is interpreted as a sign: signs have to be recognized as signs in order for them to function as signs.

In the passage from bell hooks's memoir quoted at the beginning of this section, hooks describes her semiotics of women's dress, her study of the meaning of the style and color of women's clothing, bell hooks's system of signs is based both on cultural knowledge—widely accepted interpretations of these colors and styles—and also on her own personal signification. For hooks, the color black is a sign of night, both because of its darkness, like the night sky, and because it is worn at night. Red is a sign of passion; pink, a sign of innocent girlhood. These are meanings, or significations, for the color black that many might recognize and agree with. That black is a sign of hidden passion is hooks's own, more personal signification, prompted by the fact that the grown-up women around her wear black slips when they go out at night; the slips are sexy but worn underneath dresses, which is how they come to signify hidden passion for hooks. Black wouldn't necessarily signify hidden passion to other people who didn't share hooks's imagination or experience. For me, the analysis of this passage demonstrates two things: how a sign has to be recognized as such in order to function as a sign, and that signs, like the color black, can have multiple meanings.

In many ways, the kinds of issues taken up by iconographers and iconologists also concern semioticians. For many art historians, semiotics functions as a more interdisciplinary version of iconography and iconology, an expanded way of asking questions about what works of art mean and how they go about creating or expressing these meanings. Semiotics provides a different—and some would say more precise—language and framework for understanding the multifaceted connections between image and society and image and viewer, and for understanding not only what works of art mean but how the artist, viewer, and culture at large go about creating those meanings.²³

The founding semioticians: Saussure and Peirce

Although the theory of signs has been around in different forms since ancient times, the modern theory of signs is based funda-

2.3 Diagram of Saussurean sign

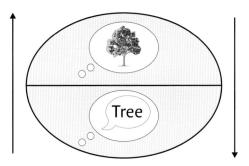

mentally on the work of two theoreticians, the Swiss linguist Ferdinand de Saussure (1857–1913) and the American philosopher Charles Sanders Peirce (1839–1914). According to Saussure, the sign is composed of two parts (Figure 2.3):

signifier the form that the sign takes signified the concept it represents

The relationship between the signifier and the signified is the process of signification, represented by the arrows. So, to go back to the example of a tree, that thing you're looking at out the window would be the signified, and the word "tree" spelled out on the page would be the signifier.²⁴

Charles Sanders Peirce explained the structure of signs somewhat differently. He argued that the sign is made up of three parts:

Representamen the form that the sign takes (not necessarily

material)

Interpretant the sense made of the sign

Object the thing to which the sign refers

Within Peirce's model of the sign, a traffic light, when considered as a sign for the concept of stopping your car, would consist of: a red light at an intersection (the representamen); vehicles halting (the object); and the idea that a red light indicates that vehicles must stop (the interpretant). Peirce understood that the process of interpreting signs tends to generate even more signs: the way the driver formulates the idea that cars should stop is a sign as well as an interpretant. Peirce's structure is often represented as a triangle in which the dotted line between the sign vehicle and the reference indicates that there's no automatic or natural connection between the two—the connection must be constructed (Figure 2.4).²⁵

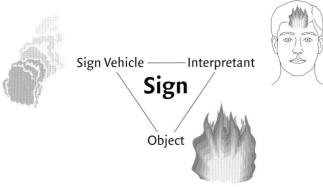

2.4 Diagram of Peircean sign

Peirce developed a very elaborate taxonomy of signs (over 59,000 types!), but what's most helpful to art historians is his identification of three basic kinds of signs:

Symbol the signifier is purely arbitrary or conventional; it does not resemble the signified. Examples: alphabetical letters, numbers, traffic signs.

Icon the signifier is perceived as resembling or imitating the signified, or being similar to it in some of its qualities. Examples: a portrait, a model airplane.

Index the signifier is not arbitrary but is directly connected in some way (physically or causally) to the signified in a way that can be observed or inferred. Examples: medical symptoms (an index of disease), smoke (an index of fire), footprints (an index of a passing person), photographs and films (the direct result of the imprint of light on a sensitized surface).

Signs don't usually belong exclusively to one category: there is a great deal of overlap, and signs often partake of characteristics of more than one of these types. For example, a photographic portrait is both an index and an icon, because it is a direct trace of the physical presence of the person (via light) and because it resembles that person. For your purposes, labeling an image as a particular type of sign isn't as important as the kinds of questions you can generate by thinking about these different processes of signification, these different relationships between signifier and signified, and the relationship between them (interpretant) generated by an observer.

Rosalind Krauss's essay "Notes on the Index: Seventies Art in America" (1977) serves as a model here. Krauss asserted that despite the diversity of seventies artistic practice—the seemingly "willful eclecticism" that encompassed everything from video to performance to earthworks to abstract painting—these works were united by their adherence to the terms of the index, rather than traditional concepts of style or medium. For example, Dennis Oppenheim's Identity Stretch (1975) transferred his thumbprint, greatly magnified, onto a large field and fixed its traces in lines of asphalt. Krauss notes that the work "focused on the pure installation of presence by means of the index." ²⁶

Systems and codes

Contemporary semioticians study signs not in isolation but as part of "sign systems," groups of signs that work together to create meaning and to construct and maintain reality. The concept of the "code" is fundamental in semiotics. Saussure, for example, stressed that signs are not meaningful in isolation, but only when they are interpreted in relation to each other: the code is the complex of signs circulating in any given society. The Russian-American linguist Roman Jakobson (1896–1982) further emphasized that the production and interpretation of signs depends on the existence of codes or conventions for communication. The meaning of a sign depends on the code within which it is situated: codes provide a framework within which signs make sense. Interpreting a text or image semiotically involves relating it to the relevant codes.

Here's an easy way to understand codes. Let's say you're a person who speaks only French. Now, if you see the English word t—r—e—e spelled out on the page, you won't recognize that as a sign for "tree," because you don't know the code—the English language in this case—that makes this particular arrangement of letters meaningful. Of course, you would recognize the word arbre, which is the word for tree in French, as a sign for tree. At the same time, you may also recognize a little plastic toy tree as a sign for a tree, because that's a visual code that many English-speaking and French-speaking people share. But even though it seems so natural a connection—the little plastic tree obviously represents a tree to your eyes—you can't assume that everyone knows that code. For example, a person from the remote Highlands of Papua New Guinea, who didn't have much exposure to plastic toys and had not learned that particular code for representing things, might not

recognize the little plastic tree as a representation of (as a sign for) "tree." A particular kind of representation, such as a plastic toy, may seem natural or obvious if you grow up with it, but it actually belongs to a highly specific cultural code that has to be learned, just like a language.

In relation to the working of codes, Jakobson's semiotic theory of communication has been influential in both literary criticism and art history.²⁷ A message (text, utterance, image) is sent by a sender/ speaker to a receiver/reader/listener/viewer. In order to be understandable this message must refer to the reality that sender and receiver share; this reality is called the context. The message must be transmitted via a medium the receiver can access, and it must be set in a code that the receiver understands and can use. (People who successfully send and receive email file attachments will recognize this principle.) So a communication exchange consists of these steps: emission-message-reception-reference-code. Jakobson's theory emphasizes that signs are about communication as a culturally specific process. Of course, communication isn't always successful. The sender and/or the receiver may not be particularly adept at manipulating the code, or the code may not be very well suited to expressing the message. (Think about the text messages that cell phones let us send: they're functional for certain kinds of communication, such as "Call home," but not for others, such as "Fifth Avenue is completely congested through midtown so if you want to meet me downtown, take Park.")

In fact, semioticians have elaborated the theory of codes in a number of ways and sometimes use a complex typology of codes to distinguish the different ways in which they work. Jakobson's work is influential in reception theory, and I'll discuss his ideas further in Chapter 4.

Interpreting codes and signs

A sign . . . is something which stands to somebody for something in some respect or capacity. It addresses somebody, that is, creates in the mind of that person an equivalent sign, or perhaps a more developed sign. That sign which it creates I call the interpretant of the first sign.

Charles Sanders Peirce, 1931-58

For Peirce, the sign was a process (Saussure thought of it more as a structure). The three-part Peircean notion of the sign—representamen/interpretant/object—leads to an important question: where

does semiosis, the production of signs, stop? If the process of interpreting a sign always generates another sign (the representamen), then semiosis could potentially go on for ever. Semioticians call this condition semiotic drift.

For the Italian semiotician and novelist Umberto Eco (b. 1932), the idea that an infinite number of readings is possible for any text (or sign) is more hypothetical than real.²⁸ Building on the work of Peirce, Eco argues that the possible meanings generated by a sign, although hypothetically unlimited, are in actuality confined by social and cultural context. To take a simple example, we can't interpret a figure of a mother with a child as the Virgin and Christ Child unless we already, within our culture, know about Christianity: our knowledge, or lack of knowledge, puts a limit on the range of interpretations we can create. At the same time, on a smaller

Are works of art puzzles? Are art historians detectives?

Underlying formalist, semiotic, and iconographic/iconological approaches to art history is the basic question of whether or not a work of art is something to be deciphered, like a puzzle or a murder mystery. The Italian art historian Carlo Ginzburg (b. 1939) raised the issue in "Morelli, Freud, and Sherlock Holmes: Clues and Scientific Method" (1980). Giovanni Morelli (1816-1891), an Italian doctor and art historian, developed a method of attribution based on the theories of scientific classification he had studied as a medical student.²⁹ He believed that what truly set artists apart from each other was not the dramatic, eye-catching features of their work, but minor things such as the rendering of earlobes. Ginzburg argues that Morelli and Freud, like the great fictional detective Sherlock Holmes, were masters of the overlooked detail, the small but telling clue that unravels the mystery. Ginzburg actually calls this a "lower" empirical methodology,

and compares it unfavorably to scientific method.³⁰ (Of course, this empirical approach runs exactly counter to formalism, which would claim that there's nothing to be deciphered in looking at a painting, only something to be experienced.)

The art historian James Elkins (b. 1955) notes that, because this deciphering mode has become such a basic art-historical practice, art historians tend to focus on works of art that can be treated this way: "We are inescapably attracted to pictures that appear as puzzles, and unaccountably uninterested in clear meanings and manifest solutions. The discipline thrives on the pleasure of problems well solved, and it languishes in the face of the good, the common, the merely true, the skillful, the private, and above all, the image that refuses to present itself as a puzzle". If art historians are detectives, it's because we choose to be.

scale, semiosis may also be limited by the (in)competence of the interpreter—the extent to which she knows the relevant codes to employ in interpreting the sign. It's important to remember that context isn't a given, it's produced. The cultural reality that restricts semiosis is a creation of the community: it may be an arbitrary, pseudo-reality, but its effect is none the less powerful.

The idea that signs relate to each other, that they're part of a larger context and not "closed," discrete little units of signification, was also emphasized by the French semiotician Julia Kristeva (b. 1041). In the sixties and seventies, Kristeva was one of a group of post-structuralist thinkers associated with the radical journal Tel Ouel, in which she published some of her most important writings. Kristeva developed the concept of intertextuality to explore the ways that texts (or signs) actually refer to each other. She situates texts in terms of two axes: the horizontal axis connects the author and the reader of a text, while the vertical axis connects the text to other texts. Shared codes unite these two axes, for according to Kristeva, "every text is from the outset under the jurisdiction of other discourses which impose a universe on it."32 It's up to the creator of the sign and the interpreter of the sign (author/reader, artist/viewer) to activate those connections. Intertextuality becomes an important idea in post-structuralist and postmodern thought, and I'll return to it in Chapter 6.

The question of intertextuality relates, too, to the ways that signs signify both directly and indirectly, indicated by the terms denotation and connotation. Denotation indicates the meanings of a sign that are obvious or generally recognized. Connotation refers to meanings of the sign that are less obvious, that are inferred: it's the interpreter's job to bring the relevant codes to the process of interpreting the sign. For example, most readers would agree that the word "rose" denotes a fragrant flower with multiple petals and thorns, but would they be able to recognize all the flowers that are classified as roses (i.e. denoted by the word "rose")? Wild roses, for example, don't look anything like the roses that fill florists' shops on Valentine's Day. The word "rose" also has many connotations: it suggests romance, purity, elegance—and, during the Wars of the Roses (1455–1485) in England, red and white roses signified the two warring factions, the houses of Lancaster and York. While the word "rose" may readily connote romance for you, only if you bring the "code" of a knowledge of English history to bear will red and white roses connote the Wars of the Roses.

The Russian linguist and semiotician Valentin Voloshinov (1895–1936) pointed out that it is hard to separate denotation from connotation completely because even the act of deciphering denotations requires interpretive abilities—the process is, as he insisted. "molded by evaluation . . . meaning is always permeated with value judgement."33 The French semiotician Roland Barthes (1915–1980) took this idea a step further. He argued that although denotative meanings may seem to be the "basic" or "natural" meanings of the sign, they are in fact themselves produced by the sign's connotations: "denotation is not the first meaning, but pretends to be so; under this illusion, it is ultimately no more than the last of the connotations (the one that seems both to establish and close the reading), the superior myth by which the text pretends to return to the nature of language, to language as nature."34 Barthes elaborated this argument through examples drawn from advertising and photography, and a number of art historians have responded to these ideas—not least because they present, indirectly, a critique of the notion of the innocent eye or pre-iconographic interpretation.

Semiotics and art history

Both Peircean and Saussurean semioticians recognized early on before art historians—that semiotics might be a very productive approach to the interpretation of art, and it wasn't long before semioticians were looking at images as well as words. In a landmark 1934 paper, "Art as Semiological Fact," Czech linguist Jan Mukarovsky (1891–1975) declared that "the work of art has the character of a sign." He went on to apply Saussure's method to the analysis of the visual arts, although where Saussure distinguished between signifier and signified, Mukarovsky distinguished between the "sensuously perceivable 'work-thing'" and the "aesthetic object" existing "in the consciousness of the whole collectivity." In 1960 the French philosopher Maurice Merleau-Ponty (1908–1961) published a book, Signs, which applies a Saussurean model to the phenomenology of perception (phenomenology is the study of experience). Merleau-Ponty connected painting and language because paintings are composed of signs, assembled according to a "syntax or logic" just like language. Barthes's influential Elements of Semiology (1964) applies a Saussurean framework to popular images such as cartoons and advertising.

In the 1960s, within the discipline of art history itself, the American art historian Meyer Schapiro (1904–1996) had begun to

explore the idea of semiotic analysis in the visual arts. In 1969 he published an important essay, "On Some Problems in the Semiotics of Visual Arts: Field, Artist, and Society," in which he links the formal analysis of works of art with the examination of their social and cultural history. In particular, he focuses on the relationship between a painted image and the surface (ground) on which it is painted, and the issue of whether or not the image is framed in any way. Schapiro ranges broadly, from Paleolithic cave painting to Egyptian art to twentieth-century art, in exploring how different devices of framing enable artists to manipulate the signs of the image. To create meaning, figures can be positioned in various ways (e.g. the right side of a god is the favored side), enlarged, elevated, lowered, etc. in relation to the frame. It's a provocative essay, but it can't be considered a blueprint for art-historical semiotics, nor is it systematically semiotic in its observations.

It was up to the "new" art historians, who were exploring critical theory in a variety of arenas, to engage semiotics in a more sustained way. The American scholar Norman Bryson has been a key figure in this development, and it's no accident that he came to the field from literature. In his landmark study Word and Image: French Painting of the Ancien Régime (1981), Bryson explores the language-like qualities of art, as well as art's relation to actual written language (see **Word and image** below). Semiotically, he is interested in examining the openness of the artwork: to him, an image is not a closed sign, but open, with multiple overlapping sign systems at work in the image and in the cultural environment. For Bryson, semiotics opens up a vision of art as a dynamic force in society, for he sees that sign systems "circulate" through image, viewer, and culture (Kristeva's idea of intertextuality is obviously relevant here).

In an influential essay on Poussin's The Arcadian Shepherds, the French art historian Louis Marin (b. 1931) addressed the challenges inherent in using semiotic theory, which had largely developed in language, to interpret the visual arts (Figure 2.5). He focused in part on the issue of deixis, the "direction" of an utterance. Every utterance exists in space and time: it is produced by a speaker (sender) and sent to a listener (receiver) in a particular context that brings them together. The deictic traits of an utterance include things such as personal pronouns, verbs, adverbs of time and place. So how do we translate this to works of art—especially history paintings, like Poussin's, which don't seem to address anyone in particular? Marin points out that except for the physical existence

2.5 Nicolas Poussin, The Arcadian Shepherds, c. 1630. Oil on canvas. Louvre, Paris.

of the painting, and the fact that we're looking at it, nothing within the image tells us about its situation of emission and reception: it does not address the viewer (with, say, a figure who looks out of the picture). As viewers, we seem simply to catch sight of the figures in the painting going about their business, as if they don't need us in order to perform their story: in this way, the painting conceals its enunciative structure. And yet, curiously, the concealment of enunciative structures (and their reappearance as representation) is the painting's very subject. A shepherd traces the words Et in Arcadia eao on a tomb, words that address the shepherds but in an open-ended way, for the verb is missing from the phrase—"I too in Arcadia" is the literal translation of the Latin. Marin's reading, which involves subtle textual and visual analysis, reveals a Jakobsonian model of communication as the subject matter of the painting, with the painter (or viewer) occupying the position of the linguist who constructs a model.35 Marin's essay is doubly important because it reminds us that theory is not a one-way street: it's not just that theory is applied to the interpretation of art, but that the interpretation of art can alter our understanding of theory.

Although Dutch scholar Mieke Bal (b. 1946) is a literary critic by training, she has made significant contributions to the semiotics of art. She emphasizes that the work of art is an event—one that takes place each time an image is processed by a viewer. In this way the work of art is an agent, too, an active producer of the viewer's experience and, ultimately, of the viewer's subjectivity. The task of

semiotic art history is to analyze simultaneously the image and the interpretation of the image, the relation between the two (why does a subject interpret it in a particular way?), and the anchoring of the image in the interpretation and vice versa. She points out that the established iconographic approach in art history emphasizes what is common to images—the history of types, for example—rather than what is distinctive about a particular image and a particular viewer's way of approaching that image. Paradoxically, she says, although iconography may claim to have been developed uniquely for visual images, it may, in fact, ignore their unique qualities.

Practicing semiotic art history

A double-page spread from the lavishly illustrated prayer book, The Hours of Jeanne d'Evreux, provides an opportunity for a range of semiotic analyses (Figure 2.6). Wealthy lay people used such books as they observed the daily round of prayers adapted from monastic

Do we "read" works of art?

As you read more art history, you'll often see the word "read" used to talk about the process of interpreting a visual image. It sounds a little strange—how is it possible to "read" a visual image? Isn't reading only for words and texts?

The idea of "reading" works of art comes from semiotic theory, which often uses terminology based on language to discuss the process of interpretation: for semiotics, language has become the model form of communication (though the visual arts, gesture/movement/ dance, and music are other forms). In semiotics, a text is an assemblage of signs constructed (and interpreted) according to the rules or conventions of a particular medium or form of communication. Thus a novel is one kind of text, a poem another. So in this sense, a work of art can be referred to as a text, and the systematic process of interpreting that work according to the rules governing that kind of text can be referred to as "reading."

A number of art historians, including Mieke Bal, Louis Marin, and Norman Bryson, have developed this idea of reading as a very specific semiotic methodology for interpreting visual images, 36 Their point is not to give preference to the textual over the visual, but to engage more fully with the visual nature of the image. In various ways, they argue that confronting a work of art requires more than just simple, direct apprehension: it requires reading (remember that reading isn't natural to humans, we have to be taught it). Ernst Gombrich (1909-2001), an important art historian who worked in England, also proposed the idea that pictures are "read," because pictures are not natural or selfevident, but created according to a "pictorial language" that must be deciphered.37 Unlike semioticians, who maintain the openness of the signifying process, Gombrich believed in the art historian's ability to fix the "real meaning" of images.

ritual, and Jeanne d'Evreux's husband, Charles IV, King of France, commissioned this precious book for her. I'll pursue just a few of the possible lines of questioning here—these images are so rich that they spark endless debate and interpretation.

➤ You may want to start with some basic questions, similar to Meyer Schapiro's, about the visual semiotics of the work: what part of the image catches the viewer's eye first? Are certain elements larger than others? Are certain elements more brightly colored, or, in the case of sculpture, in greater relief?

With respect to the right-hand page, for example, you might note that there are three distinct images on the page, yet they are all interconnected visually. One is the large scene in the architectural setting at the top of the page. The other is the text, which incorporates the image of a kneeling woman inside the large letter "D" (the illustrated capital). A scene of a game (rather incongruously, to a modern viewer) runs along the page below the text.

What are the denotative and connotative aspects of this image?

Each of these images functions as a sign, and you can seek to interpret them individually and in relation to each other. The denotative meanings are fairly straightforward. The large scene is the Annunciation, the kneeling woman in the capital is Jeanne d'Evreux—the queen for whom the book was made—at her prayers. The game is a medieval version of "blind man's bluff" called "frog in the middle."

These three signs have overlapping connotative meanings. Jeanne d'Evreux is a queen, just as Mary, the mother of God, is Queen of Heaven. The parallel is enhanced visually because the letter D enclosing Jeanne d'Evreux functions like the architectural frame enclosing the Virgin. The juxtaposition of these two women on the same page may have encouraged Jeanne d'Evreux, as queen and as an aspiring mother, to take the Virgin Mary as her role model and inspiration.

Each of these three images is also composed of multiple signs. In terms of the formal issues raised through your questions, you may note, for example, that the main floor of the Virgin's house is enlarged, signifying the importance of her encounter with Gabriel; the upper floor, charmingly filled with a supporting cast of angels, has shrunk accordingly. The figure of the Virgin is large on the page, while Jeanne d'Evreux herself is relatively small.

2.6 Jean Pucelle, The Hours of Jeanne d'Evreux, fols. 15v, 16r: The Arrest of Christ and The Annunciation, circa 1324–1328. Each folio 3½ × 2½ (8.9 × 7.1 cm). Metropolitan Museum of Art, New York, The Cloisters Collection.

The very elaborateness of the scenes, which mark the start of a new section of prayer, invites a moment of pause, or contemplation, appropriate to starting an act of devotion: so that the elaborateness connotes that a new section is beginning.

What are the codes that are brought to bear on the interpretation of these images—either by yourself, as art historian, or by contemporary viewers?

Even when you understand that the image of the game signifies the capture of Christ, it still seems strangely sacrilegious to a modern sensibility. Why is a frivolous scene incorporated into such serious devotional imagery? What "code" made this juxtaposition possible for Jeanne d'Evreux and her contemporaries?

▶ What kinds of intertextuality are at work in these images?

Think also about this page in relation to the opposite page. Why juxtapose the Betrayal of Christ and the Annunciation? Thinking about each scene as hingeing on a greeting (Judas's kiss, Gabriel's "Ave, Maria") may help you explore the intertextuality between the two images further. The idea (or sign) of salutation or greeting also includes the little portrait of Jeanne d'Evreux—for prayer is itself a form of direct address to God, the Virgin, or the saints. The two pages are potentially further connected by the game: the abuse of the blindfolded person in the game echoes the abuse showered on Christ as he was captured at Gethsemane.

A focus on intertextuality would lead you to relate this image to other prayer books or items belonging to Jeanne d'Evreux, or other books produced by this artist. At the same time, intertextuality can make you aware of the uniqueness of this image—that it may employ a new code of representation in some way (the grisaille technique, discussed below, is one example).

► How do materials and techniques signify meaning in the work?

Although materials and techniques may not be symbols or motifs, they can be signifiers. Within a semiotic framework, you can treat the material as productive of meaning. In Jeanne d'Evreux's prayer book, the use of grisaille is unusual, as is the lack of precious materials, such as gold leaf, in a book made for a queen. And yet its original owners considered the book to be extremely precious—it was listed in one inventory of royal property among the jewels, not the library. Perhaps it was the extraordinary artistry and originality of the book that made it valuable: the artistry, emphasized by the understated grisaille technique, signified value, rather than costly materials such as gold leaf.

The grisaille technique, combined with the double-page spread images, may have brought to mind another kind of image, the ivory diptych (a hinged image in two parts). Like this double-page spread, small ivory diptychs often depicted paired scenes from the life of Christ or the Virgin, and the grisaille technique could evoke light and shadow falling across the carved surface. In this regard you might note that the smallness of the work also signifies its jewel-like preciousness and emphasizes its use as an object of private devotions, in the manner of an ivory diptych. These connections may be part of the intertextuality of the prayer book.

What is the deixis, the enunciative structure, of the image? Who is being addressed by this image, and how?

This becomes a complicated question here, in a set of images that are on some level about salutation. The images specifically address Jeanne d'Evreux, because the book was made for her, and yet they do not engage her directly in visual terms (no figure looks out of the frame at the reader, for example). At the same time, Jeanne d'Evreux is depicted here in the deictic act of prayer. Louis Marin's tracing of the deictic structure of Poussin's painting (page 37 above) would be a good model for teasing out these relationships within the image and between image and viewer.

To explore the contextual issues generated within semiotic analysis, you may also want to access Marxist, feminist, queer, and post-colonial theories (see Chapter 3). Also, semiotic art history brings

attention to the role of the viewer, and so psychoanalytic and reception theory may be relevant (see Chapter 4). I do want to mention here a potentially problematic issue: both iconographic and semiotic analysis in the context of art history can be very object-oriented. If you are interested in performance art or artistic practices such as diplomatic gift-giving, you may want to think hard about how to use these frameworks effectively.

Word and image

But here the speakers fell silent. Perhaps they were thinking that there is a vast distance between any poem and any picture; and that to compare them stretches words too far . . . But since we love words let us dally for a little on the verge, said the other. Let us hold painting by the hand a moment longer, for though they must part in the end, painting and writing have much to tell each other: they have much in common.

Virginia Woolf, Walter Sickert: A Conversation, 1934

Many of the issues pertaining to iconography and semiotics discussed in this chapter have more recently been framed as the "word and image" problem. What is the relationship between texts and images? Do visual images simply illustrate the text? Do texts control images? Or is there a form of dialogue between them? What does it mean for art historians to bring words to bear on the interpretation of images?

The first part of this "problem" is the relationship between texts and images, especially within works of art that themselves contain images. This is an issue with a very long history: the Greek philosopher Aristotle discussed the parallels between poetry and painting, and today we still quote the Roman poet Horace's elegant phrase ut pictura poesis—"as is painting so is poetry" (Ars Poetica). As Mieke Bal points out, "Words and images seem inevitably to become implicated in a 'war of signs' (what Leonardo called a paragone) . . . Each art, each type of sign or medium, lays claim to certain things that it is best equipped to mediate, and each grounds its claim in a certain characterization of its 'self', its own proper essence. Equally important, each art characterizes itself in opposition to its 'significant other."38 W. J. T. Mitchell likens word and image to two countries that speak different languages but have a long history of contact and exchange. The idea is neither to dissolve these borders nor to reinforce them, but to keep the interaction going.³⁹ In Iconologu:

Image, Text, Ideology (1986) and Picture Theory: Essays on Verbal and Visual Representation (1994) Mitchell argues that both visual and verbal representations have an inescapable formal uniqueness as processes of representation, even though they are often linked to each other through previous artistic practice and social or political contexts. A number of art historians, such as Michael Camille in his work on medieval illuminated manuscripts, directly address these relationships in the works of art they study.

But images also give rise to texts—that is, they give rise to arthistorical texts. The first chapter of Bal's Reading "Rembrandt": Beyond the Word-Image Opposition (1991) maps out the tensions between word and image in the practice of art history. Bal points out that with the changes in the discipline that began in the late sixties, "new" art historians accused more traditional art historians of neglecting the word (or theory) in art history, while the traditionalists accused the new art historians of neglecting the image.40 Mitchell observes that some of these tensions were heightened because several of the key practitioners of theoretically informed art history actually came over from literature studies including Mitchell himself as well as Bryson and Bal-so that the development seemed to some like "colonization by literary imperialism."41 These issues are very much unresolved in art history —almost necessarily so, because the discipline's internal critique is ongoing and because these questions lie at the very heart of the discipline. James Elkins goes so far as to argue that art history's words are always doomed to failure on some level, because there are aspects of images that are beyond explaining.42

Conclusion

Perhaps of any chapter in this book, this one has presented the most divergent group of theories, from formalism to iconography to semiotics, each of which has its passionate practitioners. In the end, each of these approaches to art is concerned with interpretation, which can be defined as the deliberate, thoughtful explanation of something, or the search for meaning. Where and how that meaning is to be found is hotly contested—whether, as formalists claim, it lies only within the work, or, as iconographers and semioticians would assert, within the work as it exists as part of, and

in dynamic interaction with, larger contexts. Just how art historians are to deal with these larger contexts is a question taken up in the next chapter.

A place to start

These books are separated into the fields highlighted in the chapter: Formalism, Iconography/iconology, Semiotics, and Word and image. Some of these sources are scholarly studies in the field, while others are primary texts and anthologies.

Formalism

- Focillon, Henri. The Life of Forms in Art. New York: Zone Books, 1989.
- Fry, Roger. A Roger Fry Reader, edited by Christopher Reed. Chicago: University of Chicago Press, 1996.
- Greenberg, Clement. The Collected Essays and Criticism, Vol. 4: Modernism with a Vengeance, 1957—1969, ed. John O'Brian. Chicago: University of Chicago Press, 1995.
- Krauss, Rosalind. "In the Name of Picasso." In Francis Frascina and Jonathan Harris, eds, Art in Modern Culture: An Anthology of Critical Texts, pp. 210–21. New York: Icon Editions. HarperCollins; London: Phaidon Press/Open University, 1992.
- Sontag, Susan. Against Interpretation And Other Essays. New York: Farrar Straus and Giroux, 1966; London: Eyre and Spottiswoode, 1967; London: Vintage, 1994; New York: Picador, 2001.

Iconography/Iconology

- Alpers, Svetlana. The Art of Describing: Dutch Art in the Seventeenth Century. Chicago: University of Chicago Press, and London: John Murray, 1983.
- Holly, Michael Ann. Panofsky and the Foundations of Art History. Ithaca, NY: Cornell University Press, 1084.
- Panofsky, Erwin. Studies in Iconology: Humanistic Themes in the Art of the Renaissance. New York: Harper and Row, 1972.
- Steinberg, Leo. The Sexuality of Christ in Renaissance Art and in Modern Oblivion. London: Faber, 1984; revised edition, Chicago: University of Chicago Press; 1996.

Semiotics

- Barthes, Roland. Elements of Semiology, transl. Annette Lavers and Colin Smith. London: Jonathan Cape, and New York: Hill and Wang, 1968.
- Eco, Umberto. Semiotics and the Philosophy of Language. London: Macmillan, and Bloomington: Indiana University Press, 1984.
- Kristeva, Julia. Desire in Language: A Semiotic Approach to Literature and Art, ed. Leon S. Roudiez, transl. Roudiez, Thomas Gora, and Alice Jardine. New York: Columbia University Press, 1980.
- Peirce, Charles Sanders. The Essential Peirce: Selected Philosophical Writings (1867–1893), ed. Christian Kloesel, Nathan Houser, et al. Bloomington: Indiana University Press, 1992.

Word and image

- Bal, Mieke. Reading "Rembrandt": Beyond the Word—Image Opposition. Cambridge: Cambridge University Press, 1991).
- Mitchell, W. J. T. Iconology: Image, Text, Ideology. Chicago: University of Chicago Press, 1986.

Chapter 3

Art's contexts

For the past thirty years or so, "art in context" has been a catchphrase of art history. In introductory surveys, new art-history students learn to interpret art in terms of the culture of its times: art is widely seen as affecting and being affected by religion, politics, social structures and hierarchies, cultural practices and traditions, intellectual currents, etc. But for more advanced students and scholars, simply thinking about "art in context" is often too vague, for there are many different ways to approach contextual issues. This chapter presents several of the most widely practiced methods of engaging in contextual analysis: the history of ideas; Marxism and materialism; feminisms; gay/lesbian studies and queer theory; cultural studies and postcolonial theory. These perspectives are not mutually exclusive: they often intersect, and are combined with other approaches such as semiotics and deconstruction. Each of these perspectives gives you some precise language for asking questions about race, class, nationality, gender, and sexual orientation.

The history of ideas

Broadly viewed, the history of ideas considers how the cultural meanings generated by a group or society persist over time, continuing or changing in their relevance and interpretation. Just as we can look at chronology, the nation state, a war, or a particular person as an organizing principle for historical interpretation, so we can also look at an idea—say, reason in Western thought from

the Enlightenment to the present—in this way. This perspective is inherently interdisciplinary in nature, situated at the crossroads of history and philosophy, and ranging widely across numerous fields in the humanities and social sciences.

The history of ideas emerged as an approach to history in the nineteenth century; in the twentieth century, the English philosopher Isaiah Berlin (1909–1997) has been among its most famous practitioners, publishing a series of important essays on ideas such as liberty, Romanticism, historicism, and the Enlightenment. He begins his semi-autobiographical essay "The Pursuit of the Ideal" with this observation: "There are, in my view, two factors

that, above all others, have shaped human history in the twentieth century. One is the development of the natural sciences and technology... The other, without doubt, consists in the great ideological storms that have altered the lives of virtually all mankind: the Russian Revolution and its aftermath—totalitarian tyrannies of both

right and left and the explosions of nationalism, racism and, in places, religious bigotry. . . . "1

The history of ideas may focus on philosophical concepts, scholarly debates, political movements, or even popular ideas. Note, too, that this approach doesn't limit itself to the ideas that are still considered viable today—you could trace the history of the idea that the world is flat without ever subscribing to it. Similarly, many of Sigmund Freud's ideas about the human psyche, discussed in Chapter 4, are no longer current, and yet they are worthy of study not only in the context of their times but also because of the enormous influence Freud exerted on later thinkers.

3.1 Charioteer of Delphi, circa 478–474 BCE. Bronze. Museum of Antiquities, Delphi, Greece.

The Charioteer originally stood in a bronze chariot with four horses. The entire figure is carefully rendered, down to the veins in the feet, though only half of it would have been visible to the viewer. Pollitt relates this kind of careful depiction and realism to Greek ideals of order and emphasis on the individual human experience.

Any number of art historians have engaged with the history of ideas: it has obvious relations to the iconographic approaches discussed in Chapter 2, as well as to the contextual approaches discussed in this chapter. One well-known example is Jerome Pollitt's Art and Experience in Classical Greece (1972), which is still widely used as a university text. Pollitt relates Greek art to philosophy and cultural values, arguing, for example, that sculptures such as the Charioteer of Delphi, in their style and iconography, embody Greek ideals of restraint and responsibility (Figure 3.1): "Not only does it celebrate, like the Puthian Odes, a victory won at the festival games at Delphi, but the thos which it conveys is a manifestation of Pindaric aret . . . the 'innate excellence' of noble natures which gives them proficiency and pride in their human endeavors but humility before the gods."2 More recently, Linda Henderson's Duchamp in Context (1998) examines how the scientific developments of the early twentieth century, such as wave theory and the fourth dimension, affected Duchamp's work.

Marxist and materialist perspectives on art

Marxism is a whole world view. Georgi Plekhanov

The term "Marxism" can mean many different things. Of course, it derives from the name of Karl Marx (1818–1883), economic theorist, philosopher, and revolutionary activist. In the discussion of politics, Marxism has come to indicate socialist theories and systems of government based on the ideas of Marx, his collaborator Friedrich Engels (1820–1895), and their various successors. But Marx and his successors addressed history and culture as well as economics, and their theories and methods have provided the framework for a strong tradition of scholarship in art history as well as in other academic disciplines.

Because Marxism includes wide-ranging theories of history and culture, it is a mistake, as a scholar, to identify Marxist thought (and politics) too closely with the former Soviet Union. In the early and mid-nineties, several undergraduates told me that they thought Marxist cultural analysis was irrelevant or wrong since the U.S. had "won" the Cold War, as if the disintegration of the Soviet Union had somehow discredited Marxist cultural and historical analysis. I'm using the Plekhanov quote at the start of this section as a way to suggest that Marxism, contrary to what some students

might think, can be much more than a particular theory or practice of communist government. In fact Critical Marxism (sometimes called Western Marxism, because it evolved primarily in Europe and North America) encourages the production of non-dogmatic, open scholarship, and this is the tradition of Marxist thought that has been most productive for art history.³

In this section, I'll introduce Marx's basic ideas, then briefly discuss Marxist ideas about ideology and cultural hegemony that are particularly useful for thinking about art. I'll also touch on Marxist and materialist theories of art history, and finish by developing materialist, or Marxist, lines of questioning in relation to two examples.

The critique of capitalism and historical materialism

Writing in the wake of Europe's Industrial Revolution, Marx was critical of capitalist society. In his greatest work, Das Kapital (publication begun in 1867), Marx argued that the fundamental condition of capitalist society is the exploitation of the worker's labor by the capitalist. The worker does not receive full value for his labor; instead, the true value of the worker's labor is siphoned off, as surplus value, into the capitalist's profits because the free, unregulated labor market does not oblige the capitalist to pay the worker full value for his labor.⁴

As Marx and Engels saw it, this exploitation of workers led to class struggle. In the Communist Manifesto of 1848, they declared that "the history of all hitherto existing society is the history of class struggles." Under capitalism, the two major classes are the bourgeoisie (or capitalist class) and the proletariat (or working class). The capitalists own the means of production (factories, mines, financial institutions, etc.), while the proletariat own only their ability to work and so have no option but to work for the capitalists. In fact, Marx argued that each class has a consciousness, a way of seeing the world determined by its economic position.

To explain their vision of social structure, Marx and Engels used the metaphor of base and superstructure: the economy is the base, and it determines the superstructure, the forms of the state and society. You can think of society as a building: the economic base is the concrete foundation, the state and society are the house that rises on that base. It's important to remember that the base is not just the economy narrowly construed, but all relations of

production, including class relations. Later scholars have pointed out that the influence doesn't just go one way, either, from base to superstructure.

Ideology and cultural hegemony

Ideology is an especially important concept in thinking about the two-way interrelationship between base and superstructure. In its most basic sense, the term ideology indicates any coherent and systematic body of ideas. We may speak of the ideology of an individual, a group (such as a political party or a church), or a culture. In Marxist theory, ideology is part of the superstructure of society. From a Marxist perspective, art is an "ideological form" that dominant classes may use to perpetuate class relations that benefit them—or that revolutionaries may use to undermine the power of the dominant class. An impressive portrait of a factory owner, a grand presidential palace, or a cartoon showing triumphant worker-revolutionaries are all ideological artworks in this sense.

The issue of ideology came to the fore in Marxist theory during the 1920s and 1930s, at a point when the workers' movements in Europe and North America had made many gains but had failed to overthrow capitalism and establish socialist societies. Marxist theorists had to ask why capitalism was able to survive if it was so exploitative. Antonio Gramsci (1891–1937), an Italian scholar, journalist, theorist, and activist, provided one compelling set of answers to this question. During the years he spent in prison for opposing Mussolini's fascist government, Gramsci developed a theory of cultural hegemony—that is, influence or authority gained via cultural practices rather than by law or force—to explain how the bourgeoisie continued to dominate society. His Prison Notebooks and other writings have continued to inspire cultural analysts, including many art historians and literary theorists.

Gramsci argued that dominant groups in society maintain their control by securing the "spontaneous consent" of subordinate groups, who willingly participate in their own oppression. To be sure, workers are sometimes forced or persuaded against their will or better judgement to participate in exploitative capitalist systems, but often a political and ideological consensus is negotiated between dominant and subordinate groups: "spontaneous' consent [is] given by the great masses of the population to the general direction imposed on social life by the dominant fundamental group; this consent is 'historically' caused by the prestige

(and consequent confidence) which the dominant group enjoys because of its position and function in the world of production."⁷ The dominant class asserts its cultural hegemony by persuading subordinate classes to accept its moral, political, and cultural values, convincing them that these values are right, true, or beneficial to them even though, ultimately, these values benefit only the dominant classes. The dominant classes use the arts, common sense, culture, custom, taste, etc. to maintain their hold on power. If spontaneous consent fails, then the dominant classes always have at the ready "the apparatus of state coercive power which 'legally' enforces discipline on those groups who do not 'consent' either actively or passively."8 Gramsci noted that the working class can achieve its own cultural hegemony, but to do that it must build up a network of alliances with other disempowered groups, because it doesn't have the resources to achieve cultural hegemony on its own.

Writing somewhat later, in the 1960s, the French Marxist theorist Louis Althusser (1918–1990) pushed these arguments further, asserting that ideology was as important as the economy in determining social forms. Like many Marxist theorists before him, Althusser believed that capitalist society perpetuated itself by two means: direct oppression, e.g. using soldiers to put down a workers' strike, and ideology, e.g. persuading people that the system is just and beneficial. To explain how this works he developed a distinction between what he called the Repressive State Apparatus (government, the military, the police, the courts, prisons) and the Ideological State Apparatus (education, religion, the family, political parties, the media, and culture).

Marxism and art

Although Marx and Engels never undertook a systematic study of the visual arts or literature, in various writings they put forth a number of ideas about the arts that have been taken up and developed by later theorists and scholars. In The German Ideology (1845–1846), Marx and Engels asserted that art is not something produced by great geniuses in ways almost beyond understanding, but is simply another form of economic production. This was a revolutionary argument, because eighteenth- and nineteenth-century philosophers of art—including Kant and Hegel—had made strong distinctions between art and labor. Marx and Engels also believed in the egalitarian idea that every human being has some

artistic ability. Artistic specialization, in this viewpoint, results from the (capitalist) division of labor more than anything else, for they asserted that "in a communist society there are no painters but only people who engage in painting among other activities." Marx himself realized that the relationship between art and society is a complex one. For example, like many nineteenth-century observers, he believed in the superiority of Greek art, yet he also saw many failings, from a socialist perspective, in Greek society. ¹¹

A number of later Marxist thinkers took up the issue of artistic production more systematically. The Hungarian scholar Georg Lukács (1885–1971) was a revolutionary as well as a philosopher and literary critic, and he clashed frequently with the Comintern (the international governing body of the Communist movement) because of his unorthodox views. In History and Class Consciousness (1923), Lukács developed Marx's idea of commodity fetishism, which states that things can be understood in capitalist society only in terms of their exchange value in money, commodities, or symbolic capital (e.g. prestige). In discussing the commodity, he notes, "Its basis is that a relation between people takes on the character of a thing [reification, from res, the Latin word for thing] and thus acquires a 'phantom objectivity', an autonomy that seems so strictly rational and all-embracing as to conceal every trace of its fundamental nature: the relation between people."12 In the absence of true socialism, according to Lukács, art is the only way to counter these processes of commodification and reification, for art mediates between the individual and totality because it inherently relates to both: a portrait may depict a particular person and also at the same time say something about the human condition. Like the commodity, art reifies social relationships, but it does so in a way that enriches rather than estranges us. 13 Lukács believed that nineteenth-century realist novels, such as those by Honoré de Balzac, epitomized this because of the way they united the exploration of a perfectly observed exterior world and an inner truth.

Lukács strongly influenced the members of the Frankfurt School, a group of Marxist scholars based at the University of Frankfurt's Institute for Social Research (established in 1923) who focused on popular art and the "culture industry." Among them, Theodor Adorno (1903–1969) theorized the ways in which art can be used to pacify and co-opt the working classes and to spread the dominant ideology. In The Culture Industry: Enlightenment as Mass Deception (1944), written with Max Horkheimer, he argued that

capitalist society produces cheap, standardized art that deadens people's minds and makes them focus on fulfilling false needs, such as the desire for consumer goods, rather than their true needs for freedom, social equality, creative outlets, and the opportunity to fulfill their human potential. Adorno felt this most fully during the Second World War, which he spent in unhappy exile in Los Angeles: "What has become alien to men is the human component of culture, its closest part, which upholds them against the world. They make common cause with the world against themselves, and the most alienated condition of all, the omnipresence of commodities, their own conversion into appendages of machinery, is for them a mirage of closeness."14 Although Adorno wrote a great deal about film, radio, and other media, television may be the perfect illustration of his argument. Rather than making their own entertainment and expressing themselves creatively, the TV audience sits passively in front of the tube for hours a day, numbed by a barrage of awful programs and commercials for things they don't need and can't afford. Adorno himself championed difficult avantgarde art and music, emphasizing its potential for radical transformation. 15

A number of Marxist theorists have argued persuasively that art cannot be separated from its environment, especially when it comes to issues of technology or social class. The critic and theorist Walter Benjamin (1892–1940), in his famous essay "The Work of Art in the Age of Mechanical Reproduction" (1936), provided an insightful analysis of photography and film as art forms, tracing their effect on perception, and, therefore, social relations. Benjamin argued that artworks once had an aura derived from the presence of the original, but the potential for mass reproduction in photography and film eliminates that aura. Removed from ritual, art becomes politics, but of a particular kind: "The film makes the cult value recede into the background not only by putting the public in the position of the critic, but also by the fact that at the movies this position requires no attention. The public is an examiner, but an absent-minded one."16 Writing as Fascism was on the rise in Europe, Benjamin warned that Fascism would play on this sense of alienation in its drive to subjugate people, so that the working class would "experience its own destruction as an aesthetic pleasure of the first order."17

The ideological implications of such arguments were further developed by later theorists. In The Society of the Spectacle (1967),

activist and artist Guy Debord (1931–1994) declared that in contemporary capitalist society "The entire life of societies in which modern conditions of production prevail announces itself as an immense accumulation of spectacles." According to Debord, the dominant classes control spectacle, even as all other expression and forms of representation are banned: in this context spectacle is inseparable from the State, and it works to reproduce social divisions and class formations. Like Lukács, he questions the extent to which art is complicit with capitalist power structures or can work to undermine them. Debord was part of the Situationist International, a network of avant-garde artists that took shape in 1957 and sought to break down the barriers between art and life, engaging in aesthetic actions that would precipitate revolution. 19

Materialist and Marxist art history

Over the past thirty years or so, materialist art history has focused not on iconography or stylistic classification, but rather on art's modes of production—that is, it focuses on the labor that produces art and the organization of that labor. Art, in this view, is the product of complex social, political and economic relationships, not something labeled "artistic genius." In the mid-twentieth century, a movement called "the social history of art" emerged, focusing on the role of art in society rather than on iconography or stylistic analysis. Perhaps the most famous work to emerge from this strand of art history is Arnold Hauser's four-volume The Social History of Art, first published in 1951, a survey of art from the "Stone Age" to the "film Age." In some ways, with its sweeping generalizations and broad scope, it is atypical of this school of art history, whose practitioners focused on very specific and detailed analyses of artworks in terms of economy, class, culture, etc. Nonetheless, Hauser's work was an inspiration for later materialist art historians.

A classic work in this vein is Michael Baxandall's Painting and Experience in Fifteenth-Century Italy (1988), which, rather than celebrating the paintings in question as great achievements of the Renaissance, sees them as "fossils of economic life." Among other issues, Baxandall examines the monetary worth of paintings—expressed, for example, in contractual agreements between patron and artist that dictated the use of precious materials such as gold leaf or lapis lazuli. He also explores the ways in which artists drew on mathematical systems, such as gauging, also used by merchants. In this work, art becomes not the mysterious manifestation

of genius, but an outgrowth of complex interactions between artists and patrons in the context of a particular cultural environment.

An equally remarkable work is Svetlana Alpers's Rembrandt's Enterprise: The Studio and the Market (1988), in which she disregards Rembrandt's style, iconography, and the (often troubled) attribution of his works, and instead focuses on the organization of his studio as a business for the production of paintings and the strategies he used to market those paintings. Rembrandt was unique not only for his artistic skill but also because he used his paintings as a way to pay his debts: the paintings functioned essentially like currency. Alpers points out that this practice was very much in keeping with the entrepreneurial spirit of Dutch society at the time, even if it ran counter to the established system of artist–patron relationships. Although Alpers is one of the most widely respected and influential art historians of her generation, her book initially shocked many readers, who expected Rembrandt to be treated as an artistic genius not as a marketing genius.

Among the "new" art historians, and in current art history, scholars have paid increasing attention to the relationship between art and ideology. One of the most influential writers in this vein has been T. J. Clark, who has written several books about art, culture, and politics in nineteenth-century France. His Image of the People: Gustave Courbet and the 1848 Revolution (1973) convincingly argues that the lack of visual clarity in works such as Burial at Ornans (1848) represents Courbet's rejection of the political order and his involvement with socialist politics. ²¹ To support his interpretation, Clark provides both a subtle visual reading of the works and extensive analysis of texts written by the artist and critics. Similarly, art historian Michael Camille emphasizes that images are not only ideological in a secondary sense, as a reflection of spoken or written texts: for Camille, images are directly ideological in themselves and actively make meaning, for ideology is "a set of imaginary representations [whether textual, visual, etc.] masking real material conditions."22 In The Gothic Idol: Ideology and Image-making in Medieval Art (1989), he explores the ways in which Church authorities tried to suppress the practice of idolatry while simultaneously promoting their own approved visual images.

Art historians also study art's institutions, examining the ideologies that shape the practices of museums, galleries, academies, and other organizations. Art historians such as Allan Wallach and Carol Duncan have analyzed museums as places

where social hierarchies are played out and reinforced. For Duncan, the museum becomes a ritual space: "it is the visitors who enact the ritual. The museum's sequenced spaces and arrangements of objects, its lighting and architectural details provide both the stage set and the script."²³ Annie E. Coombes has examined the history of British museums as places where intertwining ideologies of race, colonialism, and nationalism were articulated for the general public.²⁴

Two recent surveys you may encounter in your art-history studies have made materialist and Marxist art history available to a broader audience. Stephen F. Eisenman and Thomas Crow have edited a survey, Nineteenth Century Art: A Critical History (2002), which focuses on the relationship between art and ideology. Rather than using artistic style as the organizing framework of the book, they discuss class, gender, race, and the relationship between popular and elite culture in the visual arts. Similarly, Richard Brettell's Modern Art, 1851–1929: Capitalism and Representation (2000) explores the works of modern artists such as Gauguin and Picasso in relation to colonialism, nationalism, and economics.

Practicing Marxist art history

Jacques-Louis David's painting The Consecration of the Emperor Napoleon and the Coronation of Empress Josephine (December 2, 1804) provides an opportunity to ask a range of questions about ideology, and its economic and social conditions of production (Figure 3.2). David had been appointed official painter to Napoleon and was assigned to produce a series of four large paintings documenting his coronation (only two were ever executed).

- Who was the patron? What was his/her social and economic status?
- What was the social status of this artist—and that of the artist in society at this time?
- ► What is the significance of the scale of the work? (Think about the tradition of history painting in this regard.)
- ► How did David receive the assignment from Napoleon? Does the contract for the work survive? If so, what does it specify? Do other records of their interactions survive?
- ► What was David's role as official painter to the emperor? What kind of image of the emperor did he promote? How did this work to reinforce Napoleon's power?

3.2 Jacques-Louis David, The Consecration of the Emperor Napoleon and the Coronation of Empress Josephine (December 2, 1804), 1806–1807. Canvas. Musée du Louvre, Paris.

- ▶ What were Napoleon's motivations in choosing David as court painter? (David had been a supporter of the Revolution, and he was perhaps the most celebrated artist in France at the time; he was famous for developing a severe neo-classical style that seemed to express revolutionary values.)
- ▶ What ideologies—on the part of the painter, patron, and intended audience—shaped the creation and reception of this image? If Napoleon demanded images of grandeur, how does this painting fit that need?
- ▶ Why did David choose to depict this particular moment? (Napoleon had pre-empted the Pope by taking the crown from his hands and crowning himself, and then subsequently crowning Josephine, leaving Pius VII to deliver blessings from the sidelines. The Pope had thought Napoleon would pledge his allegiance to the Holy Roman Empire.)
- ► What qualities in Napoleon does this moment emphasize? How are these emphasized formally in the image? (Napoleon is at the center of an awesome spectacle—notice how marginalized the Pope is.)
- ▶ Where was the painting displayed? Who saw it? Was it reproduced as an engraving or otherwise made widely available to the public?

Notice that in a materialist or Marxist line of questioning, formal issues don't disappear, but the emphasis is on understanding how

formal aspects of the work shaped and were shaped by ideology and social and economic power. In studying this painting, which so compellingly represents the dominant ideology of Napoleon's regime, you could usefully read any number of Marxist theorists: Debord's ideas about spectacle or Gramsci's theory of spontaneous consent could help deepen your understanding of the work. An interpretation combining Marxist and feminist perspectives might address the role of the Empress Josephine in this image. Why did David choose to focus not on Napoleon's crowning but on Josephine's? This single moment emphasizes the ways in which Josephine—as wife, queen, and citizen—is both glorified by and subject to Napoleon. Does her image stand here for France itself, glorified by and subject to Napoleon?

Of course, Marxist or materialist analysis is also suited to works that challenge the dominant ideology. A good example is Judith Baca's The Great Wall of Los Angeles (1976–1983), a public mural that stretches for half a mile across one of Los Angeles's Latino neighborhoods (Figure 3.3). It presents a history of people of color in California from prehistory to the present. Baca created this mural so that people in the neighborhood would have access to their history, which is often excluded from official accounts and textbooks. The part of the mural shown here is called Division of the

3.3 Judith Baca, The Great Wall of Los Angeles: Division of the Barrios/Chavez Ravine, 1976–1983. Los Angeles.

Barrios/Chavez Ravine. It depicts two events from the 1950s: the building of a freeway through poor, Latino neighborhoods, a process that destroyed the neighborhoods but enabled white suburban motorists to commute by car to their jobs in the city. Chavez Ravine is the neighborhood in which the Dodgers' Stadium was built despite the protests of local residents. Although developers and city officials often proclaim that such projects benefit local areas, the residents of Chavez Ravine were forced to evacuate their houses and never received adequate compensation for the destruction of their homes and neighborhood.

- ▶ What is the dominant ideology that Baca is challenging here? How does her subject matter work to critique that ideology?
- ▶ In this particular frame from the mural, how are people of color being oppressed? How does the mural emphasize this visually? What is the dominant ideology about projects such as thruways and baseball stadiums? How are the neighborhood people represented here as protesting this ideology?
- ► How does mural format, which is large-scale and public, help Baca convey her message? (Think about the different effect this imagery would have if it were displayed in a museum, a restricted space that not everyone knows about or feels comfortable entering.)
- ▶ Why present history in pictures? Why is this an effective form of retelling history in this neighborhood? (Think about issues of literacy, multilingualism, authorship, access to books, etc.)

Baca developed an innovative working method for this project, collaborating on the mural with dozens of young people from the neighborhood. She wanted it to be a neighborhood piece, something everyone could take pride in, even as it provided work and valuable working experience in a neighborhood troubled by high unemployment rates among teenagers. A materialist art historian might ask these kinds of questions about the mural:

- ► How does Baca's working method challenge prevailing ideologies about artists (such as the idea of the solitary genius creating art for art's sake)?
- ► How does her working method enhance the impact of her imagery?
- ► What are the economic effects of her working method on the surrounding community?

What is the ideological impact of her working method? Do her helpers think differently about such issues as their social status (or race or gender) after participating in the creation of this mural?

Baca is working in the great tradition of the Mexican muralists—artists such as Diego Rivera (1886–1957) and José Clemente Orozco (1883–1949), who saw mural art as a way to challenge society and forge a new class consciousness among workers and farmers. In framing a Marxist/materialist analysis of her work, you may want to look at some of the studies of muralists that focus on these kinds of ideological issues, such as Anthony Lee's Painting on the Left: Diego Rivera, Radical Politics, and San Francisco's Public Murals (1999). You could also use a theorist such as Adorno to frame your analysis, since Baca's working method—getting the neighborhood involved and giving young people cultural and economic alternatives—resonates with his critique of capitalist society.

Feminisms

What did it mean for a black woman to be an artist in our grandmothers' time? In our great-grandmothers' day? It is a question with an answer cruel enough to stop the blood.

Alice Walker, "In Search of Our Mothers' Gardens"

Feminist art history is one of the most exciting and innovative modes of inquiry in art history today, and yet it can often be confusing to students. Does it only mean studying women artists? Is it also the study of women as subject matter in art? Are all studies of women artists feminist by definition? To practice feminist art history, is it necessary to be a politically active feminist?

As you get to know more about feminist art history, you'll learn how multiple and varied it is. If feminists today say there is no such thing as a single, unified feminism, but a collection of "feminisms," so too can we say that there is not a single feminist art history but "feminist art histories."

A brief history of the women's movement

When asked when the women's movement started, a lot of my students will answer the 1960s or 1970s. Actually, the modern women's movement dates back to the late eighteenth century, when Enlightenment philosophers argued for the equality of all human beings. One of the key texts from this time, Mary Wollstonecraft's

A Vindication of the Rights of Woman (1792), challenged the idea that women, as a group, were in any way inferior to men. ²⁵ If women were less capable than men, Wollstonecraft declared, it was only because they were poorly educated and had limited opportunities, not because of any inherent or natural difference in ability. As the women's movement developed in the nineteenth century, it focused primarily on the issue of suffrage, the right to vote, for women (in the United States, many suffragists had also worked in the movement to abolish slavery). Women won the right to vote in most European countries and the United States in the early twentieth century, and, in response to that victory, the Depression, and Second World War, there was a lull in feminist politics and scholarship. One notable exception was Virginia Woolf's A Room of One's Own, published in 1929, in which she discusses the challenges facing women writers.

In the 1950s, books such as Simone de Beauvoir's The Second Sex (1953) and Betty Friedan's The Feminine Mystique (1963) began to spark debate about women's issues—"the problem that has no name," at least among middle-class women. 26 Partly in response to the liberation movements in African and Asian colonies, and the American Civil Rights movement of the early 1960s, the women's movement reawakened. Sometimes called the Second Wave of the feminist movement, this period saw the growth of vibrantly feminist scholarly and artistic traditions as well as political activism. Young feminists today, who have grown up with feminism as part of their world, sometimes identify themselves as the Third Wave.

The beginnings of feminist art history

A feminist art history is one that focuses on women as artists, patrons, viewers, and/or subjects. A feminist study must explicitly address the issue of female gender—that is, the idea of femininity and/or the experience of being a woman—in one or more of these arenas. So, for example, a study of a painting by a woman artist isn't a feminist art history if it doesn't take into account the ways in which the identity of the artist as a woman affects her imagery or her career, or the ways in which her representations of women are affected by her gender or by dominant (or subversive) gender ideologies.

In many ways, the beginnings of feminist art history in the United States are marked by a very influential article published by Linda Nochlin in 1971, titled "Why Have There Been No Great Women Artists?" Nochlin essentially gave two answers to her

provocative question. In the first, she points to the kinds of discrimination that have historically meant that women have had a very difficult time training as artists. Nochlin says that the surprise is not that there haven't been great women artists, but that there have been any women artists at all, given the obstacles they have had to confront. In Europe, for example, women weren't allowed to study from the nude model—a process that was a fundamental part of artistic training from the sixteenth through the nineteenth centuries.²⁷

Nochlin's second answer challenges the set of assumptions underlying the very question "Why have there been no great women artists?" Nochlin suggests that maybe art historians haven't been able to find great women artists because the way art historians go about defining and looking for greatness excludes women artists. She reminds us that "genius" is a historically and culturally determined concept, and that art is not "a free, autonomous activity of a super-endowed individual," but "a process mediated and determined by specific and definable social institutions."28 Men aren't naturally better at art than women; they have just had more opportunity to fulfill the culturally determined requirements for artistic genius. In the end, she argues, the point of feminist art history is not simply to add in women artists—as if to say, "Look, we've forgotten all about Artemisia Gentileschi, but she's a great artist too"—but to challenge the paradigms, the ways of thinking, that are at the heart of the discipline.

While Linda Nochlin and others were fomenting an art-history revolution in North America, similar events were taking place in Britain and Europe. British scholar Griselda Pollock was, and continues to be, a leading feminist art historian, addressing ideologies of gender in the representation of women and in women's work and lives as artists. She and art historian Rozsika Parker published Old Mistresses: Women, Art, and Ideology in 1981.²⁹ The book itself represents a different way of doing art history, for the authors acknowledge the contribution to their work of a feminist art history collective in which they participated. The title itself is ironic: "old mistresses" doesn't have quite the ring of "old masters," and the authors explore some of the reasons why. They draw especially on theories of ideology developed in Marxism and Cultural Studies to examine the attitudes toward women artists in art history, and consider how women artists such as Mary Cassatt negotiated their own status as women and how they represented femininity.

Current issues in feminist art history

If the first feminist art historians were concerned with the recuperation of women artists and with some fundamental revisions to art history's paradigms, feminist art historians today are expanding the goals of art history in new ways. In The Subjects of Art History (1998), art historian Patricia Mathews outlined three representative practices of recent feminist art history:

- 1 recuperating the experience of women and women artists;
- 2 critiquing and deconstructing authority, institutions, and ideologies and/or examining resistances to them;
- 3 rethinking the cultural and psychological spaces traditionally assigned to women and consequently re-envisioning the subject self, particularly from psychoanalytic perspectives.

Matthews notes that these three areas are in continual flux and continual interaction with each other.³⁰

Feminists have challenged art history's long-standing focus on painting, sculpture, architecture, and works on paper produced by artists trained in the European tradition who were, almost always, male. The American novelist Alice Walker (b. 1944), in her famous essay "In Search of Our Mothers' Gardens," asserted that discovering the history of black women's art requires looking at forms we don't usually consider as art—such as quilts, church singing, and gardens-because black women historically were denied access to education and training as artists. Describing a quilt made by an "anonymous" African-American woman in Alabama, Walker writes poignantly of "an artist who left her mark in the only materials she could afford, and in the only medium her position in society allowed her to use."31 In a similar vein, art historians such as Patricia Mainardi, Rozsika Parker, and Griselda Pollock have confronted the gendered nature of the division of art and craft (or high art and low art), the assumption that what women make is "craft" and what men make is "art." 32 A number of studies in both art history and anthropology have discussed the artistic practice of women in such media as textiles and ceramics, which were not formerly considered worthy of serious attention.

The American art historians Norma Broude and Mary Garrard have contributed a great deal to the development of feminist art history through their own research as well as through editing three volumes of essays in feminist art history. In the introduction to the

first of these volumes, published in 1982, they emphasize feminist art history's examination of the ideologies that shape the production of art and of art history, working to exclude women.33 A decade later, in 1992, the introduction to the second collection notes the expansion of feminist art history through its engagement with critical theory, and addresses newly defined areas of interest such as the body, the gaze, and the social construction of femininity.³⁴ The third collection focuses more specifically on feminist artists of the 1970s, and provides a rich documentary history as well as art criticism and history that takes the politics of this art fully into account.35 Garrard's own book on Artemisia Gentileschi was a landmark study in feminist art history; through in-depth archival work and sensitive re-readings of the paintings themselves, she recuperated the work of this seventeenth-century female artist. who had been quite well known in her day but who was consigned to oblivion by later scholarship.³⁶ If some of Garrard's biographical and psychoanalytic readings have been challenged, even the possibility of staging such a debate around multiple perspectives on a woman artist signals the vitality of the field.³⁷

Feminist art historians are also exploring how multiple and intertwining identities—race, class, family, age, sexual orientation, etc.—help to shape both women's artistic production and the representation of women. In this regard, the engagement with theories of psychoanalysis (as represented, especially, in the work of Julia Kristeva, Luce Irigaray, and Hélène Cixous), with deconstruction, and with post-structuralism has been especially productive for feminist art historians, enabling them to develop theories of artistic practice and discuss the artist without resorting to traditional artistic models of genius (see also Chapters 4 and 5). Rather than assuming a stable identity for artists, an identity embedded in the work of art that can be revealed through art historical analysis, feminist art historians envision a more fragmented and multiple subject, one situated within and shaped by not only history and culture but also by the psyche and individual experience. A number of feminists work to investigate the "subject effect" in this way, recognizing that the subject isn't natural or whole but is produced through discourse, always gendered and shaped by power relations in society.³⁸ Pollock's recent analysis of the work of artists as diverse as Artemesia Gentileschi and Lubaina Himid is a good example.39

Women of color and lesbians have made their voices heard

within mainstream art history and in the feminist movement, examining the ways in which race and/or sexual orientation affect artistic production and reception (see also "Sexualities, LGBTI Studies and Oueer Theory" and "Cultural studies and postcolonial theory" in this chapter). The cultural critic bell hooks, for example, has written extensively on intertwining issues of race, gender, and representation. Her analysis ranges from film to painting to photography, demonstrating the common cultural ground of a wide variety of visual images. The artist and scholar Freida High Tesfagiorgis has pointed to the "semi-invisible" status of African-American women artists, marginalized simultaneously by feminist art historians, who focus on the work of Euro-American women. and by African-Americanist scholars, who focus on the work of African-American men. She calls for a black feminist art history and art criticism that would not only work to uncover the lives and work of African-American women artists, but would also challenge the paradigms that allow them to remain invisible. 40

Parallel to this interrogation of the subject is the interrogation of the female body as the object for the male gaze and as a vehicle for expressing and reinforcing patriarchal values, such as the association of women with nature rather than the "higher" sphere of culture (see Chapter 4 for a discussion of the gaze).⁴¹ In her study of early 1970s body art, art historian Amelia Jones reminds us that body art has a particular power to engage the viewer—and that feminist body art, like the work of Hannah Wilke, is potentially deeply political in the ways that it challenges the construction of women's subjectivities. 42 Johanna Frueh turns to the culture at large to study the aesthetics and erotics of older women's bodies, stemming from her own experience as a midlife body-builder and professor. She notes that "beauty is not natural to anyone, for people create or negate their beauty" by various means, and asks why the culture at large so consistently denies beauty to older women. 43 The Black Female Body: A Photographic History (2002) by Deborah Willis and Carla Williams examines the ways in which photography extended the Western fascination with black women's bodies, as representations of the exotic, the primitive, or the maternal, and in the context of scientific experimentation and the development of race theory. They also examine the ways in which black women, including performers such as Josephine Baker and artists such as Renée Cox, have reclaimed photography and the representation of their bodies.44

Essentialism and feminist art history

Is "woman" a universal category? Does it mean the same thing to be a woman in medieval England as among the pre-Columbian Olmec people of Mexico, or in China today? Is there a universal female aesthetic? Can you always recognize the art of women as distinct from the art of men? Does the art of women share certain characteristics across time and space?

Feminists and feminist art historians struggle with such questions, which revolve around the issue of essentialism. Feminist philosopher Diana Fuss defines essentialism as "a belief in the real true essence of things, the invariable and fixed properties which define the 'whatness' of a given entity."⁴⁵ Essentialist arguments are not intrinsically good or bad, but they can be used to support a variety of positions. Some feminists have asserted the universality of the female condition, an essentialism that forges a sense of connection across time and space. Such essentialist connections can be, in the moment, creatively productive, politically useful, or culturally fulfilling (see "The Problems and Promises of Identity Politics" below). Other feminists emphasize that a category or identity such as "woman" is determined by cultural discourse, not by a "natural" or "essential" existence, some going so far as to assert the impossibility of cross-cultural understanding.

As a scholar, you need to retain a sense of historical and cultural specificity in relation to the works of art you are studying: you wouldn't assume, for example, that an upper class nineteenth-century Parisian woman who bought a print by Mary Cassatt necessarily shared experiences and beliefs with a fifteenth-century Italian woman who sat for a wedding portrait, much less with a Mende woman who commissions a mask in Sierra Leone today. Keep in mind that women artists may share as much or more with male artists of their own culture than with women artists of other cultures and times. At the same time, be aware of aspects of women's experience that are continuous—similarities that are there not because of some "essential" or innate characteristic, but because of the persistence of sexist institutions, beliefs, and practices.

Practicing feminist art history

I'll take a celebrated painting by the Italian artist Artemisia Gentileschi (1593–circa 1653) to demonstrate feminist lines of questioning (Figure 3.4). (I make no apologies for using this picture again, since it validates my points here as well as in Look!)

Unlike most other women, Artemisia Gentileschi had access to extensive training through her father, who was himself a professional artist. She became a famous painter in Rome and Florence, and was particularly known for the depiction of powerful biblical heroines. As a young woman, Gentileschi was raped by another artist, and some feminist scholars, including Mary Garrard, have speculated about a connection between her choice of subject matter and her life experiences. Others, such as Griselda Pollock, have pointed to a larger cultural taste for images of sexually charged violence. The painting here depicts the Old Testament story of Judith, a heroine who saved the Jewish people from destruction by decapitating the Assyrian general Holofernes.

Here are some of the questions you might ask about this work from a feminist perspective:

- ► What was Artemisia Gentileschi's training as an artist? How was it different from the training of male artists?
- ► Was the development of her career different from that of her male peers? Did her studio function differently from theirs?
- ► Was she an exception, or were there other women artists like her working at the time?

3.4 Artemisia Gentileschi, Judith and her Maidservant Slaying Holofernes, circa 1625. Oil on canvas. Uffizi, Florence.

- ► How does this painting relate to her other subjects? Did she usually paint female subjects?
- ► Is her subject matter different because she's a woman? Because she was raped? Do her male contemporaries also depict this subject? Is her approach to the subject different from that of her male peers or from her female peers? Are there subjects she, as a woman, was not able to paint?
- ▶ Does the choice or treatment of subject matter relate to her life, and her experiences as a woman?
- ► Who is her intended audience here? Is she painting with male or female viewers in mind?
- ► How does the portrayal of a woman here reflect or shape social values with regard to women?
- ▶ Who bought her paintings? Who were her patrons? Did she have women patrons, and, if so, did she have special relationships with them? (Here feminist and materialist concerns intersect.)
- ► How did male artists and critics respond to her work? And female artists and critics?

In crafting a feminist analysis of this image, you might want to look at the feminist writings about it and extend, critique, or respond to their perspectives. For example, Griselda Pollock's Differencing the Canon (1999) re-evaluated the scholarly literature on Gentileschi, and her arguments could be a starting point for your own analysis.

I'll shift my focus here to an African mask to examine issues of women's patronage and performance in addition to the depiction of a woman. The nowo mask shown in Figure 3.5 was used by the members of a women's society called Sande among the Mende people of Sierra Leone. Although male artists actually carve these masks, women commission and perform with them. The masks depict a beautiful female water spirit who visits the village during the initiation of young women into the Sande society.

Some of the questions you might ask in a cross-cultural feminist analysis might well be different from those that you would ask about a European painting. The cultural situation itself is different and may prompt new questions, and the information you have to work with in a cross-cultural analysis may also be different. For example, the element of artist's biography that informs the study of Artemisia Gentileschi's work may be missing in the study of an African mask, because the identity of the artist and patron may not

3.5 Mask, Mende people, Sierra Leone. Early twentieth century. British Museum (1956.Af27.18).

be known. Working from a feminist perspective, you might ask the following questions about this mask:

- What is the relationship between the female patron and the male artist? To what extent does she determine the final appearance of the work?
- ► Which women can be patrons? How do they pay/compensate the artist? To what extent do they have creative input into the making of the mask?
- ▶ Do men also serve as patrons for similar masks? How is their relationship to the artist similar to or different from that of female patrons?
- ► Does this mask depict an ideal of feminine beauty? What are the elements of that ideal? How do women and men respond to this image of ideal beauty?
- ▶ Which women wear the masks? How does a woman train to be a dancer? Is the patron who commissioned the mask also the performer?
- ▶ What role does the masked spirit play during initiation?
- ► How do the young female initiates respond to the mask and the spirit it represents?
- ► Do male villagers and elders respond differently than female villagers and elders to the appearance of the mask in the village?

Here again you may want to turn to particular theorists to help you frame your analysis. Feminist art historians and anthropologists Sylvia Arden Boone and Ruth Phillips have both written about this masking tradition based on their own extensive field work. ⁴⁶ Comparing and contrasting the feminist perspectives presented in their work—published nearly ten years apart—might prove to be interesting. For additional help in framing your argument, you

could also look at feminist theories of performance or writings by feminist art historians about women's artistic patronage. Even if these writings don't focus on the Mende or other West African cultures, the cross-cultural comparisons may prove illuminating.

Sexualities, LGBTI Studies, and Queer Theory

Between the time of Sappho and the birth of Natalie Clifford Barney lies a "lesbian silence" of twenty-four centuries. Bertha Harris, Our Right to Love (1978)

So how do "Gender Studies" differ from feminism? What's "queer" about Queer Theory? How do Gay and Lesbian Studies mesh with Queer Theory? Or with Gender Studies, for that matter? Why is that field called Gay and Lesbian Studies instead of LGBTI (lesbian/gay/ bisexual/ transgender/intersex) Studies?

All of these scholarly arenas share common ground, but there are distinctions among them, both in terms of their academic history and in terms of their areas of inquiry. Whereas feminism is particularly concerned with the social construction of women's identity, Gender Studies is concerned with the social construction of all gender identities and experiences—whether man, woman, transgendered, gender-blended, queer, or something else altogether. Gay and Lesbian Studies developed in the 1970s as a response both to feminism in the academy and to the lesbian and gay liberation movement (itself sparked by the 1969 Stonewall Rebellion, when a multicultural crowd of drag queens, transsexuals, gay men, and working-class lesbians fought back against a police raid on the Stonewall Inn in lower Manhattan). Gay and Lesbian Studies provides a forum for recuperating the forgotten or concealed histories of gay and lesbian people, cultures, and institutions. Although you'll still see this term, it is being supplanted by the terms Sexuality Studies or LGBTI Studies, which are more inclusive. Queer Theory has a political as well as a scholarly tradition. It emerged from and in reaction to the Gay and Lesbian Studies movement and the AIDS epidemic, calling for a radical reconfiguration of scholarship and politics and an examination of all forms of gender oppression.

In this section, I'll provide an introduction to LGBTI Studies and Queer Theory, discuss gender performativity—a key concept in Queer Theory—and explore the practice of art history in relation to LGBTI Studies and Queer Theory.

So what's normal—or normative?

Feminists, gender theorists, and queer theorists use the term "normative" to identify and critique oppressive gender standards and categories. Normative means not what is "normal" but what is considered "normal." One of my queer students once noted that just because heterosexuality is more common in our culture, that doesn't make it normal, just as brown eyes may be

more common, but not more normal. Society dictates that certain ways of living are normal, and then coerces or persuades individuals to conform to these standards and perpetuate them. But when you look at the range of human behavior, you soon realize that there's no such thing as "normal," however much society would like us to think that there is.

LGBTI Studies

The history of LGBTI Studies is parallel to and intertwined with political feminisms and feminist scholarship. Initially, like feminism, the ambition of Lesbian and Gay Studies when it first developed was to document specific gay and lesbian identities and cultural practices. In art history, this meant researching artists who were gay and lesbian, and exploring homoerotic themes and subjects in works of art. Like feminist scholarship, LGBTI Studies retains strong connections with LGBTI political activism—especially around civil rights and the AIDS epidemic. Again, just as feminist studies are largely produced by self-identified feminists (largely, though not exclusively, women), LGBTI Studies are largely produced by scholars who self-identify in these ways.

Queer Theory

Queer Theory is certainly related to LGBTI Studies, but takes a somewhat different approach. You probably know that the word queer means "weird" and has been used as derogatory slang for lesbian/gay/bisexual/transgender people; it's a word that some LGBTI people have reclaimed, using it proudly instead of "gay" to subvert its stigma. Queer theorist and literary critic Eve Kosofsky Sedgwick defines queerness as: "the open mesh of possibilities, gaps, overlaps, dissonances, and resonances, lapses and excesses of meaning when the constituent elements of anyone's gender, of anyone's sexuality aren't made (or can't be made) to signify monolithically."⁴⁷ For Classics scholar and queer theorist David Halperin, "queer is by definition whatever is at odds with the

normal, the legitimate, the dominant. There is nothing in particular to which it necessarily refers. It is an identity without an essence." 48

The practice of Queer Theory is not so much about identifying and bringing to light particular LGBTI subjects and histories, as LGBTI Studies does. Rather, it focuses on tracing the power dynamics of what lesbian feminist poet Adrienne Rich (b. 1929) calls "compulsory heterosexuality," the way in which heterosexuality is placed at the center of society and other sexualities are marginalized.⁴⁹ Queer theorists argue that homophobia is not just a byproduct of individual ignorance and prejudice, but an essential aspect of social organization and the distribution of power. Moreover, gender identity and sexual orientation aren't natural. inevitable, or inherent, but created by society—after all, the terms homosexual and heterosexual, which you may think of as scientific and descriptive, were only coined in the late nineteenth century. Of course, "queer" is itself a historically specific term, like "homosexual" or "straight" or "man" or "woman." Queer Theory isn't any more inevitable or natural than anything else, but it is strategically useful: it makes sense to its practitioners as a way of analyzing the world. And yet as productive as Queer Theory has been, Teresa de Lauretis, the scholar often credited with introducing the phrase, later abandoned it, arguing that it had been co-opted by the very mainstream forces it was coined to resist. 50

Michel Foucault, whose work is discussed at length in Chapter 5, was enormously influential in the development of both LGBTI Studies and Queer Theory. His multi-volume History of Sexuality (1978, 1984) argued that "homosexuality" should be seen as a historically specific product of a particular society. In the West, Foucault argued, the homosexual person was called into being by the legal, medical, and cultural discourses that created—and regulated—the category "homosexual" in the mid-nineteenth century: "the sodomite had been a temporary aberration; the homosexual was now a species." Although Foucault's work has been criticized for its lack of historically-specific analysis and its failure to recognize human agency, it did in many ways set an agenda for the study of sexuality as a cultural construct rather than as a biological given.

Gender performativity, a key queer idea

Judith Butler's work on gender performativity has been central to the development of queer theory.⁵² She argued that gender is performative—that is, a sense of gender identity for an individual or group develops via actions such as wearing certain clothes (skirts and dresses for women, ties and jackets for men), engaging in certain rituals (such as marriage), taking certain jobs (women don't typically work in construction), and employing certain mannerisms (girls are quiet, boys are rowdy); there is no natural, true, or innate essence to gender—or any other identity, for that matter. For Butler, identity is "performatively constituted by the very 'expressions' that are said to be its results."⁵³

According to Butler, this performance functions according to two basic mechanisms: citation and iteration; she notes "femininity is thus not the product of a choice, but the forcible citation of a norm." ⁵⁴ (And I would point out here that the same can be said for masculinity: men may end up with much more social and economic power than women do, but the process of masculine gendering can be just as constraining.) Citation is copying others, a performance.

Butler points out that change happens—and that there's potential for resistance—because it's impossible to copy or to repeat things exactly.⁵⁵ Think about playing the game "telephone" or "Chinese whispers" and how much the message changes by the time it goes around the circle, sometimes by accident and sometimes because a player deliberately introduces a change. From a performative gender perspective, not only do artists themselves sometimes perform or undermine mainstream (normative) gender identities and sexualities (male/female, straight) in their own lives, but they also sometimes create images that can perpetuate or challenge mainstream gender identities and sexualities.

LGBTI/Queer art history

The art historian Jonathan Weinberg has noted that among the humanities, art history has been relatively late to address the interrelationship of art and sexual orientation: "From its beginnings in the writings of Johann Winckelmann, art history has been a closeted profession in which the erotic is hidden or displaced." ⁵⁶ Although there has been an increasing number of essays on lesbian and gay artists and images, there are still few full-length studies of these subjects, and work on transgender, intersex, gender-blending, bisexuality, pansexuality and other gender identities and sexualities has yet to emerge fully. The critic Laura Cottingham has pointed out the near invisibility of lesbian artists and themes in art history: the challenge may be to face the double whammy of homophobia and sexism. ⁵⁷ Confronting such gaps, some scholars acknowledge that

"Queering" works of art (that is, destabilizing our confidence in the relationship of representation to identity, authorship, and behavior) is important, but they also emphasize that this approach should not completely supplant the process of recovering LGBTI iconographies and historical moments.

In the end, many art historians combine LGBTI and Oueer Theory approaches—mining archives and museums for information about LGBTI images, artists, communities, and institutions, while employing Queer theoretical frameworks. A landmark in the field is a collection of essays edited by Whitney Davis, Gay and Lesbian Studies in Art History (1994), first published as a special issue of The Journal of Homosexuality. The essays raise a number of critical questions, and provide methodological models as they engage with specific images, from Boucher's paintings of women in bed together to Safer Sex posters. Also an important study is Jonathan Weinberg's Speaking for Vice: Homosexuality in the Art of Charles Demuth. Marsden Hartley, and the First American Avant-Garde (1993), which explores how Demuth and Hartlev reconciled the tensions between the creation of their self-consciously "American" art and the representation of their own marginalized sexuality. Weinberg also reflects on the ethics of research, the process of "outing" artists who felt compelled to conceal their identities and desires in their lifetimes.

The study of sexuality crosses boundaries in multiple ways, reminding us that "queer" and "straight" are not necessarily opposite terms, especially in relation to other cultures and periods in which such categorizations and identities do not exist. One good example of this is an edited collection of essays entitled Sexuality in Ancient Art (1996). Studying sexuality, art historian Natalie Kampen reminds readers in the introduction, is not the same as studying the erotic (that which attempts to arouse the viewer). The study of sexuality encompasses the representation of the [clothed and nude] body, the ways in which sexual identity and sexual conduct define social categories and individuals, and the way that imagery allows human beings to find and measure themselves as sexual.⁵⁸

Practicing Queer/LGBTI art history

In the first half of the twentieth century, the American artist Charles Demuth (1883–1935) produced a series of watercolors that represent men's homoerotic desire. This example, Two Sailors Urinating, provides an opportunity to consider a number of ques-

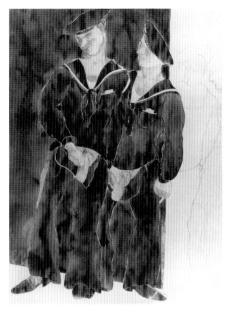

 3.6 Charles Demuth, Two Sailors Urinating, 1930.
 Watercolor and pencil on paper.

tions from the perspectives of LGBTI Studies and Queer Theory (Figure 3.6). It's often very difficult to analyze the role that the artist's own sexual orientation and identity play in the production of works of art, especially when an artist has left few statements or images that give us insight into his or her own sense of self. An artist's identity—including but not limited to sexual orientation—also has to be seen in the context of the larger society.

- ► How does the artist visually construct homoerotic content? (Think about the focus on genitals, facial expressions, gestures, and the viewer's implied position in the scene.)
- ► What were the possible sexual identities at this time? Was the artist expressing or forging a new kind of identity through this image? Or conforming to an available identity through this imagery?
- ► How does this scene represent the idea and experience of homoerotic desire in the 1930s? Why sailors, for example? (There was enormous oppression of gay, lesbian, bisexual, and transgender people at this time. Same-sex sexual acts were outlawed in most states—as they still were in some states until a 2003 Supreme Court ruling banned such discrimination—and meetings had to be clandestine. Such sexualities could be

- practiced most freely in socially marginal places such as waterfront bars or theatres.)
- ▶ Who was the viewer for these works? Did the works present an image of homoeroticism that was meant to attract? Repulse? (Demuth, for example, intended the works for himself and a very small circle of trusted friends who knew and shared his sexual orientation. You could also work, however, on images that were negative or ambiguous in their representation of such sexualities—the sensationalist covers of 1950s dimenovels with lesbian themes are one example).
- ▶ Does the artist address homoerotic subjects in other media and kinds of images (oil painting or drawing, for example)? Why did Demuth choose to work in watercolor and a relatively small format in depicting these subjects?
- ► How does this body of imagery relate to the other imagery Demuth produced (for example, abstract works, still lives, precisionist images of factories and silos)?
- ▶ You might also look at the scholarship on Demuth: which scholars discuss the homoerotic watercolors? (Jonathan Weinberg's "Speaking for Vice" is an obvious starting point.) Are there scholarly works that seem to suppress these watercolors, and, if so, why? (For example, a recent visit to the Charles Demuth Museum website revealed no mention of his sexuality or the homoerotic content in his work. I can't help but think that if he had been a heterosexual married man, his personal life would have been mentioned.)

Cultural Studies and postcolonial theory

Culture is ordinary. Raymond Williams, "Moving from High Culture to Ordinary Culture" (1958)

Culture is everything. Culture is the way we dress, the way we carry our heads, the way we walk, the way we tie our ties—it is not only the fact of writing books or building houses.

Aimé Césaire, "Culture and Colonization" (1956)

Cultural Studies is an interdisciplinary academic movement that takes culture out of the realm of the elite and examines its interconnections throughout society. From a Cultural Studies perspective, all people engage in culture, in the making of symbols and the practices of representation (verbal, visual, gestural, musical, etc.).

Cultural Studies is wide-ranging—its practitioners may discuss novels, workers' diaries, concepts of race or gender, soap operas, or objects of daily life, from hand-embroidered tablecloths to Ikea furniture. In doing this work, Cultural Studies is strongly interdisciplinary: it derives its methods and issues from anthropology, history, economics, sociology, literary criticism, and art history. Art historians have been particularly involved in the branch of Cultural Studies known as Visual Culture Studies.

Cultural Studies emerged in Europe and the US after the Second World War, and in many ways it was strongly influenced by Marxist cultural analysis; in fact, the English scholar Raymond Williams (1921–1988), quoted above, could just as easily have appeared above in the Marxism section. Cultural Studies is particularly concerned with ideology and power. It takes as a primary concern subjectivity—that is, how human subjects are formed by the social and cultural forces around them, and how they experience their lives in culture and society. It has a particular interest in both "ordinary" people and in communities marginalized by race, class, gender, sexual orientation, etc. For example, Stuart Hall, one of the founding figures in the field, argues that people are simultaneous makers and consumers of culture, participating in that culture according to their place in economic and political structures. He argues that people, via processes of encoding and decoding, shape culture, and that institutions such as the church, the state, etc. encode certain ideas in mass media, which audiences then decode (this is an alternative perspective to Adorno's). But Hall holds that we are sophisticated consumers of mass media: we can respond to these representations with skepticism and make oppositional readings. Depending on their cultural backgrounds, individual experiences, etc., some people may accept most of the "text" of the media message, while others reject it almost entirely.⁵⁹

Postcolonial theory has been important to the development of Cultural Studies, so I've put the two together here, though there's nothing necessary or inevitable about this placement. Colonialism has been a powerful cultural force across the globe, and has manifested itself in several forms. The term postcolonial refers not only to the shaping of new identities, and political and cultural practices in former colonies, but also to a body of theory that supports the study of the distinctive cultural, social, and political dynamics of both colonial and postcolonial societies. I do also want to note here that the term postcolonial has its critics. Some argue

that the "post" in postcolonial fails to recognize the exploitation still present in neo-colonial relationships: despite political independence, former colonies are often economically dependent on former colonizers, and oppressive relations of power may develop within a former colony itself. Moreover, studying cultures, regions, or nations through categories such as pre-colonial/colonial/postcolonial prioritizes the colonizer's perspective and can be, itself, a form of neo-colonialism.⁶⁰

Of course, engaging in Cultural Studies requires a working definition of the term "culture." For Raymond Williams, culture is an organic "way of life." Culture can also be social process, communication, interaction between people, the common frames of reference for interpreting experience. Culture is group identity. Culture is also a site of struggle for dominance by competing groups.

Race and postcolonial theory

In discussing race, Stuart Hall argues that there are two kinds of identity: identity in being (which offers a sense of unity and commonality) and identity as becoming (or a process of identification, which shows the discontinuity in our identity formation). Identity is important, but it is a process of "imaginative rediscovery": he argues against the idea of identity as true or essential, emphasizing instead the ways in which cultural identities are subject to the continuous "play" of history, culture, and power. For Hall, identities of race or gender are not an unchanging essence, but a positioning, unstable points of suture within the discourses of history and culture (see also the discussions of essentialism and Queer Theory above). 62

Race is a key issue not only in studying contemporary cultures, but also in studying the history of colonization, especially through postcolonial theory. According to one influential definition, the term "postcolonial" signifies "all the culture affected by the imperial process from the moment of colonization to the present day... there is a continuity of preoccupations throughout the historical process initiated by European imperial aggression." ⁶³ Colonial relationships are inherently unequal: social, political, and economic power are held by the colonizer, who exploits the colonized people and territory. Even so, it's important to remember that there's no one, single type of colonial experience. Scholars distinguish between different kinds of colonial relationships. For example, there are settler societies, to which Europeans emigrated in

large numbers (such as Australia and the United States) and also colonies that served primarily as sources of raw materials and as market outlets (like many African colonies). Moreover, there is also variation, among both the colonists and the colonized, based on race, class, education, religion, gender, and other factors. ⁶⁴ An army officer, a merchant, and a low-level plantation manager would potentially have very different colonial experiences, as would, among the colonized, a local aristocrat and a plantation worker.

The Palestinian cultural critic Edward Said's Orientalism (1978) was a groundbreaking work in postcolonial theory. In it, Said (1935–2003) employed Foucault's ideas about discourse and power to assert that the West, via Orientalism, represented the East (including the Middle East, China, Japan, and India) as exotic, mysterious, distant, unknowable, as a way of controlling it. 65 According to Said, there never was an "Orient," except as an invention that Westerners used to subjugate the region.

Critiques of Said's work (including those of Bernard Lewis and Aijaz Ahmad) have argued that Said's divide between East and West is too simplistic, that colonial experience was more complicated and multifaceted, with more players and participants, than this binary division allows. 66 Moreover, scholars have applied Said's framework to a variety of colonial situations and relationships, some of which it doesn't fit very well. Nonetheless, Said raised a set of theoretical issues—especially about representation and discourse—that has been widely influential.

In The Location of Culture (1994), Homi Bhabha, a leading scholar in postcolonial studies, explores mimicry and hybridity as ways of negotiating the power relationships between colonizer and colonized. In mimicry, the colonizers compel the colonized to imitate them—to use their language, customs, religion, schooling, government, etc.⁶⁷ Bhabha considers what this means not only to the colonized, but also to the colonizer. How does it distort culture and experience to be imitated? What are the power dynamics of the relationship? How is resistance possible? Bhabha also investigates hybridity—what happens when cultures come into contact with each other, especially in colonial situations. He argues against binary oppositions (such as First World/Third World, black/white, men/ women) and fixed borders. Instead, he explores what happens at the interstices, at the places where peoples, cultures, and institutions overlap, where identities are performed and contested.

Drawing on the writings of the Caribbean political theorist and activist Franz Fanon (1925–1961), Stuart Hall points out that within colonial contexts a process of "self-othering" takes place. This is distinct from Said's Orientalism, where the colonized were constructed as different by the colonizer within the categories of Western knowledge. Hall argues that the colonizer had "the power to make us see and experience ourselves as 'Other.'"68 That is, in a colonial regime, the colonized people begin to see themselves as inferior, strange, uncivilized, etc.—they internalize the negative view of the colonizer. Hall writes eloquently of the ways in which this inner expropriation of cultural identity undermines people, and he emphasizes the need to resist it. He quotes Fanon, who wrote that this process produces "individuals without an anchor, without horizon, colourless, stateless, rootless—a race of angels."69 This is a process that has implications not only for formerly colonized nations such as Jamaica, Ghana, or Papua New Guinea but also for people of color in places such as New York and London.

The broadening scope of art history in recent years has meant that art historians have addressed the impact of race on visual representation in a variety of cultural contexts, including colonialism. One area of interest is the representation of colonized people and people of color, especially in painting and photography: a good example is Colonialist Photography: Imagining Race and Place (2002), which includes essays on subjects as diverse as Algerian postcards. French films of the Second World War, and Hawaiian advertising images.⁷⁰ Australian art historian Bernard Smith (b. 1916) has written pioneering studies of the European depiction of the Pacific and Australia, and the kinds of values expressed in those images, which addressed difference, the exotic, the taming of the wilderness etc.⁷¹ Among art historians, practices of hybridity—the fusing of cultures and traditions—have also been an important focus. Recent studies of colonial architecture address not only official architecture (court houses, governors' mansions) but also the houses, churches, and market buildings of colonized peoples grappling with newly introduced forms.⁷² New understandings of modernity and modernism have also emerged: scholars have pointed out that there isn't just one Modernism, located in Europe and the United States, but multiple Modernisms that developed in Africa, Latin America, and elsewhere.73

In the United States, African-American Studies (sometimes also called Black Studies) has made important contributions to

these theoretical debates as well as to the knowledge of African-American and Diaspora artists. African-American Studies, much like Women's Studies or LGBTI Studies, both develops theories of race and power and also mines the archives to recuperate forgotten histories. Henry Louis Gates, Jr., a key figure in the development of African-American Studies, has stressed the need to define a canonical tradition in African-American literature.⁷⁴ Whether or not a canon is necessary (canons work both to include and exclude), art historians have worked at recuperating the history of African-American artists, from highly trained sculptors and painters to quiltmakers and potters. David Driskell was one of the founders of this movement, while Sharon Patton's recent survey provides an excellent introduction to the material and the issues.⁷⁵

Subaltern Studies

I'll discuss briefly here the work of the Subaltern Studies Group, although it could as easily have been included in the Marxism section above. Subaltern Studies is the discipline of a loose collective of scholars who study colonial and postcolonial history, largely in South Asia. The term "subaltern" (which literally means "subordinate") comes from the work of Antonio Gramsci: he used it to indicate the ways in which proletarian voices are deliberately silenced by dominant, bourgeois capitalist narratives. Subaltern Studies emphasizes that powerful institutions and individuals (the government, the Church, business leaders) control the ability and opportunity to tell history and to represent what's going on in society, even as they suppress the voices of protesters, the poor, revolutionaries, women, the sick or disabled.⁷⁶

Subaltern Studies seeks to recuperate those silenced voices, especially those of peasants, merchants, small land-holders, and others who either do not have power or else have limited kinds of power, within colonial and postcolonial regimes. Subaltern Studies does this by innovative historical methods: scholars read the sources produced by the dominant culture "from within but against the grain" so that subaltern voices emerge, and evidence of agency and resistance can be uncovered.⁷⁷ For example, one of the primary resources is court records, for trial testimony sometimes reveals subaltern voices representing themselves and their viewpoints. As Gayatri Spivak notes, these voices are a necessary and pervasive part of such records, even though the records deliberately try to suppress them.⁷⁸

Art history, Cultural Studies, and Visual Culture

Art historians, as well as anthropologists, film theorists, sociologists, and others, have created Visual Culture Studies as a distinctive arena within Cultural Studies.⁷⁹ What's the difference between art history and visual culture? One answer is that, in certain respects, visual culture invites the study of a broader array of objects than art historians typically engage with.⁸⁰ So, taking a visual culture approach, an art historian may focus not on "high" art produced by trained artists, but on middle-range housing, family snapshots, textiles, advertising images, postcards, etc. Another helpful way of framing the distinction (as well as the potential overlap) between the two disciplines is to say that visual culture focuses not on objects but subjects—that is, the ways in which works of art (broadly defined) catch up their creators and viewers in interconnecting webs of cultural meanings and relations of power.⁸¹

While some art historians find Visual Culture Studies liberating, others argue that this focus on subjects fails to engage with the materiality of art objects, or else they object that it promotes the model of textual analysis in ways that don't address the specific visual characteristics of works of art.⁸² Still others point out that the kinds of questions asked in Visual Culture Studies already have their roots in the art history of an earlier generation: scholars such as Alois Riegl ranged widely in the questions they asked and the kinds of objects they addressed.⁸³ It's important to note here that art historians sometimes use the term "visual culture" in a very specific way to discuss theories and the technology of vision in different cultures and periods. Such scholars as Jonathan Crary and Barbara Maria Stafford have discussed, in the context of particular time periods, theories of vision, image-making devices, and visual skills.⁸⁴

Browsing through some of the many readers in Visual Culture Studies will give you a sense of this emerging interdisciplinary field. One example of visual culture studies—produced at the crossroads of art history, visual cultural, and Queer theory—is Erica Rand's Barbie's Queer Accessories (1995). Trained as an art historian, Rand brings all her critical skills to bear on Barbie, controversial and beloved doll. Any good feminist could point out the cultural messages encoded in Barbie that work to reinforce a very narrow vision of womanhood. But Rand goes beyond this, examining how consumers of all ages have rewritten the Barbie script to challenge discriminatory cultural messages about bodies, gender, and sexuality.

Practicing art history informed by Cultural Studies/postcolonialism

To explore how this line of questioning might evolve, I'll take as an example a set of photographs from a geography book published in 1909. These pages from The Harmsworth History of the World (London 1909) are captioned "Racial Contrasts under the British Flag" and "Dusky Beauty and Ugliness Under the British Flag" (Figure 3.7). This isn't the kind of celebrated masterpiece you may be used to analyzing in art history, but from a Cultural Studies/visual culture perspective, whether or not a work can be thought of as a "masterpiece" is irrelevant: what's important is what that work tells us about the culture in which it was produced.

- ▶ Who is the intended audience? (In this case, an educated, middle-class general readership of both sexes; the assumption is that they are British and white.) Why would such a collection of pictures be made available to this audience?
- ▶ What does it mean for the reader to be confronted by the array of nine photographs on a two-page spread? What kinds of

3.7 Pages from The Harmsworth History of the World (London 1909) captioned "Racial Contrasts under the British Flag" and "Dusky Beauty and Ugliness under the British Flag" (Coombes, Reinventing Africa, p. 204, fig. 100).

- messages are encoded in the ways that the photographs are arranged and juxtaposed? You could combine a Cultural Studies perspective with semiotics here to analyze these images further.
- ► How would this collection of images help to shape the typical reader's sense of self and others? Think, for example, about the location of the reader in terms of racial hierarchies displayed here and the imperial hierarchies displayed. Think, too, about the person from Nubia or Sudan reading this magazine—how might Stuart Hall's ideas about internalized self-othering be relevant here? (To develop a line of questioning about the reception of the image further, see Chapter 4).
- How are cultural ideas about race, class, and gender played out here? What does it mean, for example, to label the image of a French-Canadian man a "gentleman" and the Central African man a "dandy"? What is the effect of labeling the English woman and the Egyptian woman "beauties" while the other women (Zulu, Sudanese, Ceylonese) are not? If the Egyptian woman is the only "beauty" among the women of color, then are the others, by implication, representative of "ugliness"? What kinds of racial hierarchy do all these words establish?
- ▶ In Reinventing Africa: Museums, Material Culture and Popular Imagination in Late Victorian and Edwardian England (1997), art historian Annie E. Coombes examines this image in relation to the colonial and missionary ideologies that informed museum displays of African art at this time. You might also think about this collection of images in relation to other ways of representing African and Middle Eastern peoples—perhaps in novels or erotic photographs.

Of course, contemporary art history studies not only objects in themselves, but practices related to the visual arts: the history and philosophy of collections and exhibitions, for example, or the practice of art criticism in a particular culture. Such studies focus on the practice itself, with artworks themselves appearing only as a secondary object of analysis, if at all.

Although such a case study could appear in any chapter of this book, let me take as an example here the repatriation of War God figures, ahayu:da, to the Zuni people of New Mexico. (Repatriation in this context is the return of an artwork to its rightful owner or owners by a museum or other cultural institution.) My focus here is not on the contextual or formal analysis of the figures themselves but on the practice of repatriation, how and why it has unfolded,

and its significance to the Zuni people, to museum practices, and to the culture at large. 85 Cultural studies, postcolonial theory, the history of ideas, and Marxist/materialist perspectives are particularly useful in this analysis. I won't reproduce a photograph of an ahayu:da here because, until very recently, the Zuni people did not want these figures exhibited or published (some pictures have recently been allowed to circulate, enabling museums and private collectors to identify such works in their possession).

- ▶ What is the legal basis for repatriation? In legal terms the War Gods are considered "inalienable property"—that is, property that cannot be sold or given away (alienated) by an individual or community. Thus, in legal terms, any War Gods removed from the Pueblo have been stolen. Several laws, including the 1990 Native American Graves Protection and Repatriation Act, have addressed this issue and established guidelines for the process of repatriation.
- ▶ What is the moral basis for repatriation, as it relates to the history of relations between Zuni people and the dominant culture?
- ▶ What are the major concepts structuring this discourse—for example, the idea of inalienable property, or the Zuni idea that artworks are, in some sense, living beings and members of the community? What are the places of commonality or difference in these ideas between the Zuni and the dominant culture?
- ▶ What is the process of repatriation? What are the power relations at work in this process? Do the Zuni have the community and financial resources to press their claims? Do museums resist these claims?
- ► How does ideology work to shape the process of repatriation? Think, for example, about the Western notion of the museum as an institution that permanently holds its collections, or the history of museums in relationship to colonialism. How do these histories and ideologies shape the museum staff's reaction to this process—and that of the public at large?
- ▶ What has repatriation meant to the Zuni people? Has the return of the War Gods fostered a stronger sense of cultural identity or renewal? Are there conflicting ideas about repatriation within the community?
- ► Has the repatriation of Zuni War Gods changed how the museums involved perceive their function? Has it changed collecting practices?

► Does repatriation reflect or create a new respect for Native Americans before the law and in the culture at large?

Conclusion

This chapter has introduced a number of ways to address contextual questions in art history. These contextual questions have compelled art history to reach out to anthropology, political theory, sociology, and other disciplines. At the same time, questions of context, with their political implications, also break down the barrier between academia and the world at large, especially in relation to aspects of identity such as gender, sexual orientation, race, and class.

More than any other cluster of theories, the history of ideas, Marxism and materialism, feminisms, LGBTI Studies/Queer theory, cultural studies, and postcolonial theory work to open up the art-historical canon, the list of accepted "great" works of art and artists that are the primary focus of art-historical study. These perspectives demand that we look at advertising, industrial ceramics, women's embroidery, snapshots, missionary churches alongside Michelangelo and Monet. In her feminist and deconstructive critique of the canon, Griselda Pollock has pointed out that the canon is a "discursive strategy for the production and reproduction of sexual difference and its complex configurations with gender and related modes of power."86 From the perspectives presented in this chapter, we could argue that the art-historical canon also works to produce and reproduce differences in class, sexuality, race, and ethnicity. Whether it continues to do so is up to the practitioners of art history today.

A place to start

History of ideas

Berlin, Isaiah. The Power of Ideas, ed. Henry Hardy. Princeton, NJ: Princeton University Press, 2002.

Marxism

Alpers, Svetlana. Rembrandt's Enterprise: The Studio and the Market. Chicago: University of Chicago Press, 1988.

Althusser, Louis. Lenin and Philosophy, and Other Essays, transl. Ben Brewster. New York: Monthly Review Press, 1972.

Benjamin, Walter. Illuminations, ed. Hannah Arendt. New York: Schocken Books, 1985. Gramsci, Antonio. Selections from the Prison Notebooks, transl. Geoffrey Nowell Smith and Quintin Hoare. New York: International Publishers Co., 1971.

Marx, Karl. Selected Writings, ed. David McLellan. Oxford and New York: Oxford University Press, 1977.

Feminisms

Cixous, Hélène. Hélène Cixous Reader, ed. Susan Sellers. New York: Routledge, 1994. hooks, bell. Talking Back: Thinking Feminist, Thinking Black. Boston: South End Press, 1989. Jones, Amelia. The Feminism and Visual Culture Reader. New York: Routledge, 2003. Nochlin, Linda. Women, Art, and Power and Other Essays. New York: Harper and Row, 1988. Pollock, Griselda. Differencing the Canon: Feminist Desire and the Writings of Art's Histories. New York and London: Routledge, 1999.

LGBTI Studies and Queer Theory

Bright, Deborah, ed. The Passionate Camera: Photography and Bodies of Desire. New York and London: Routledge, 1998.

Butler, Judith. Gender Trouble. New York: Routledge, 1999.

Davis, Whitney, ed. Gay and Lesbian Studies in Art History. New York: Hawthorne Press, 1994. Foucault, Michel. The History of Sexuality, vol 1: An Introduction. Vol 2: The Uses of Pleasure. Vol 3: The Care of the Self. New York: Vintage Books, 1990.

Hammond, Harmony. Lesbian Art in America: A Contemporary History. New York: Rizzoli, 2000.

Lauretis, Teresa de. "Queer Theory: Lesbian and Gay Sexualities." differences: A Journal of Feminist Cultural Studies 3/2 (1991).

Cultural studies and postcolonial theory

Ashcroft, Bill, Gareth Griffiths, and Helen Tiffin, eds. The Post-colonial Studies Reader. New York and London: Routledge, 1995.

Hall, Stuart, ed. Culture, Media, Language: Working Papers in Cultural Studies, 1972–79. London: Hutchinson, 1980.

Hall, Stuart and Jessica Evans, eds., Visual Culture: The Reader. London: Sage, 1999.

Said, Edward W. Orientalism. New York: Random House, 1979.

Williams, Raymond. Culture and Society, 1780-1950. Harmondsworth: Penguin, 1963.

Chapter 4 **Psychology and perception in art**

How the viewer experiences art is an important subject in art history. There is a great, and ancient, tradition of writing, called ekphrasis, in which people describe works of art (among other things) and record their impressions of them. But art historians today also investigate the psychological/psychical and physical aspects of the experience of looking at art. This chapter will review the basic elements of such approaches, starting with psychoanalytic theory and proceeding to various theories of reception and the gaze. Because of the complex interrelations of these theoretical approaches, and the need to present a lot of background material that isn't directly used in the practice of art history today, I'll save the examples of art-historical analysis for the end of the chapter, rather than interspersing them with each section.

Art history and psychoanalysis

Happy people have no stories.
Louise Bourgeois

Narrowly speaking, psychoanalysis is a method of analyzing psychic (psychological) phenomena and treating emotional disorders; broadly speaking, it is a philosophy of human consciousness, both individual and social. Its modern founder is Sigmund Freud (1856–1939), an Austrian doctor who developed a therapeutic method for analyzing the unconscious through the interpretation of dreams, verbal slips, jokes, etc. and through the use of free association.

Freud himself, and many after him, applied the theory and practice of analysis to works of art and literature and to society at large.

Psychoanalysis is also an enormous field of inquiry in its own right, and I won't exhaustively explore all aspects or branches of psychoanalysis here, but instead will discuss some basic concepts that have been particularly relevant to the practice of art history. Psychoanalysis has at various times been used to address the content or subject-matter of individual works of art; the relationship of individual works of art to the artists who created them; the relationship of the viewer to the image; and the nature of creativity and of art itself.

Basic Freud

Freud galvanized late Victorian society when he argued that repressed desire was at the root of human civilization. His work revolutionized the way people thought about desire (sexual and otherwise), about the workings of the mind, about basic human interactions and the human sense of self. Although subsequent theorists have challenged virtually every aspect of his work, it remains a touchstone of psychoanalytic theory. I'll summarize Freud's basic ideas here before delving into the critique.

Freud's theory rests on the observation that humans have to work to survive, which means that, unfortunately, we can't just hang around and have fun all day; instead, we have to repress some of our tendencies to pleasure and gratification. Freud saw this process of repression as the key to the human psyche. As literary critic Terry Eagleton has pointed out, if Marx looked at consequences of labor in terms of social relations, politics, and the economy, Freud looked at its implications for the psyche. It's not surprising that both the materialist conception of history and psychoanalysis emerged amid the rapid industrialization and urbanization of nineteenth-century Europe, with its new forms of work that oppressed body and spirit.

For the individual, managing repressed desires is a difficult business, and Freud named that place in ourselves where we store our unfulfilled desires the unconscious, because we are unaware of them. One way we try to manage our unfulfilled desires is through sublimation, directing them toward a more socially valued objective. Like so many other psychoanalytic ideas, this one has entered popular culture—for example, we talk about exercise as an outlet for sexual frustration. Freud pointed out that sometimes the *reality*

principle (the necessity of work) represses the pleasure principle (the desire to have fun) so much that it makes us sick. This is neurosis.

Unfortunately, human beings aren't born equipped with the psychic mechanisms for repressing our unfulfilled desires. We have to learn how to do it in childhood, and Freud was intensely interested in the sequence of childhood development. In particular, he focused on the harnessing of the libido, the individual's psychic (not merely sexual) energy. As the child's libido develops, it is centered first on the child's body. The baby will nurse, and in the process learn that this biological process is also pleasurable—this is the first dawning of sexuality. After weaning, the child passes to the anal stage. The anus becomes an erotogenic zone, and the child takes a sadistic pleasure in defecation; at the same time, the child is anarchic and aggressive.

As the erotogenic zone shifts from the anus to the genitals, children pass into the phallic stage. Freud deliberately called this the phallic stage, rather than genital stage, because girls had to be content with the clitoris, which he saw as inferior to the penis. At this point, the Oedipus complex in boys and the Electra complex in girls involves the child's unconscious desire to possess the opposite-sexed parent and to eliminate the same-sexed one. The boy feels aggression and envy toward his father, yet also fears the retaliation of this powerful rival: the boy has noticed that women have no penises, and he fears that his father will remove his penis, too. He only resolves the conflict by realizing that he can possess his mother vicariously by identifying with the father, thereby assuming his appropriate sexual role in life. Similarly, the Electra complex has its roots in the little girl's discovery that she, like her mother and other women, lacks the penis that her father and other men possess. Her love for her father then becomes both erotic and envious, as she yearns for a penis of her own. She comes to blame her mother for her perceived castration, and is struck by penis envy, the counterpart to the boy's castration anxiety.

As the child grows, the pressure of dealing with conflicting and repressed desires splits the mind into three aspects: id, ego, and superego. The id is the part of the self devoted to the pleasure-principle, the part that can't suppress or defer pleasure, but instead always demands immediate gratification. The ego has a better grasp on the reality principle: it understands that sometimes it's preferable, even safer, to delay gratification. Because of this, the ego often has to repress the id. The ego's efforts to satisfy these

urges in acceptable ways eventually builds memories and skills (projection, rationalization, and displacement), and the ego gradually becomes aware of itself as an entity. With the formation of the ego, the individual becomes a self, instead of an amalgamation of urges and needs. While the ego may temporarily repress the id in fear of punishment, eventually these external sources of punishment are internalized. The superego uses guilt and selfreproach to enforce these rules and repress the id. The superego is subdivisible into two parts: conscience and ego ideal. Conscience tells what is right and wrong, and forces the ego to inhibit the id in pursuit of morally acceptable, not pleasurable or even realistic, goals. The ego ideal aims the individual's path of life toward the ideal, perfect goals instilled by society. (This dynamic has implications for the understanding of the workings of ideology, discussed in Chapter 3.) In this way, the psyche attempts to make up for the loss of the perfect life experienced as a baby.

The idea that the self is split into warring parts has been absorbed into pop culture, and so may not seem strange to you, but in Freud's time it was revolutionary. Early twentieth-century Europe had inherited the humanist idea of the unified self, which is whole and exercises free will and self-determination. Freud undercut all this, although he did hold out the promise that the ego, the sense of self, can be strengthened enough to manage repressed desires and achieve a sense of unity.

Unfortunately, repressed desires aren't just stored in the unconscious like unwanted files in an office warehouse; instead, like nuclear waste, they always seem to have a way of leaking out. According to Freud, there are a number of relatively harmless ways in which repressed desires assert themselves. Freud saw dreams as the expression of repressed desires that play out in symbolic terms because they are too disturbing to express directly and think about consciously. The unconscious also manifests itself through parapraxis: unexplainable failures of memory, mistakes, misreadings, mislayings (you can never seem to find your keys on weekday mornings), and the odd misspeakings we call "Freudian slips." Freud argued that these aren't random occurrences, but can be traced to unconscious wishes and intentions. Similarly, jokes aren't just funny in the Freudian world: they express unconscious libidinal, aggressive, or anxious impulses. However, if the repressed desires are very strong, the ego will have to work extra hard to reroute them, and this internal conflict results in neurosis,

paranoia, or schizophrenia (it's important to remember here that Freud was working before any real understanding of the impact of genetics, biochemistry, and environmental factors on such conditions). Freud developed psychoanalysis, "the talking cure," as a way to heal psychic conflicts.

For Freud, human society operated like the individual psyche, but on a grand scale. Culture provides a way to express and manage desires in conflict with one another and with society, and is at the same time the product of impulses denied a more directly sexual or aggressive satisfaction. Because social life originates in these irresolvable conflicts, civilization is always vulnerable to radical disruptions. From the First World War until his death in 1939, as the Second World War began, Freud witnessed increasingly violent social crises, which he interpreted as irrational "symptoms" of these primal conflicts. In Civilization and its Discontents (1930), he explored the consequences of repressing impulses in order to live in society. He argued pessimistically that civilization must curtail the death instinct, but, if people are denied the satisfactions of aggression, they turn against themselves.²

Freud on art

Only in art does it still happen that a man who is consumed by desires performs something resembling the accomplishment of those desires and that what he does in play produces emotional effects—thanks to artistic illusion—just as though it were something real.

Sigmund Freud, Totem and Taboo (1912–13)3

Freud himself was extremely interested in art. He frequently illustrated his writings with examples drawn from art and literature—and of course such names as the Oedipus complex derive from Greek mythology. In fact, he kept a copy of Ingres's Oedipus and the Sphinx in his office and avidly collected art and antiquities.

Despite this intense interest, only two of Freud's publications directly analyze the visual arts. In an essay on Michelangelo's Moses (1914), he discusses the similarities in the ways that art history and psychoanalysis both focus on the significant, but overlooked, detail, and he interprets the Moses via a close examination of the figure's posture and gestures. Freud argued that Michelangelo depicted Moses just at the moment when he stops himself from breaking the tablets. Thus Michelangelo represented an inhibited

action, Moses's triumph over his passionate anger for the sake of a higher cause.⁴

In Leonardo da Vinci and a Memory of his Childhood (1010), Freud developed the pathographical approach, applying the methods of clinical psychoanalysis to the artist's life and work, trying to "explain" the artist's homosexuality, the slowness with which he worked, even his use of certain forms and motifs.5 Freud focused on Leonardo's early childhood, which he spent with his unmarried mother, only moving to his father's house later. One of Leonardo's childhood memories concerned a vulture that came to him in his cradle, opened his mouth with its tail, and repeatedly struck his lips with it. (Strangely, it turns out that "vulture" was a mistranslation of the Italian: the bird was actually a kite, a raptor that doesn't have nearly the same degree of cultural resonance.) Freud argued that this was actually a fantasy, transposed to childhood, that concealed Leonardo's memories of nursing at his mother's breast and also expressed his unconscious desire for fellatio. The replacement of his mother by the vulture indicates that the child was aware of his father's absence and found himself alone with his intensely affectionate mother. Freud draws a range of implications

Jungian archetypes

One of Freud's sometime collaborators, the Swiss psychoanalyst Carl Jung (1875–1961), argued that the unconscious was not individual but collective and shared by all humanity. The collective unconscious is a kind of knowledge we are all born with, though we are never conscious of it. In Man and His Symbols (1964) and other writings, Jung discussed the archetypes, key symbols or images, which, he argued, appear in the arts, histories, philosophies, myths, and dreams of all cultures. 6 Archetypes include the shadow, the animus and anima, the mother, the divine couple, the trickster, the child, and the maiden, among others. Because archetypes are not under conscious control, we may fear them, and Jung argued

that people who experience mental disturbances or illnesses are haunted by them. Psychoanalysis, for Jung, is an exploration of the archetypes, so that we can heal by understanding how they shape our emotional and spiritual lives.

In the mid-twentieth century, Jung's ideas were widely discussed among people interested in psychoanalytic interpretations of art. Today, art historians are more interested in culturally specific interpretations of images, rather than crosscultural comparisons and analogies that may work to erase cultural difference and historical specificity.

from this interpretation, arguing, for example that Mona Lisa's famous smile embodies the history of his childhood, simultaneously maternal and boyish, tender and menacing.

Freud's critics

Freud is the father of psychoanalysis. It had no mother.

Germaine Greer, The Female Eunuch (1970)

More than a century of argument and scientific investigation has left few of Freud's theories unchallenged. At the same time, the idea that human consciousness is affected by underlying motivations or thoughts, the realm of the unconscious, is widely acknowledged. The literary critic Terry Eagleton argues that Freud's importance lies in having developed a materialist theory of the making of the human subject.7 We come to be what we are through an interrelation of bodies, through the complex transactions that take place during infancy and early childhood between our bodies and those around us. Such interactions are inevitably situated in culture, and in history: parental roles, modes of caring for children, the notion of the ideal individual all vary considerably from one society or era to another. According to Eagleton, Freud makes it possible for us to think of the development of the human individual in social and historical terms even if Freud's own presentation of the material is often universalizing and ahistorical.

In fact, it's important to recognize that Freud's theories of development and the workings of the psyche are very culturally specific, not universal. For example, toilet training takes place in different ways and at different times in the child's life in different cultures and may not always be the source of conflict and repression that it often was in late nineteenth- or early twentieth-century Europe. Then there's the question of what's normal—or normative—in personality and the psyche and who gets to decide such questions. Some critics argue that psychoanalysis is a repressive form of social control, working to eliminate ways of thinking, feeling, and behaving that are uncomfortable or inconvenient for society.

Feminists have been very vocal critics of Freud's theories of the body, sexuality, and individual development. These critiques have emerged both within psychoanalysis (Karen Horney,⁸ Helene Deutsch,⁹ Nancy Chodorow¹⁰) and outside it (Simone de Beauvoir,¹¹ Kate Millet¹²). Freud's feminist critics note that ideas such as the Oedipus and Electra complexes, the castration complex, and penis envy reflect Freud's experience of nineteenth-century

bourgeois male culture, not the range of human experience. They challenge the way Freud places the penis at the center of human sexuality and his inability to see the clitoris and vagina as anything other than inferior alternatives to it. In Freud's terms, female sexuality is never without conflict and not really fully resolvable, unlike male sexuality.

Critics such as Judith Butler have challenged the ways that Freud privileges heterosexuality by making it the normative model for all sexualities and sexual identities, with homosexuality a "deviation" from that norm. ¹³ Freud did break new ground by insisting that heterosexuality is not natural or inevitable: he said that everyone is born bisexual and everyone experiences a homoerotic phase of psychosexual development, and argued that the search for a sexual object can lead either to heterosexuality or homosexuality. At the same time, he regarded homosexuality as undesirable, and, in many respects, pathological; for him, it was an immature form of sexuality typically resulting from bad or incompletely processed child-hood experiences.

In terms of Freud's specific contributions to the study of art, his pathographical method is not an approach that art historians typically utilize today, although psychoanalysts sometimes do. The method faces real challenges in terms of the nature of the evidence available. It's difficult enough to diagnose a patient with whom you can speak, much less one you know through documents or works of art. And if it's a challenge to understand an artist's conscious intentions (see Chapter 5), how much harder is it to understand her unconscious intentions? There's a fundamental question here, too, about the nature of works of art: do works of art really function like parapraxes or jokes, expressing unconscious desires? Pathography assumes that the meanings (whether conscious or unconscious) an artist invests in a work are primary, and it potentially overlooks the role of patrons or sitters, and the larger social context. In his essay "Leonardo and Freud: An Art Historical Study," Meyer Schapiro points out that Freud's framework does not allow Leonardo's work to be related to his artistic context. The features of such figures as the Mona Lisa and St. Anne are not only significant for Leonardo's personality or pure invention on his part, but exist within the larger history of art of that time. In support of his critique, Schapiro notes that Mona Lisa's smile was probably adopted from the sculptural style of Leonardo's master, Verrocchio 14

Object relations theory and the nature of creativity

The Austrian psychoanalyst Melanie Klein (1882-1960) closely examined artistic creativity in the context of human psychic development. In her essay "Infantile Anxiety Situations Reflected in a Work of Art and in the Creative Impulse" (1929), Klein argues that the creative impulse stems from a desire to make reparation. According to Klein, because of its frustrated desires, the infant experiences contradictory phantasies (sic) about the maternal body: phantasies of erotic possession (the "good breast") and phantasies of violent dismemberment (the "bad breast"). (Klein deliberately spelled phantasies with a "ph" to distinguish these simmering unconscious dramas from ordinary fantasies and daydreaming.) This creates a profound psychic conflict in the infant that it carries throughout life; making art is one way to make reparation. to atone for the fantasies of hatred and destruction that the infant harbored about the maternal body. 15 The Kleinian view of art as a kind of "constructive guilt"

influenced a number of art historians and critics, including Adrian Stokes and Richard Wollheim (see below).

Also strongly influenced by Klein, the British psychoanalyst D.W. Winnicott (1896–1971) located the origins of creativity in the early pre-Oedipal relationship of mother and child. 16 Winnicott noted that between four and twelve months of age babies become attached to what he called the transitional object, such as a blanket, stuffed animal, pacifier, etc. Similarly, there are transitional phenomena, such as singing, babbling, and daydreaming. Both transitional objects and transitional phenomena enable the baby to separate from the mother because they stand for her in some way. These transitional objects and phenomena form the basis for creative pursuits later in life: the transitional object serves as a template for all art, which always, for Winnicott, has a transitional function, standing in for something else.

Basic Lacan

In the mid-twentieth century, the French psychoanalyst Jacques Lacan (1901–1981) revolutionized his field by reinterpreting Freud's work through semiotics, linguistics, and structuralism. For Lacan, the ego—the sense of self as coherent, rational actor expressed in the word "I"—is nothing but an illusion of the unconscious, which is the true foundation of all existence. Where Freud focused on how the pleasure-seeking, anarchic child learns to repress his desires so that he can become a (productive, heterosexual) social being, Lacan asks how this illusion of the self comes into being in the first place.

At the core of Lacan's work is the idea that the unconscious is structured like language. He was inspired to this insight by structuralism and semiotics, especially the work of the French anthropologist Claude Lévi-Strauss (b. 1908) and the semiotician Ferdinand Saussure (see Chapters 2 and 5). The linguist Roman Jakobson had already noted the similarities between dreams and language, for both rely on metaphor (condensing meanings together) and metonymy (displacing one meaning on to another).¹⁷ Lacan built on this idea, emphasizing that Freud's dream analyses, and most of his analyses of the unconscious symbolism used by his patients, depend on word-play, puns, associations, etc.

Where semioticians talked about the relationship between signifier and signified, Lacan focuses on relations between signifiers alone (see Chapter 2 for a discussion of semiotics). For Lacan, the elements in the unconscious—wishes, desires, images—all form signifiers, which in turn form a "signifying chain." There are no signifieds attached to signifiers in the psyche: they don't ultimately refer to anything at all. A signifier has meaning only because it is not some other signifier, not because it is linked to a particular signified. Because of this lack of signifieds, the signifying chain is constantly shifting and changing. There is no anchor, nothing that ultimately gives definitive meaning or stability to the whole system. Lacan says that the process of becoming a "self" is the process of trying to stabilize the chain of signifiers so that meaning—including the meaning of "I"—becomes possible. Of course this "I" is only an illusion, an image of stability and meaning created by a misperception of the relationship between body and self.

Like Freud, Lacan talked about three stages in the trajectory of development from infant to adult, but rather than labeling them the oral, the anal, and the phallic, he called them the Real, the Imaginary, and the Symbolic. Lacan asserts, like Freud, that infants have no sense of self and no sense of an identity separate from the mother (between self and other). The baby's needs for food, comfort, etc. are satisfied by an object (the breast, the diaper, etc.). There's no absence or loss or lack; the Real is all fullness and completeness, where there's no need that can't be satisfied. And because there is no absence or loss or lack, there is no language in the Real. Lacan says that language is always about loss or absence; you only need words when the object you want is gone.

Between six and eighteen months of age, the baby starts to be able to distinguish between its body and everything else in the world. The baby starts to become aware that it is separate from the mother, and that there exist things that are not part of it; thus the idea of "other" is created. (Note, however, that as yet the binary opposition of "self/other" doesn't exist, because the baby still doesn't have a coherent sense of "self".) That awareness of separation, or the fact of otherness, creates anxiety and loss. At this point, the baby shifts from having needs to having demands, which can't be satisfied with objects.

At some point in this period, the baby will see itself in a mirror. It will look at its reflection, then look back at a real person—its mother, or someone else—then look again at the mirror image. The baby sees an image in the mirror; it thinks, "that's me there." Of course, it's not the baby; it's only an image of the baby. But the mother, or some other adult, then reinforces the misrecognition: when the mother says, "Look, that's you!" she affirms the baby's identification with its image. The baby begins to have a (mistaken, but useful) sense of itself as a whole person.

The baby's experience of misrecognizing itself in its mirror image creates the ego, the conscious sense of self. To Lacan, ego is always on some level a fantasy, an identification with an external image. This is why Lacan calls the phase of demand, and the mirror stage, the realm of the Imaginary. The mirror image (the whole person the baby mistakes for itself) is known as an "ideal ego," a perfect self who has no insufficiency. This "ideal ego" becomes internalized; we build our sense of "self" by (mis)identifying with this ideal ego. The fiction of the stable, whole, unified self that the baby sees in the mirror compensates for having lost the original oneness with the mother's body that the baby enjoyed in the Real.

Once the baby has formulated some idea of Otherness, and of a self identified with its own "other," its own mirror image, then it begins to enter the Symbolic, which is the realm of culture and language. The Symbolic order is the structure of language itself; human beings have to enter it in order to become speaking subjects, and to designate themselves by the "I" that was discovered in the Imaginary. To enter the Symbolic as speaking subjects, humans must obey the laws and rules of language. Lacan calls the rules of language the Law-of-the-Father in order to link the entry into the Symbolic to Freud's notion of the Oedipus, Electra, and castration complexes, with their pivotal figure of the angry father.

The Law-of-the-Father (or Name-of-the-Father) is another term for the Other, for the center of the system, the thing that gov-

erns the whole structure—its shape and how all the elements in the system can move and form relationships. This center is also called the Phallus, to emphasize the patriarchal nature of the Symbolic order. No one is or has the Phallus, just as no one actually rules language. The Phallus governs the whole structure, it's what everyone wants to be (or have), but no element of the system can ever take the place of the center: the desire to be the center, to rule the system, is never satisfied. The individual's position in the Symbolic is fixed by the Phallus. Unlike the unconscious, the chains of signifiers in the Symbolic don't circulate and slide endlessly because the Phallus, as center, limits the play of elements, and gives stability to the whole structure. The Phallus stops play, so that signifiers can have some stable meaning in the conscious world, even if that stable meaning is an illusion.

Lacan on art

Lacan addressed art and literature in his "Seminars" on numerous occasions. He was interested in Melanie Klein's interpretation of art as reparation (see boxed text on p. 96), although he insisted at the same time on the historical specificity of art, what he called "social recognition." That is, art isn't only private fantasy: it belongs also to the public arena of history and culture. In The Ethics of Psychoanalysis (1959–60), Lacan writes that "no correct evaluation of sublimation in art is possible if we overlook the fact that all artistic production, including especially that of the fine arts, is historically situated. You don't paint in Picasso's time as you painted in Velázquez's." 18

In The Four Fundamental Concepts of Psychoanalysis (1964), Lacan asserts that, in addressing art, psychoanalysis must go beyond Freud's pathobiographical concerns. ¹⁹ Art, for Lacan, is about lack: "A work of art always involves encircling the Thing." That word encircling is important: art, for Lacan, isn't straightforward, it doesn't simply represent the presence or absence of the object of desire (the Thing). Instead, paradoxically, art represents the Thing's presence as its absence, and helps society bear this void. Psychoanalysis enables us to address not only the artist's own psyche, but also the larger social dimensions of sublimation through art.

Lacan's critics

Among Lacan's fiercest critics and defenders are feminist psychoanalysts, who have found his re-reading of Freud both enormously liberating and deeply problematic. Lacan's elimination of much of Freud's biological essentialism is a huge plus. But feminists, following in part the example of Melanie Klein, have argued for the centrality of the maternal function and its importance in the development of subjectivity and access to culture and language. If, as Freud and Lacan suggest, our primary motivation for entering the social realm is fear of the father, then more of us should be psychotic. The missing piece in their theories, according to feminist critics, is motherhood. In *Tales of Love* (1987), for example, the French psychoanalyst and linguist Julia Kristeva (b. 1941) argues that maternal regulation is the law before Paternal Law, before Freud's Oepidal complex or Lacan's mirror stage.²⁰

In "Motherhood According to Bellini" (1980) and elsewhere, Kristeva suggests that the maternal function cannot be reduced to "natural" ideas about the mother, the feminine, or womanhood. By identifying the mother's relationship to the infant as a function, Kristeva separates the function of meeting the child's needs from both love and desire. Kristeva's analysis suggests that to some extent anyone can fulfill the maternal function, men or women. As a woman and as a mother, a woman both loves and desires and as such she is primarily a social and speaking being. As a woman and a mother, she is always sexed. But, insofar as she fulfills the maternal function, she is not sexed.²¹

In fact, Kristeva uses the maternal body, with its two-in-one structure, or "other" within, as a model for all subjective relations, displacing Freud and Lacan's idea of the autonomous, unified (masculine) subject. Kristeva argues that, like the maternal body, each one of us is what she calls a subject-in-process. As subjects-in-process we are always negotiating the "other" within, that which is repressed. Like the maternal body, we are never completely the subjects of our own experience. But even if the mother is not the subject or agent of her pregnancy and birth, she never ceases to be primarily a speaking subject.

This Freudian and Lacanian unitary subject even reveals itself in the way psychoanalysis approaches the issue of sexuality, based on the norm of the single unitary member: the penis. The French feminist philosopher Luce Irigaray (b. 1932), for example, has noted that there is no one single female sex organ that corresponds to the penis. ²² According to Irigaray, both Freud and Lacan do not have an adequate way of talking about women's sexuality and women's bodies because they are wrapped up in this idea of the penis and can define women's sexuality only in terms of male bodies (for

Freud, female genitalia are "nothing" since he sees girls as castrated boys, essentially). For Irigaray, female desire is like a lost civilization whose language hasn't been deciphered. Because Western philosophy, since the Ancient Greeks, has emphasized the visible and concrete over the absent or invisible, feminine desire is erased or subsumed into male desire. Irigaray argues that we must find specifically female imaginary and symbolic realms, challenging the necessity of the monolithic law of the father. She takes a radical step in this direction in arguing that female sexual pleasure (jouissance) is of a completely different order from male sexual pleasure. In a celebrated passage, she explores the uniqueness of women's sexuality, for woman touches herself all the time—via the "two lips" of the vagina—whereas a man needs something external (the hand, vagina, language) to touch the penis to produce pleasure.

Just as Irigaray explored the notion of a unique feminine sexuality, French novelist, playwright, and feminist theorist Hélène Cixous proposes the idea of a unique female way of writing, écriture féminine, as a way of breaking free from patriarchy. ²³ Ecriture féminine is an "Other" mode of discourse—it subverts the phallocentric symbolic order even as it is repressed by it. Ecriture féminine gives voice to that which is silenced or marginalized in the masculine symbolic order. Critics have sometimes interpreted this as an essentialist idea (see Chapter 3), but Cixous emphasizes that neither woman nor language is natural—they are both socially constructed.

Along with other feminists, American literary theorist Jane Gallop (b. 1952) has challenged Lacan's insistence on the split, the divided subject.²⁴ The antagonistic model, Gallop suggests, emerges from a certain male-centered ideology in which both Freud and Lacan are immersed. She points to feminist and postcolonial theorists who have critiqued the processes of Othering that are foundational to what Europeans call "Western culture": the Self, in this scenario, is always white and male, the Other always female or dark-skinned. She characterizes this Othering, this split in Western culture, as a heavily policed border aimed at the domination and exploitation of women (and people of color, I would add; see Chapter 3). Gallop asks whether the relationship to the unconscious has to be adversarial, constantly undermining the ego. She draws on Freud's Psychopathology of Everyday Life (1901) and other writings that present the unconscious as a wonderful ally and a tremendous resource.25

Within psychoanalysis, the clinical and therapeutic value of Lacan's work has been widely debated. There have been a number of critics, too, of Lacan's linguistics, particularly his dependence on Saussure's work, which has been widely critiqued by Noam Chomsky and others as adequate only to the individual word and unable to address grammar or context.²⁶ Shifting from a Saussurean to a Peircean framework, for me at least, addresses a number of these objections (see Chapter 2).

Psychoanalysis and contemporary art history

Many art historians have engaged with psychoanalytic theory over the past century or so to study the personality of the artist, the creative process, the effect of art on the viewer, as well as the issues of reception discussed below. Some of this work is not central to the practice of art history today (such as Freud's pathobiographic method, discussed above), and so I won't review it here just for historiography's sake. Instead, I'll focus on recent works by philosopher Richard Wollheim, art historians Suzanne Preston Blier and Rosalind Krauss, and literary theorist and art historian Mieke Bal, who all use psychoanalytic theory to discuss art in provocative ways.

In Painting as an Art (1984), Richard Wollheim analyzes paintings as parapraxes, actions motivated by unconscious intentions.²⁷ He demonstrates that the explanatory roles of painter and painting can be reversed: the painting reveals the painter's intentions no less than the painter's intentions illuminate the painting. Drawing heavily on the work of the psychoanalyst Melanie Klein²⁸ and the critic Adrian Stokes,29 Wollheim focuses on the specific formal and visual ways in which the artist transfers his/her unconscious fantasies to the painting. He argues that paintings are particularly suited to expressing unconscious desires that can't adequately be expressed in words. This has led to some interesting perspectives. Although many art historians (and artists) emphasize the distinction between abstract and figurative art, Wollheim, like Stokes, argues that this distinction is largely irrelevant. In terms of pictorial metaphor, an abstract painting can metaphorically evoke the body without actually depicting a body: so the texture of a painted surface may suggest flesh, for example. What is more important is the extent to which the artist emphasizes the distinction between abstraction and interpretation.

4.1 Bocio figure, Fon people, Benin. Ben Heller Collection, New York.

In her book African Vodun (1995), the American art historian Suzanne Preston Blier brings psychoanalytic theory to bear on the investigation of small sculptures called bo or bocio, made by the Fon people of Dahomey (now Benin) (Figure 4.1). Psychoanalytic theory, particularly the notion of transferences, helps Blier to unpack the spiritual and political power of their sculptures. She does not regard bocio as parapraxes that provide insight into the artist's psyche, but as therapeutic tools, helping to achieve the psychic health of the individual and the community. Bocio sculptures are active in the world—they deflect or absorb harmful forces, such as sickness. To make it active and effective, the small wooden figural sculpture might be sprayed with saliva, prayed over, and wrapped with various materials that relate to the problem of the owner (thus undercutting the notion of "the artist" since several people would participate in the process of creating the work).³⁰

According to Blier, the person who acquires a botio projects onto it his or her own anxiety in order to restore a sense of balance and control. So, for example, a man whose daughter rejected a suitor whom he himself had selected commissioned a botio that

represented her. This botio was meant to control and direct her affections, so that the father could then go about his daily life without worrying about the social consequences of her rejection. Blier points out that in a situation like this, a kind of transference takes place. Just as an analysand transfers problems onto the analyst during psychotherapy, the father transferred his problem onto the botio, thereby experiencing relief.

In this analysis, Blier takes figures that were once called "fetishes" and regarded as signs of the superstitious "primitive" mind, and shows how they "make sense" aesthetically, culturally, and intellectually in a local context. She thereby enables the outside viewer to make sense of them as well. Thinking innovatively via psychoanalytic theory, Blier comes to a very local understanding of sculpture and the meaning (and power) of a work of art. She also places the therapeutic dynamic invested in botio in the larger cultural and historical context of Fon culture. For her, botio testify to the disturbing effects of war, poverty, the slave trade, and the plantation labor system supported by the Dahomean monarchy. Transferring strong and potentially disabling emotions to these sculptures enables Fon people to manage their emotions and survive in a difficult and hostile world.

Working in a very different vein, Rosalind Krauss's The Optical Unconscious (1994) employs psychoanalytic theory as a way of rethinking the history of modern art. ³¹ Borrowing a phrase from the German philosopher Walter Benjamin (1892–1940), Krauss examines the "optical unconscious" of modern art, focusing on the way in which a number of different modern artists, including Max Ernst, Marcel Duchamp, Jackson Pollock, and Eva Hesse, construed their work "as a projection of the way that human vision can be thought to be less than a master of all it surveys, in conflict as it is with what is internal to the organism that houses it." Krauss argues that the formalist history of modern art, as practiced by Clement Greenberg or Michael Fried, has focused on formal and optical works of art at the expense of art generated from the unconscious. She labels this art "modernism's repressed other."

In this argument, the artist is not a master in control of the process of creating and viewing, so much as a force who releases unconscious drives and desires through represented (painted, sculpted) seeing. The works that construct "the optical unconscious" all have in common an exploration of seeing itself. At the same time, these works all prompt unconscious projections from

viewers. This takes place not so much through the viewer's identification with their imagery ("Gosh, I have dreams about human-headed birds too!") but by the way in which the work positions the spectator and by formal qualities such as rhythm, variation, and repetition.

As her key point of reference in charting visual relations, Krauss uses two diagrams derived from psychoanalysis: the Klein group and Lacan's L-Schema (Figures 4.2 and 4.3). The Klein group diagram describes the opposition between figure and ground, and the implied opposition between their opposites, not-figure and not-ground. Lacan's L-Schema uses a similar structure to graph the subject as an effect of the unconscious: here the paired oppositions occur between an imagined self and a misrecognized object, and between the unconscious Other and the resulting Self. Krauss uses these charts to analyze modern artists' inventive working processes, such as Max Ernst's collage technique and Duchamp's readymades. For example, Krauss shows that Ernst created his collages not only by clipping images from magazines, catalogues, scientific manuals, etc., and adding elements to them,

4.2 Klein Group diagram

4.3 Lacan L-schema diagram

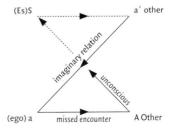

but also by removing unwanted elements from those pages—a subtractive as well as an additive process.

Art historians have also turned to the idea of the mirror stage in the analysis of works of art, seeing it as a process experienced not only at the individual level but also at the societal level. Societies, too, know and define themselves in relation to others, and a society's sense of itself is not unified and identical with the self. but is the product of its relation to the other (the mirror image). In this vein, Mieke Bal has written a provocative analysis of Caravaggio's painting of Narcissus.³² In Greek myth, Narcissus wastes away when he falls in love with his own reflection in a pool of water: as Bal points out, he mistakes a sign for reality. Bal rewrites Lacan's narrative of the mirror stage through Caravaggio's image. She points out that the "real" body of Narcissus in the painting is disjointed and fragmentary: the knee projects out into the viewer's space, while the reflected Narcissus is much more coherent. Bal departs from Lacan's theory in noting the presence of the viewer in this exchange: the sharply foreshortened knee of Narcissus is recognizable as such only from the viewer's vantage point. So the mirror stage in Bal's account becomes not a story of self and other, but of intersubjectivity—the I/you exchange that incorporates the viewer.

The gaze

Looking is a powerful weapon. To look is to assert power, to control, to challenge authority. Parents say "Don't look at me like that!" or "Look at me when I'm speaking to you!" to disobedient children.

Freud observed that desire is crucially involved in the process of looking, and Lacan saw the Gaze as one of the main manifestations of the four fundamental concepts of psychoanalysis—the unconscious, repetition, transference, and drive. Following Lacan, psychoanalytic theorists use "Gaze" to refer to the process of looking, which constitutes a network of relationships, and "gaze" (with a lower-case "g") to refer to a specific instance of looking. According to Lacan, we try to give structure and stability to our illusions, our fantasies of self and other via the Gaze. It is only through art and language (that is, through representation) that the subject can make his or her desire for the lost object known. So, for Lacan, looking at art is not a neutral process: instead, the viewer is a desiring subject open to the captivation exerted by the work of

4.4 Barbara Kruger, Your Gaze Hits the Side of My Face, 1981. Collage.

The text signals the power of looking – and the complex relationship between the gaze and violence. Kruger's use of a classical sculpture, rather than an actual woman, connects this issue to the history of art, and the ability of male artists to look while women can only be looked at. At the same time, the gender identity of the viewer ("you") is open, rendering the image doubly ambiguous and disturbing.

art. In fact, Lacan argues provocatively that the function of the work of art, especially a painting employing linear perspective, is to "trap" the gaze (dompte-regard), because the image (falsely) puts the viewer in the position of the eye (Figure 4.4).³³

A lot of contemporary theorizing about the Gaze emerged in film theory, which emphasized the psychic process and experience of viewing. In her groundbreaking essay "Visual Pleasure and Narrative Cinema" (1975), English filmmaker and feminist theorist Laura Mulvey challenged patriarchal models of viewing in her critique of classic Hollywood cinema.³⁴ Drawing on psychoanalytic theory, Mulvey argued that viewers derive pleasure from films in two ways: through scopophilia (or voyeurism), the pleasure in looking, and through identification with the ideal ego, represented by the on-screen hero. Hollywood cinema reflects and reinforces the way that, in patriarchal society, "pleasure in looking has been split between active/male and passive/female." In the film, the hero is male and active and possesses the gaze; he makes the story move forward. In contrast, the film treats women as objects of desire, not heroes: they are passive, and, rather than possessing

the gaze, they are the object of it. In fact, Mulvey argues, the woman's appearance on screen often interrupts the flow of the narrative—she is pure spectacle. (If you're not sure what Mulvey means by this, check out the opening credits of Hitchcock's Rear Window, which perfectly illustrates her thesis. While you're at it, the opening credits of Desperately Seeking Susan, in which Madonna's character takes charge of a camera, provide a very funny antidote to the patriarchal Gaze.)

According to Mulvey, this leaves the female viewer in a tough spot. Hollywood's ideal viewer is straight and male (African-American cultural critic bell hooks would later point out that he's white, too). The viewer can easily identify with the hero on screen, and can also get full pleasure out of looking at the female object of desire flashing across the screen. The straight (and white) female viewer isn't left with much. Does she suppress her identity in order to identify with the male hero? Does she identify with the passive spectacle of womanhood on the screen? Classic Hollywood cinema forecloses her gaze, and her pleasure in film, in multiple ways.

There have been a number of responses to and elaborations of Mulvey's provocative thesis. Many critics have argued that, whatever Hollywood may intend, viewers may actually occupy multiple viewing positions, not just the binary either/or male/female. There are various ways for both men and women to possess the gaze or to be excluded from it due to such factors as sexual orientation, class. or race. Similarly, a woman viewer may indeed identify with a male protagonist, even if the Hollywood machine doesn't intend her to: and a lesbian woman may fully experience the scopophilia, the erotic viewing pleasure, to be had from the spectacle of a woman on screen, while a gay man may not. The boundaries between active/passive and male/female aren't always so clear-cut, either: the male body can also be fetishized and displayed as spectacle. In her essay "The Oppositional Gaze," bell hooks argues for a gaze that challenges and critiques what's going on in the film, rather than passively complying with it.35

Film theory, and theories of the gaze, have been important for art history because they provide an account of the individual experience of viewing. As they've developed, these theories have been able to account for gender, sexual orientation, race, and class as factors shaping the gaze and subjectivity in general in ways that the theories of vision generated within art history and the psychology of art, though provocative, have often failed to do.

Reception theory I: the psychology of art

Interpretation on the part of the image maker must always be matched by the interpretation of the viewer.

No image tells its own story.

Ernst Gombrich, The Image and the Eye (1982)

Reception theory shifts attention from the artist to the viewer. The history of reception may focus on what contemporary critics and other viewers had to say about a particular artist or works of art, or it might trace the history of taste, as in Francis Haskell's Taste and the Antique: The Lure of Classical Sculpture, 1500–1900 (1981). The psychology of art, meanwhile, is concerned with the psychic and physiological aspects of viewing works of art. The idea is that the viewer actively completes the work of art. The art historian Ernst Gombrich (1909–2001) calls this the "beholder's share," the stock of images stored in the viewer's mind that she brings to the process of viewing art. Interest in reception has been strong in psychoanalysis, art history, and literary theory, and the development of reception theory has been an interdisciplinary effort.

Art historians have long discussed what we would identify as issues of reception. In The Group Portraiture of Holland, first published in 1902, Alois Riegl observed that the painters of Dutch group portraits assumed an ideal viewer who could negotiate the interplay between collective and individual identity in these images.³⁶ However, it was the conjunction of art history, psychoanalysis, and Gestalt psychology in the early twentieth century that crystallized this line of questioning. The art historian and psychoanalyst Ernst Kris (1900–1957) proposed a theory of creativity and artistic experience that was important in the development of reception theory. He argued that, through art, the artist—and, vicariously, the spectator—secures psychic gratifications that are unavailable in daily life via a process of regression. Art makes these gratifications available because, in the first place, the regression does not occur defensively or under pressure, rather the ego exploits it; and, secondly, the regressive gratifications are not related to specific desires but come from recognizing that there are such sources of pleasure that may still be tapped.³⁷ Kris was partly inspired in this work by Freud's Jokes and their Relation to the Unconscious (1905), which Freud himself had seen as providing a potential model for the analysis of art and literature.38

Kris noted that the creation of a work of art is not a narrowly

The anxiety of influence

Literary critics and art historians have taken the idea of artistic influence beyond identifying sources for motifs and images to consider the complex ways in which artists respond to the art of the past. In 1973, the American literary critic Harold Bloom published a widely read and influential book about these processes called The Anxiety of Influence. In it, Bloom argues that new poems originate mainly from old poems because the primary struggle of the young poet is against the old masters. The young poet must "clear imaginative space" for her own work through a "creative misreading" of previous literature. According to Bloom, only gifted poets can overcome this anxiety of influence; lesser artists become derivative flatterers and never achieve greatness for themselves. The truly great poet, however, will succeed in making us read the earlier works through the lens of her creative misreading.39

Norman Bryson, in Tradition and Desire (1984), adapts Bloom's work, and that of literary critic W. Jackson Bate (b. 1918), to the history of art. ⁴⁰ Bryson traces the different ways in

which David, Ingres, and Delacroix perceived their places in artistic tradition and negotiated the promise—and the burden—of tradition. Tradition, he points out, "supplies every reason for activity and celebration" when it inspires and excites us. At the same time, for the artist who is obliged by a stylistic consensus (for example, neoclassicism) to imitate the art of the past, or who perceives himself as a latecomer to the tradition of art-making he admires, tradition can be inhibiting and anxiety-producing, threatening the artist's sense of self. For example, in discussing Ingres's portraits of the Rivière family, Bryson argues that for Ingres, the meaning of a painting is always, explicitly, another painting. The Rivière portraits reference works by Raphael, and in so doing, set up a signifying chain, a series of displacements in which no sign, no image, stands alone. The portrait of Mme Rivière may reference Raphael's Madonna of the Chair, but only by way of the Giardiniera. These links are elusive—the viewer is left with an enigma, rather than a direct and conclusive viewing experience.

individualistic activity: it requires the participation of both artist and spectator. Ernst Gombrich, who collaborated with Kris, took the point further and argued that the essentially social character of art imposes limits upon what psychoanalysis can explain: Gombrich doesn't see psychoanalysis as fully addressing either the social, political, and religious context in which the artist had to work, or the choices the artist must make within "the logic of the situation." (Of course, this is something that Lacan emphasized as well.) Gombrich's basic question is not about the classification or description of artistic styles, as it was for so many of his contemporaries, but the question of how style comes into being—the idea, which he takes from Wölfflin, that "not everything is possible in

every period." Gombrich argues that the illusionistic style—the representation of the real—is a lot more complex than it may seem at first to people like us, who are used to negotiating illusion. Gombrich uses a wide range of imagery, from Renaissance painting to cartoons and advertising images, to build his argument. For example, he reproduces the famous duck/rabbit diagram to demonstrate how complex even such a simple visual ruse is—much less a complex narrative painting (Figure 4.5).

4.5 Duck/rabbit diagram, after Ernst Gombrich, Art and Illusion (1961).

Gombrich used this image, which we can see as either a duck or a rabbit but never as both simultaneouslu, to argue that we cannot simultaneously see both a painting itself (as literally paint on canvas) and the representational illusion it creates. In Art and Its Object (1980), Richard Wollheim rejects this claim, arguing that such artists as Titian and Vermeer use their virtuoso skills with line, color, and brushwork to focus our attention on particular representational effects; Wollheim asserts that this wouldn't work if we had to alternate our gaze between the materiality of the work and the illusion of representation it creates.

For Gombrich, the work of art is fundamentally the record of a perception that is itself shaped by the previous representations available to the artist in his/her tradition. In one of his most famous works, Art and Illusion (1960), Gombrich outlines the way in which images are created via a process of testing not unlike that of the sciences. When an artist confronts a problem, such as representing the human face, she turns to tradition, to the work of previous artists, for a formula or schema that she can use to create her image. As she works with these available schemata, she realizes that they are inadequate for the task of representing her own perceptual findings, and she must modify them accordingly. The modified schemata then enter the repertoire of visual schemata available for use, testing, and modification by other artists.⁴¹

The psychologist and art theorist Rudolf Arnheim (b. 1904) has covered similar terrain in the psychology of visual perception from a somewhat different perspective. Arnheim challenges the idea that vision is a mechanical and primarily physiological function. and argues vehemently against the idea that vision and thought are two separate processes. Arnheim had studied Gestalt psychology in Berlin with major figures in the field; the word Gestalt in German means simply "shape" or "form," and Gestalt psychology focuses on experiments in sensory perception. To support his arguments about the nature of visual thinking, Arnheim engaged in penetrating and wide-ranging studies of the basic perceptual structures of works of art. His first major work, Art and Visual Perception (1954), traces how vision becomes the apprehension of significant structural patterns, with chapters focusing on such visual characteristics as balance, shape, form, space, light, color, and movement. Interestingly, he completely revised that book for republication in 1974, having changed a number of his conclusions. In his 1969 book Visual Thinking, Arnheim expanded his challenge to the idea that verbally articulated thought precedes perception. He argued that artistic expression is a form of reason— "A person who paints, writes, composes, dances, I felt compelled to say, thinks with his senses." In works such as The Power of the Center (1982) and The Dynamics of Architectural Form (1977) he has explored particular spatial and pictorial patterns, such as the grid, and argues that form and content are inextricably intertwined.⁴²

Norman Bryson and others have critiqued the psychology of art for focusing exclusively on the artist's "arc of inner vision or perception" running from the hand to the retina. This model excludes the arc that extends from the artist to viewer, across the contextual (and conceptual) spaces in which the artist, the work of art, and the viewer are all situated. In Visual Theory (1991), Bryson argues that the psychology of art leads to "a vision of art in isolation from the rest of society's concerns, since essentially the artist is alone watching the world as an ocular spectacle but never reacting to the world's meanings, basking in and recording his perceptions but apparently doing so in some extraterritorial zone, off the social map."43 It's an issue that Gombrich and Arnheim both acknowledged at various points in their writing, and art-history students today, while employing Arnheim's and Gombrich's work to achieve fresh perspectives on perception and the viewing process. also address social and historical issues at the same time.

Reception theory II: reader response theory and the aesthetics of reception

The text is a tissue of quotations drawn from the innumerable centres of culture . . . The reader is the space on which all the quotations that make up a writing are inscribed without any of them being lost; a text's unity lies not in its origin but in its destination. Yet this destination cannot any longer be personal: the reader is without history, biography, psychology; . . . the reader] is simply that someone who holds together in a single field all the traces by which the written text is constituted.

Roland Barthes, The Pleasure of the Text (1973)

According to reader-response theory, meaning happens through reading—it doesn't exist as a pre-given element of the text. Reading isn't for the lazy: the reader has to make connections, fill in gaps, draw inferences, and make hypotheses as she proceeds through the text. Without the active participation of the reader, there wouldn't be any text. The Polish literary theorist Roman Ingarden (1893–1970) said that the text is nothing more than a series of schemata—predictable or usual patterns—which the reader then interprets and shapes into meaningful language.⁴⁴ The reader brings "pre-understandings," a set of contexts and beliefs and expectations, to the work. The idea is that there are three interconnected worlds: the world of the author, the world of the text, and the world of the reader.

When she picks up a book, the reader encounters not the world of the author, but the world of the text. The world of the author (her tastes, interests, experiences, goals) has certainly helped to shape the world of the text, but it's not as if the two are identical (not even in autobiography, where the author will include or exclude all sorts of events and emotions for various reasons). And, of course, as the author has worked on the book, the world of the text has shaped the world of the author. Furthermore, the reader brings her own world to the process of reading that book, and, in turn, her world may be affected by the experience of having read it.

The German literary critic Wolfgang Iser (b. 1926), in The Act of Reading (1978), discusses further the idea of the schemata, the

strategies that texts use, and the repertoires of familiar themes and allusions they contain.⁴⁵ The text itself, according to Iser, suggests the existence of an "implied reader," who may or may not fit the profile of the actual reader. The reader who is familiar with the strategies and repertoires employed in the text will have a fuller, richer reading experience, but there's never going to be a perfect match between the text's codes and the reader's codes. This isn't a bad thing: the mismatches give literature its power to challenge, awe, surprise, and change us. Literature doesn't simply reinforce what we already think and know, it gives us new ways to think and see and understand. Although Iser more or less ignores the social and historical dimensions of reading, German literary theorist Hans Robert Jauss (1921–1997) emphasizes that people within a culture share a common set of understandings about what's possible or probable. 46 He calls this the horizon of expectations, the context of cultural meanings within which the text is produced. Texts and literary traditions are themselves actively altered according to the various historical horizons in which they are received by readers. (In relation to this, you may want to think about the idea of unlimited semiosis and the practical limitations placed on it by context.)

American literary theorist Stanley Fish (b. 1938) makes a similar point when he argues that readers belong to "interpretive communities" that share reading strategies, values, and assumptions that's what constitutes the "informed reader." Fish is concerned with what the text does, rather than with what the text means. For him, what the text means and how it goes about creating that meaning happens within the reader, through reading; meaning does not exist as a pre-given element of the text. For example, Fish's essay "Surprised by Sin: The Reader in Paradise Lost" (1967) argues that the text of Paradise Lost employs a number of literary techniques to lead the reader into a false sense of security, only to then introduce a surprise, disappointing the reader's expectations and making her aware of her own proud-and mistaken-sense of selfsufficiency. The text urges the informed reader to see her own sinfulness in a new light and opens up the possibility of returning to God's grace.47

So what's the point of reading? Reader-response theorists answer that question in different ways. Iser, for example, argues that the purpose of reading is to stabilize meaning, to eliminate the text's multiple possibilities and pin down one true meaning. Roland Barthes, in The Pleasure of the Text (1973), opposes this idea

by saying that the pleasure of the text lies not in pinning down meaning, but in enjoying the free play of words—the gliding of signs—as the reader catches provocative glimpses of meanings that surface only to submerge again.⁴⁸ (I sometimes think of this as the whale-watching concept of reading.) There is an obvious connection here to Lacanian psychoanalysis and the sliding of signifiers in the unconscious.

A number of art historians have adapted reader-response theory to the study of visual art—and, indeed, we can regard a "text" as an image, sound, gesture, or any other cultural phenomenon to be interpreted. In a series of books and articles ranging widely in European art, the German art historian Wolfgang Kemp (b. 1946) has outlined a methodology and history for the process of what have been called the aesthetics of reception.⁴⁹ Kemp argues that the context of reception—the conditions of access and conditions of appearance—has to be taken into account in any interpretation of a work of art. Whether a work is seen in a church or in a museum has a great deal to do with how the work is seen. In fact, Kemp is highly critical of the institutions and modern techniques of reproduction that present works of art as single entities unrelated to anything else—"ubiquitous, homeless, displaced."

Kemp borrows the idea of the implied reader from readerresponse theory to discuss the notion of the implied beholder the idea that the work of art implies a particular viewer or tries to set up a particular viewing experience. Related to this is the issue of "forms of address," the ways in which elements or figures in the image interrelate with each other and with the viewer. (See also the discussion of deixis in Chapter 2.) Sometimes in a painting, for example, a figure makes eye contact with the viewer to draw her into the image. Such figures, called focalizers, may even direct the viewer's attention toward a particular element within the scene, perhaps by pointing directly at it. Similarly, perspective works to situate the viewer in relation to the image. In architecture, you would want to look at how the viewer is positioned by elements of the architecture to experience it—for example, by the placement of doorways, staircases, hallways, etc. (Similar attention to various viewing positions, the forms and directions of the gaze, emerges within film studies.)

Kemp also calls on art historians to pay attention to the ways in which the artwork is unfinished or indeterminate. This doesn't mean literally that brushstrokes or bricks are missing, but that the

spectator, as part of the viewing experience, must mentally complete the invisible reverse side of a painted figure, or trace the course of a staircase past its curve. Following Iser, Kemp notes that sometimes these blanks, these missing elements, are as important as what is actually there—they are often used deliberately to emphasize schemata and are meant to trigger particular responses in the viewer.

Practicing reception theory/psychoanalytic art history

Edóuard Manet's Olympia, 1863 (Figure 4.6), and Yasumasa Morimura's Futago, 1990 (Figure 4.7), have an obvious relationship to each other, and I'll develop lines of questioning for them both individually and together. Manet's painting is, of course, one of the most celebrated works of the nineteenth century. Rather than painting a classical nude, Manet depicts a woman (the model Victorine Meurent) who seems to be a prostitute or courtesan. She challenges the viewer with her stare, even as a black servant (an Afro-European woman named Laure) presents her with a bouquet of flowers. Morimura's image reimagines Manet's painting as part of a series of photographs in which Morimura restaged great works of art with himself as protagonist. Morimura takes care to replicate Victorine's pose—the hand pressed in front of the genitals, the challenging stare—but his male, Japanese body disrupts not only Manet's pictorial scheme but also the ideologies of race. gender, and sexuality in which Manet's image was-and isembedded. Manet's flower-embroidered shawl and kitten are replaced with a lavishly decorated kimono and a waving cat statue (a sign of luck displayed in many Japanese homes and shops).

- ▶ Each of these works sets up a complicated relationship with the viewer. Is there an implied ideal viewer for either work? If so, how is that established? Does Manet's painting imply that the viewer is a client or lover, and, if so, is the viewer a welcome guest or an unexpected intruder? Is there an implied gender, race, class, or sexual orientation to the viewer of Manet's painting? If so, what are the schemata that help establish this implied viewer?
- ► The kinds of issues raised by Kemp in terms of "forms of address" are peculiarly appropriate to these images. How does communication takes place between figures in the image? Who is the "focalizer" for the viewer?

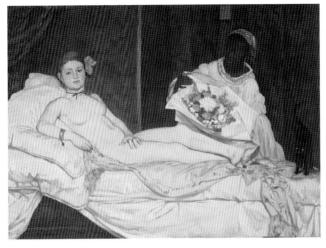

4.6 Edouard Manet, Olympia, 1863. Oil on canvas. Musée d'Orsay, Paris.

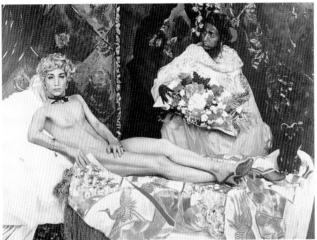

4.7 Yasumasa
Morimura, Futago,
1990. Cibachrome
print. Logan
Collection/San
Francisco Museum
of Modern Art.

- ► The gaze is critical in these works—how is it operating? Analyze this in Lacanian terms, or in terms of film theory. Does Morimura's work represent an "oppositional gaze" in relation to Manet's painting?
- How might the notion of the mirror stage be at work here? What is the sense of self—does the viewer look into the image as into a mirror? Has Morimura looked at Manet's image as a mirror image? Is he "reflecting" back to Manet's image a mirror image? The whole self? The fragmented self? How might race, gender, sexual orientation, and class affect these mirroring dynamics?

- Morimura's Futago raises the issue of the anxiety of influence, in relation to both Manet and also the photographer Cindy Sherman, who stages herself as the heroine of Hollywood drama in her Untitled Film Still series, and restaged Raphael's La Fornarina as a self-portrait in 1989. You could draw on both Bloom's and Bryson's work in exploring these issues.
- ▶ Manet's Olympia shocked many viewers when it was first displayed at the Paris Salon in 1865. If you were going to approach these images from the history of spectatorship, then you might want to trace the responses to these works, and think also about what's shocking in art, when and why. Does Morimura's work have a similar capacity to shock its viewers today?
- ► Could you argue that Krauss's notion of the optical unconscious in art is at work in either of these images?

Over thirty feet tall, Maman (Figure 4.8) depicts a pregnant spider that is overwhelming, even menacing, and yet, at the same time, somehow fragile. The title of the work and the fact that the spider is pregnant raise the issue of maternity. Louise Bourgeois notes on one of her drawings that she associates spiders with her mother, "Because my best friend was my mother and she was also intelligent, patient, clean and useful, reasonable, subtle and as indispensable as a spider. She was able to look after herself."

- Because Bourgeois discusses her works in autobiographical terms, it may be tempting to perform a Freudian pathobiography of the artist through this image. Instead, you may want to look at how the issues of maternity represented here potentially play out for the viewer. Reader-response theory, which focuses on the effect of the text on the reader, not on the author's intentions, would help you frame your arguments.
- ▶ Bourgeois has said that her sculpture is problem-solving, especially in terms of working out anxieties or emotions. She has likened the challenge of working with sculptural materials to the challenge, the resistance, in dealing with human relationships. Does the concept of transference or the idea of the transitional object help you understand this sculpture?
- There are tensions in this image between the protective mother, who takes all her children in her arms (the viewers become like small children moving among her legs) and the threatening, overwhelming aggressive mother, not only because of the size of the image, but also because it is a poisonous brown recluse spider. What kind of psychoanalytic interpretations can you bring to bear here? If you think of this sculpture as an image of the mother, what does it mean in psychoanalytic terms for the viewer to (re)enter the mother's body? Think not only about the mother-child relationship, but also about the egg sac holding large marble eggs, which represents the promise of new life and a deadly threat all at the same time (it has to make the viewer just a little nervous to walk under that sac...)

4.9 Shirin Neshat, Fervor, 2000. Video, Morocco/US. Barbara Gladstone Gallery, NYC.

Shirin Neshat is a photographer and video artist born in Iran but educated in the US. Her work focuses on Muslim women and challenges sexist and racist stereotypes about Muslim women generated both within and outside Islam. Fervor (Figure 4.9) is a poetic exploration of romantic love between a Muslim man and woman. It raises a provocative set of questions about gender, culture, and the gaze.

- ► The eye of the camera here is Neshat's eye: how does the shooting of the film reflect her sense of herself as living between two worlds, as an Iranian-born artist living and working in New York? How does her gaze work to undercut a patriarchal, Western gaze?
- ► This video challenges the viewer, resisting easy assumptions about Self and Other (who is Self here? Who is Other?). How does your position as a viewer, your own understandings of culture, religion and gender, shape your experience of the work?
- ▶ In this film, the female protagonist wears a black chador, with only her face exposed, and for most of the video, a large black screen physically separates her from the male protagonist. Neshat asserts that the piece is about the clash between sexual desire and social control. How can theories of desire, sexuality, and the gaze help the viewer "unpack" this work? How does the video challenge the viewer to realize the cultural specificity of such theories?
- ► What does it mean when the female protagonist of Neshat's film turns to face the camera? What are the implications for the gendering of the gaze? What is the significance of this gaze for Neshat's representation not of "women" but of Muslim women?
- ► Postcolonial and Subaltern Studies theory may also help you here. How does Neshat's film work to represent the complex voices and experiences of Muslim women? How do stereotypes around gender, race, and religion often work to silence Muslim women?

Conclusion

Psychoanalysis and reception theory provide challenging and provocative perspectives on the visual arts. These theories open up art history to fundamental questions about the self,

the mind, and society. If psychoanalysis destabilizes our sense of self, challenging what we think we know about ourselves, it also destabilizes our sense of our own discipline, what we think we can know about the artist's intentions or the viewer's experience. The next chapter, in taking up issues of epistemology, will further destabilize your sense of self (as art historian, that is).

A place to start

Psychoanalysis

Freud, Sigmund. Civilization and its Discontents, transl. Jean Rivière. New York: J. Cape & H. Smith. 1930.

Gallop, Jane. Reading Lacan. Ithaca: Cornell University Press, 1985.

Lacan, Jacques. "The Ethics of Psychoanalysis." The Seminar series, Book VII, ed. Jacques-Alain Miller. New York: Norton, 1992.

, "The Four Fundamental Concepts of Psychoanalysis." The Seminar series, Book XI, ed. Jacques-Alain Miller. New York: Norton, 1977.

Marks, Elaine, and Isabelle de Courtivron, eds. New French Feminisms: An Anthology.

Amherst: University of Massachusetts Press, 1980.

Psychoanalysis and art

Freud, Sigmund. Writings on Art and Literature. Palo Alto: Stanford University Press, 1997.

"Leonardo da Vinci and a Memory of His Childhood." Standard Edition of the
Collected Psychological Works of Sigmund Freud, vol XI, transl. James Strachey. London:
Hogarth Press, 1957.

Iversen, Margaret, ed. Psychoanalysis in Art History, a special issue of Art History 17:3 (September 1994).

Kris, Ernst. Psychoanalytic Explorations in Art. New York: International Universities Press, 1952.

Spitz, Ellen Handler. Art and Psyche: A Study in Psychoanalysis and Aesthetics. New Haven: Yale University Press, 1989.

Reception theory

Arnheim, Rudolf. Art and Visual Perception. Berkeley: University of California Press, 1954. Barthes, Roland. The Pleasure of the Text, transl. Richard Miller. New York: Farrar, Straus & Giroux, 1975.

Gombrich, E.H. Art and Illusion: A Study in the Psychology of Pictorial Representation. Princeton: Princeton University Press, 1961.

———. The Image and the Eye. Oxford: Oxford University Press, 1982.

Wollheim, Richard. Painting as an Art. Princeton: Princeton University Press, 1987.

Freedberg, David. The Power of Images: Studies in the History and Theory of Response. Chicago: University of Chicago Press, 1991.

Chapter 5

Taking a stance toward knowledge

This chapter presents a number of different theoretical perspectives that I call "ways of thinking about ways of thinking." These perspectives ask us to consider how we're approaching knowledge, and how we're engaging in interpretation. What is it that we think we can know about works of art, their creation and reception? How can we know it? From what vantage point? And to what end?

Hermeneutics

The work, by its own force and fortune, may second the workman, and sometimes outstrip him, beyond his invention and knowledge.

Michel de Montaigne, "Of the Art of Conferring" (1580)

Hermeneutics focuses on the theory and practice of interpretation. It first developed as a branch of philosophy and theology largely concerned with the interpretation of biblical texts. Hermeneutic readers of the Bible held that all biblical tales—however mythic, folkloric, or even strange they seemed—were divinely inspired and therefore contained moral truths and lessons, if they were interpreted correctly. Practitioners studied grammar and phrasing, and tried to set biblical stories in a historical context. Hermeneutics later expanded to the analysis of many kinds of spoken and written texts, and it has since been applied to all sorts of representations and cultural practices.

The hermeneutic trio

Although a number of scholars have made important contributions to non-biblical hermeneutics, three in particular stand out.

In the nineteenth century, the German scholar Wilhelm Dilthey (1831–1911) did a great deal to broaden the scope of hermeneutics. Dilthey distinguished between the human sciences (history, economics, religion, philosophy, the study of art and literature, etc.) and the natural sciences, arguing that the goal of the human sciences was understanding, while the goal of the natural sciences was objective explanation.¹ "Understanding" (Verstehung) can address the meanings expressed in a range of cultural practices, including texts and images. According to Dilthey, understanding a particular cultural practice or object requires a familiarity with both its social and cultural context and also with fundamental human mental processes. Most of all, understanding requires an almost mystical, sympathetic identification with the mind of another person or the culture of another era.

In the twentieth century, the German philosopher Martin Heidegger (1880–1976) also made key contributions to hermeneutic theory. His career was marked by controversy because he joined the Nazi Party in 1933 and had participated in the Nazification of the University of Freiburg.² Nonetheless, his major work, Being and Time (1027), had a profound influence on twentieth-century thought. Heidegger addressed himself to the basic philosophical question "What does it mean to be?", and was concerned that modern industrial society had fostered nihilism, depriving human life (being) of meaning. He argued that human beings don't exist apart from the world—the world isn't just out there somewhere, waiting to be analyzed and contemplated from the distant heights of rationality. Instead, we emerge from and exist in the world, and can only know it, and ourselves, as part of it, as being-in-the-world. This is what Heidegger means when he discusses the "pre-understanding" that underlies any human knowledge.3 Understanding isn't an isolated act of cognition but part of human existence, emerging from the assumptions and opinions generated by our concrete experiences in the world. Understanding, then, is rooted in history and rooted in time: it is always embedded in the observer's experience.

Language has great significance for Heidegger, for he says that "the human being is indeed in its nature given to speech—it is linguistic." In this view, language isn't just a tool for conveying information; instead, it is our way of being in the world. Heidegger distinguished between "calculative" or scientific/representative language, and "essential" or meditative/philosophical/non-representative

language. In the calculative mode, language is information, and it pretends to describe things as they are. In contrast, essential language doesn't pretend to deal directly with objects: instead, it deals with being, the ground of reality, via the intricate relationships of language. Heidegger argues that philosophers must reject the idea that they can possibly represent being via calculative language. Instead, the philosopher should approach language creatively, like a poet. For Heidegger, poetry and philosophy say what they have to say not directly but through metaphor. Metaphor enables philosophers to express, in a non-representational (or non-calculative) way, the relations that reflect what is involved in being in the world. Metaphor is not literal and descriptive, but imaginative and allusive, and a better way to show relations without ossifying them as literal "things" via representational, descriptive language.

Although Heidegger rarely commented directly on art, he did write an important essay, "The Origin of Art," in which he argued that the work of art has a special character: it is "a being in the Open" and "opens up a world." The Open is a cultural space created by a particular understanding of what it is to be a being—a thing, a person, an institution. Works of art express this shared cultural understanding of the meaning of being, for they give "to things their look and to men their outlook on themselves."7 When art functions in this way, it can clarify and make coherent any number of related practices. But, at the same time, art cannot itself be explained and rationalized; the artwork has a kind of stubborn irreducibility—Heidegger says this is why people argue about the meaning of art. Of course, art can stop working in this way. When artworks no longer function as cultural paradigms, they can become "merely" objects of aesthetic contemplation—precious treasures, perhaps, but relegated to the margins of human experience. Heidegger argued strenuously against this kind of aesthetic appreciation of art; for him, art is about experience, not about feeling.8 He also opposed the idea that art is representational or symbolic, arguing that this approach can't even begin to capture the way that art functions to shape human experience. (Just imagine a conversation between Heidegger and Panofsky . . .)

The leading contemporary hermeneutician, the late German philosopher Hans-Georg Gadamer (1900–2002), was Heidegger's student. In his major work, Truth and Method (1960), Gadamer engaged with the history of Western philosophy, entering into dia-

logue with the philosophical tradition in order to interpret and understand it.9 He argues that the meaning of literature—or art, for that matter—isn't limited to the creator's intentions. Rather, for Gadamer, art takes on new meanings as it passes into different time periods and different cultures, meanings that could never have been anticipated by the creator. He declares that "the work of art is one with the history of its effects." 10

Gadamer thought of interpretation not as a sympathetic leap into another's mind, but as a process of language and communication. He insisted that the hermeneuticist in search of understanding cannot overcome historical distance from her subject. Using art as his paradigm, Gadamer argued that the contemporary interpreter can never perfectly recreate the artist's original intentions, or the original conditions of reception. Both the artist and the hermeneuticist are limited by their different social, cultural and intellectual horizons. For Gadamer, the interpretation of a work of art is a dialogue: the hermeneuticist tries to alter her own horizon to encompass the horizon of the work. 11 As a result, both horizons are changed, and neither the meaning of the work nor the nature of the interpreter remains the same. (Again, Peircean semiotics is not unrelated here—see Chapter 2.) A common language, the product of previous interpretations, connects past and present, artwork and interpreter, and each new interpretation contributes to and extends it.

The hermeneutic circle

Both Heidegger and Gadamer asserted that "the hermeneutic circle" governs all knowledge: they argued that the process of interpretation does not proceed in linear fashion, from a beginning point (no knowledge) to an end point (full knowledge). ¹² Rather, interpretation is circular, a constant process that we are always already engaged in. Dilthey says that the hermeneutic circle arises because the meaning expressed by a cultural artifact or practice does not emerge only from the creator's intentions, but also depends on the whole system of meaning of which it forms part. To understand each part implies an understanding of the whole, yet there is no way of understanding the whole independently of its parts. As Heidegger famously noted, a hammer is a hammer not by itself, but only in relation to nails, walls, and the practice of carpentry in general. ¹³ This hermeneutic understanding of meaning should remind you in some ways of Peirce's construction of the

sign, in which the interpretant, yet another sign, is generated in response to the sign.

The hermeneutic circle means that all understanding begins somewhere in the middle of things, with some sort of pre-understanding already in place. For Gadamer, interpretation is about achieving "an" understanding of the work, not "the" understanding. All truths are relative, depending on time and place and interpreter. When you take your first art history class, it's not as if you've never seen a work of art before. You may have visited museums many times, or have a poster of a favorite artwork in your room, and you probably have a working definition of the concept of art that seems right to you. You may even already have some exposure to art history itself from all those museum visits—or maybe even because you're a devoted Sister Wendy fan. When you first step into that art-history lecture hall, the subject may seem absolutely new, but you're actually starting somewhere in the middle.

In terms of the practice of art history, this is something we see very clearly in the history of reception. Take, as an example, quilts made by African Americans during the era of slavery and reconstruction (Figure 5.1). When they were made in the nineteenth and early twentieth centuries, these quilts were seen as craft. Media hierarchies meant that quilts, as textiles, were less valued than the arts of painting or sculpture, and works by African Americans (and

5.1 Marie Hensley, Quilt, circa 1900–10. Philadelphia Museum of Art.

Historically, quilts made by African Americans for their own families and communities often featured asymmetrical patterns and distinctive color combinations. Scholars have compared this style to the improvisational and rhythmic aesthetics of jazz, and have noted its connections to the textiles of West and Central Africa.

local artisans generally) were valued less than those produced by highly trained artists. So, the media hierarchies of the art world, combined with the racism of society at large, meant that these works were largely ignored and unappreciated, except by the people who made them and the family members who inherited them. With time, not only have quilts come to be seen as an art form, but society at large has begun to challenge the race and class prejudices that rendered these works invisible. ¹⁴ There is no such thing as an unchanging, eternally correct interpretation.

At the same time, of all the interpretations available at any given time, some will be more persuasive than others and better able to account for the available evidence. In practical experience, the process of interpretation may seem to stop, just as semiosis may seem to stop, when the interpreter reaches an understanding that makes sense at that moment, but the hermeneuticist takes a larger perspective and knows that the hermeneutic circle goes on. Heidegger asserted, "What is decisive is not to get out of the circle but to come into it in the right way." 15

Hermeneutics and art history

In general, you could say that contemporary art history has a hermeneutic orientation, in that art historians are self-conscious about the process of interpretation. They work from an awareness of the historical context not just of the work of art, but also of the act of interpretation itself. Although art historians are still deeply interested in the artist's intentions, this interest is accompanied, and shaped, by a greater skepticism about our ability to know the intentions of the artist fully, or to interpret them in any way other than through our own cultural lens. In fact, there are numerous links between Gestalt psychology, hermeneutics, and reception theory. The development of reception theory, particularly the idea that the viewer "completes" the work of art, owes a great deal to hermeneutics, especially to Gadamer's work (see above, p. 124).

Art historians who engage deeply with hermeneutic theory shift attention away from iconography to the experience of the work of art itself. Art historians such as the Swiss scholar Oskar Bätschmann (b. 1943) take the aesthetic experience as a starting point for interpretation, and examine the interrelationship between aesthetic experience, theory, art history, and the practical work of an artist. ¹⁶ The art historian Gottfried Boehm is also interested in hermeneutic perspectives and the history of ideas: he

coined the phrase "iconic turn" to describe the proliferation of visual images in the twentieth century and their increasing centrality in cultural practice. Boehm's contributions to hermeneutics and art history include the edited collection *Was* ist ein Bild? ("What is a Picture?", 1994).¹⁷

Some of Mieke Bal's recent writing also suggests a hermeneutic approach to art history, especially at the points where the hermeneutic circle and semiotics cross. In Quoting Caravaggio: Contemporary Art, Preposterous History (1999), Bal provocatively argues that the work of art actively produces the viewer's subjectivity. She asserts that the work of art "thinks" culture: like many other art historians, she sees art as actively shaping its social and historical context, rather than merely reflecting it. However, whereas traditional art history sees the artwork's cultural context as fixed historically at its point of creation, Bal's art objects produce interpretations of the culture they occupy, including the present, where they may exist as museum objects or reproductions. To make her point, Bal focuses on images in which contemporary artists, such as Andrés Serrano and Carrie Mae Weems, use visual techniques that are akin to Caravaggio's. These artworks suggest a kind of "preposterous history" composed of scraps and fragments of other discourses, in which the image that comes later in some ways gives rise to the earlier. 18

Practicing hermeneutic art history

In practicing hermeneutic art history, you would focus on your process of interpretation. Start from the idea that history is not recovered information:

- ▶ What questions am I asking? Why am I asking them?
- ► How do these questions relate to contemporary art-historical practice? Or to other sources of ideas and inspirations?
- ▶ In what ways do my questions stem from my previous understandings of this work or its context? In what ways are these questions very much of my moment? How do my questions, or my process of interpretation, differ from others at other points in time?
- ► In what specific ways are these questions generated by my engagement with the work of art itself?
- How can I reframe my understanding so as to be able to see this work of art or issue as part of other wholes, or as a whole rather than a part?

I'll take a difficult, and potentially emotional, example to discuss how the context of the present shapes our interpretation of the past, and to explore questions that might reveal how objects from the past actively shape the present. I would strongly suspect that there are few readers of this book who can look at an image of the New York World Trade Center (Figure 5.2) without thinking about the tragic events of September 11, 2001. So there's no way of interpreting the architecture of the World Trade Center, really, without taking that "present" into account. It's a situation that foregrounds, in a very visible way, our inability to be objective about the past: there's no way of being some kind of disembodied neutral eve at this point in history when viewing a photograph of the World Trade Center before its destruction. Similarly, the Libeskind model for rebuilding the complex (Figure 5.3) makes reference to the original Center's architecture, and to the events of September 11, and so must strongly influence our view both of those destroyed buildings and of the tragedy itself.

5.2 Minoru Yamasaki, World Trade Center, 1966–77. New York.

5.3 Studio Daniel Libeskind, Model for the new World Trade Center, 2002.

- ► How do the events of September II shape how I interpret the World Trade Center as architecture? Similarly, how does my understanding of the World Trade Center's architecture inform my understanding of September II? (Think here about the record-breaking height of the buildings, the way they fitted into the Manhattan skyline, the ideas evoked by their high modernist style, etc.)
- ► How do the events of September II shape the interpretation of the Libeskind plan? And vice versa? (The Libeskind plan, of course, wouldn't exist without September II, and it must take both the previous buildings, and the tragedy, into account. Think here about the incorporation of a memorial into the plan, and the reworking of the two towers.)
- ► How does the architecture of the destroyed World Trade Center shape our understanding of the Libeskind plan?
- ► How does the architecture represented by the new plan shape our understanding of the original World Trade Center?
- ► The discussions around the rebuilding of the World Trade Center may remind you of the fifth-century BCE debates around the building of the Parthenon on the ruins of the Acropolis, which had been sacked by Persian invaders in 480 BCE. To what extent might the Parthenon debates become part of your context, as an art-history sudent, for understanding the rebuilding of the World Trade Center?

Let me turn to another, less disturbing image (Figure 5.4), to explore hermeneutics further. A hermeneutic approach toward the process of interpretation can often be most successfully combined with other theoretical models in generating questions. You could, for example, consider this print from hermeneutic, feminist, and postcolonial perspectives combined:

▶ What kind of pre-knowledge do you bring with you to the analysis of this image? The image of the geisha is highly charged and subject to numerous stereotypes, especially in cross-cultural contexts—in the West, she becomes a beauty, a courtesan, a prostitute, the embodiment of "the mysterious Orient." How do such stereotypes affect your interpretation of this image? How does this image support or undermine such stereotypes? How does your response to these stereotypes, and to such an image, change, depending on your own cultural background?

5.4 Kitagawa Utamaro (1753-1806), Geisha with Samisen, from the series Daughters of Edo Who Chant Drama. circa 1805. Woodblock print.

Utamaro presents this woman in close-up as an exquisite object of contemplation—her beautiful kimono, impeccable coiffure, and elegant instrument are designed to appeal to the viewer. How does your understanding, from a feminist perspective, of the workings of the (male) gaze affect how you interpret this image? How does your experience as a filmviewer affect how you view this close-up from the past? Do ideas about woman as spectacle, as object of the gaze, shape your interpretation?

Structuralism and post-structuralism

Structuralism emerged in France in the 1950s and 1960s among anthropologists, sociologists, and literary theorists who took as their model the linguistics of Ferdinand de Saussure (see Chapter 2). Saussure saw language as a network of structures that could be studied if one broke them down into their component parts—such as letters or words-which could then be defined by their relationship to each other. Structuralists argued that this Saussurean concept of language structure provided a model for the analysis of many different kinds of cultural production, from myths to kinship networks to literary genres. Structuralism, therefore, views cultural practices as being made up of a system of underlying structures.

Culture as structure

The French anthropologist Claude Lévi-Strauss (b. 1908) made major contributions to the development of structuralist thought. He had worked in the Amazon as a young anthropologist and had begun, in the light of the cultural sophistication he encountered there, to re-evaluate his concept of "primitive" peoples. During the Second World War, as a refugee living in New York, Lévi-Strauss met the structural linguist Roman Jakobson, whose work had a profound influence on him.

Lévi-Strauss analyzed kinship, myths, totems, and other cultural phenomena as if they were language systems. He argued that such phenomena were built according to structures inherent in the human mind, structures that cut across cultural differences. So, for example, he argued that even though myths seem to vary widely from culture to culture, they are, in fact, merely variations on basic themes (or structures): "a compilation of known tales and myths would fill an imposing number of volumes. But they can be reduced to a small number of simple types if we abstract from among the diversity of characters a few elementary functions."19 Lévi-Strauss explained that myths, like languages, are created from units that are assembled according to known rules. In Saussurean linguistics, these basic elements of language (a letter, sound, or word) are called phonemes, so Lévi-Strauss coined the term mytheme to refer to these basic units of mythology.²⁰ Of course, in the end, what's important is the larger set of relations contained in a myth, not simply the relationship between the signifier and signified in a particular mytheme, for, as Saussure noted, "normally we do not express ourselves by using single linguistic signs, but groups of signs, organized in complexes which themselves are signs."21

Like language, which is constantly changing, myths aren't entirely preprogrammed according to their structures. Myths, as they are retold, change in various ways: they can be expanded or edited, paraphrased or translated, and elements of the story can be emphasized or de-emphasized. In this way, myths have both synchronic and diachronic aspects. The synchronic is the unchanging, basic structure of the myth; the diachronic is the specific telling of the myth at any particular time. (The synchronic/diachronic divide corresponds to the Saussurean idea of language and parole, or language and speech.)

French cultural critic Roland Barthes applied structuralist analysis to contemporary Western culture, noting that such struc-

tures were not only characteristic of so-called primitive societies, but also of modern industrial societies. In Mythologies (1957), Elements of Semiology (1964), and The Fashion System (1967), he examines the structural units of cultural practices in diverse arenas, from advertising to clothing. He argued that popular icons could be interpreted in just the same way as Levi-Strauss's myths, for a myth is something that "transforms history into nature." Myth is read as true and non-ideological—as if its representations, the relationships between its signifiers and signifieds, were natural instead of constructed. For Barthes, this means that myths can be used to justify dominant beliefs, values, and ideas. But where Lévi-Strauss insisted on the scientific nature of his structuralist method, Barthes approaches cultural analysis as a form of play.

Like Barthes, many structuralists address a wide range of cultural practices, including the visual arts as well as religion, cooking, or sexuality. The English anthropologist Mary Douglas (b. 1921), for example, in her celebrated book Purity and Danger: An Analysis of the Concepts of Pollution and Taboo (1966), emphasizes the importance of looking at the larger context of any cultural practice, observing, as the Earl of Chesterfield (1694–1773) so famously did, that dirt is only matter out of place.²³ The soil in a flower bed may be admired as fertile loam, but as soon as a careless gardener tracks it into the house, it becomes dirt that must quickly be swept up. As scholars we don't want to locate ourselves either in the flower bed or in the house—we need to encompass both viewpoints on soil.

Binary oppositions

Lévi-Strauss says that myths are important because they provide a logical model capable of overcoming contradiction. How is it that we live in a world that encompasses life and death? Beauty and ugliness? Selfishness and altruism? Violence and peace? Myths seek to explain these opposing concepts because, Lévi-Strauss asserts, every culture organizes its view of the world through pairs of opposites, and the idea of binary oppositions is central to structuralist thought.²⁴ Although the term binary oppositions may be unfamiliar to you, the idea surely isn't: black/white, male/female, rich/poor, dark/light, old/young, right/left, healthy/sick, public/private, and—thinking back to the previous chapter—Self/Other.

Structuralists emphasize the fundamental nature of these binary divisions to human thinking, seeing them as part of the "deep" or hidden structure of human creations. Like many other aspects of structuralist analysis, the emphasis on binary oppositions derives from Saussure's work. Saussure noted that we define signs in relation to each other: a working definition of "healthy," for example, is "not sick." These paired opposites, known as antonyms, are practical and useful because they help us sort out our experiences.

Binary oppositions don't only exist alone, in isolated pairs. Instead, they link up, or align, with other binary pairs, to create "vertical" as well as horizontal relationships. Lévi-Strauss discussed this in terms of analogies, which enable us to see some oppositions as metaphorically resembling other oppositions ("edible" is to "inedible" as "native" is to "foreign"). Units within the system have meaning only in relation to other units, and can be analyzed only in binary pairs; according to Lévi-Strauss, you should look not at why A is A, but at how A is to B as C is to D.²⁶

Binary pairings aren't always equal: often, one term is valued more highly than the other, an idea that Lévi-Strauss explored in The Raw and the Cooked (1964). For example, in the pair healthy/sick, we would typically pick out the term healthy as the preferable term. Structuralists and semioticians often call the preferred term in the pair the unmarked term, while the less desirable term is the marked term.²⁷ Although the two terms can only really be defined in relation to each other—neither one makes sense without the other—it can often seem as if the unmarked term is independent of the marked term, as if it doesn't need the marked term to make sense. To go back to the healthy/sick pair, when you've got the flu you most appreciate how it feels to be healthy, while when you're feeling well. you don't think much about how it feels to be sick. Structuralists point out that the unmarked term can appear to be universal, timeless, fundamental, original, normal, or real while the marked term seems to be secondary, derivative, dependent, or supplementary.²⁸ But this is an illusion: the secondary term, although considered marginal and external, is essential to the existence of the primary term. The unmarked term is "transparent" and its privileged status isn't immediately evident, while, in contrast, the deviance or inferiority of the marked term is immediately obvious.

Intertextuality and the death of the author

In Chapter 4, under reception and reader-response theory, I discussed those theorists who focused on the reader's and viewer's experience of the text or the image, arguing against the idea that the primary goal of the reader or viewer was to recuperate the

author's or artist's intentions. Similarly, structuralists and poststructuralists argue that the concept of authorship—the idea that individual genius and expression determine the work of art—is itself a cultural construct, a legacy of the Renaissance which reached its peak in the Romantic era. Instead, they see texts and images as works that are embedded in a web of cultural representations, where the reader's (or viewer's) context, the patterns and conventions of representation with which she is familiar, are as important as the author's or artist's intentions.

Again, the ideas of Saussure were important in this development. Saussure emphasized that language is a system (or structure) that pre-exists the individual speaker: communication, therefore, always employs pre-existing concepts, patterns, and conventions. Structuralists refer to the subject as being spoken by language—Barthes went so far as to say that "it is language which speaks, not the author; to write is . . . to reach the point where only language acts, 'performs,' and not 'me.'" ²⁹ Barthes ultimately moved away from rigid structuralism, coming to understand that writing was not a process of recording pre-formed thoughts and feelings—that is, working from signified to signifier; instead, writing meant working with the signifiers and letting the signifieds take care of themselves. There are not fixed, pre-given meanings for Barthes, for he notes that "writing ceaselessly posits meaning ceaselessly to evaporate it."³⁰

The notion that language pre-exists the individual speaker was part of a larger structuralist rejection of the humanist idea of the autonomous, thinking, coherent, integrated, human subject—an idea that had already been questioned by psychoanalysis (see Chapter 4). The humanist tradition holds, of course, that the human subject can know the world through rational thinking and through language that is fixed and conveys fixed meanings. In art history, this leads to an emphasis on the artistic genius as the center figure in cultural production, so that the scholar's primary goal becomes that of uncovering the artist's intentions.³¹ Of course, for the artist, her intention to communicate and what she intends to communicate may be important to her as an individual; however, meaning, in a larger cultural sense, cannot be reduced to her intentions. An artist may, for instance, communicate things without intending to do so.

In this spirit, Roland Barthes dramatically declared that "the birth of the reader must be at the cost of the death of the Author." 32

According to Barthes, the author doesn't endow the text with organic unity. Instead, the work of art or literature is an artifact that brings together any number of codes available in the artist's or author's culture. As articulated by Barthes, Julia Kristeva, and others, the concept of intertextuality reminds us that each text exists in relation to other texts, to other cultural expressions—texts owe more to other texts than to their own makers. For Kristeva, the text is really an intersection of texts in which we read yet another text; the act of reading is in this sense also an act of creation.³³

Post-structuralism

Post-structuralism refers to the theoretical movement that grew out of structuralist theories. Art historian Jonathan Harris notes that we can take this "post" in two senses—as "over/finished/ after," or as "in light of/in relation to/meaningful in terms of."³⁴ The trend toward post-structuralism occurred because of some problems with structuralist thought. Structuralism was, according to some critiques, ahistorical: if structures are always already there, what do we make of class struggle or feminist struggle in the context of this theoretical framework? How do we account for social and cultural change? In addition, structuralism often assumes the presence of an ideal reader/viewer and doesn't take the experience of actual readers or viewers into account. Many of the same theorists worked in structuralist and post-structuralist modes, and, despite a tremendous diversity of perspectives, post-structuralists share fundamental assumptions about language, meaning, and subjectivity.

The Russian linguist Mikhail Bakhtin (1895–1975) pointed to some of these problems early on, arguing against a static and ahistorical model of structures. Bakhtin's life as a scholar was marked by political upheaval, and he addressed the social and cultural issues raised by the Russian Revolution and Stalinism. For Bakhtin, language was always ideological—it was always rooted in struggle and the social conditions of speaking.³⁵ Bakhtin says that theories of language have always postulated an isolated, single speaker, whose utterances create unique meaning. He calls this monologic language, because it seems to come from a single, unified source, and contrasts it with "heteroglossia," the multiple forms of speech that people use in the course of their daily lives.³⁶ So, for example, you may have very different ways of speaking with the random people that you encounter daily—from the waiter who takes your breakfast order to the police officer who stops you for

speeding. These different ways of speaking use different vocabularies, sentence structures, accents, even tones of voice.

Bakhtin points out that monologic language is centripetal: the speaker of monologic language is trying to push all the varied elements and forms of language into one single form or utterance, coming from one central point. Monologic language requires one standard language, an "official" language that everyone would be forced to speak (the ongoing debate over the validity of Ebonics, or Black English, is a good example). Heteroglossic language, on the other hand, tends to be centrifugal, moving language toward multiplicity by including a wide variety of different ways of speaking, different rhetorical strategies and vocabularies. Both heteroglossia and monologia, Bakhtin says, are always at work in any utterance.³⁷ This concept is critical for helping us to recognize, value, and interpret the different ways of speaking in relation to and via the visual arts—whether that's studying home-made quilts as well as the Sistine Chapel ceiling, or researching the experience of workingclass families at museums as well as the work of Clement Greenberg or other celebrated art critics.

Post-structuralists further argue that structures aren't some kind of universal, timeless truth just waiting to be uncovered. Rather, structures are fictions that we create in order to be able to interpret the world around us. Kristeva argued that a text—or, we could say, a cultural practice—is not a "structure" but a process of "structuration."³⁸ Similarly, Jacques Derrida, an important post-structuralist theorist who will be discussed in detail below, argues that, in texts, structures are really dependent on the conventions of writers. For post-structuralism, meaning is a lot less stable than structuralism would suggest. Post-structuralism emphasizes the constant slippage in the play of signs, in the relations between signifier and signified.

Post-structuralism has important implications for the practice of history—and art history. Post-structuralist historians argue that history isn't just waiting out there to be found in documents and images. When we write history, the context that is important is not only the past but also the present, which conditions what we find and how we interpret it (a notion that hermeneutics also recognizes). Art historian Norman Bryson has pointed out that the evidence for historical interpretation is vast—potentially limitless.³⁹ Stop to think about this, and you'll realize that the shape of the final interpretation can't really come from this enormous mass of

evidence: it has to come from the perspective the art historian brings to the process of interpretation. A good example of this is the relatively recent scholarly interest in issues of gender and sexuality: these issues were always there, but it took the right "lens" to focus on them.

Foucault's history: knowledge is power

What we need is awareness, we can't get careless
You say what is this?
My beloved let's get down to business
Mental self defensive fitness
(Yo) bum rush the show
You gotta go for what you know
Make everybody see, in order to fight the powers that be
Lemme hear you say . . .
Fight the Power

Public Enemy, "Fight the Power" (1990)

The work of the French historian, philosopher and post-structuralist theorist Michel Foucault (1926–1984) has had a profound influence on the humanities and social sciences since the late sixties. Although he has been attacked variously as a poor historian, an ideologue and a charlatan, I believe there is a great deal to be learned from his work.

Foucault, as a philosopher, starts from a fundamental question: who are we today? To answer this question, he finds he also has to ask, how did we get to be this way? History, effective history, is for Foucault a genealogy of the present.⁴⁰ We don't trace from the past to the present; instead we trace from the present to the past, examining the choices and accidents that resulted in the present. There is no inevitable march of history, no model of progress, there are no continuities: history is a process of leaps, gaps, acccidents, ruptures, and disjunctures, and the task of the historian is to focus on these.⁴¹ For Foucault, the historian isn't someone who connects the past to the present; instead, the historian disconnects the past from the present, challenging our sense of the present's inevitability and legitimacy.

History is about asking who are we in terms of our knowledge of ourselves, about inquiring into the political forces that shape us, and investigating the sense of our relationship to ourselves—the ethical choices we make to govern these internal relationships. This means that history has to focus on tracing the effects of power

in society, how it acts, who has access to it. Instead of the story of great men and battles, history is about institutions, ideas, beliefs, and practices; it is about ordinary people caught in the web of power relations. Foucault's work focused on topics in European history that hadn't ever been framed in quite this way: the history of sexuality, the history of prisons, the history of insanity.

Though power is a critically important concept for Foucault, it is elusive and not easily defined, taking on multiple associations and meanings in different works. Power is hard to grasp conceptually, because it is itself plural, fragmentary, and indeterminate. At its core, for Foucault, power is "a multiple and mobile field of force relations where far-reaching, but never completely stable, effects of domination are produced."⁴² At the same time, it is historically and spatially specific, working through normative values, social institutions, and politics (for more on normativity, see Chapter 3). Moreover, power isn't only at issue in the State or the law: it permeates all aspects of society and all relations, from the economic to the spiritual, sexual, or artistic.

Foucault focused in particular on the idea of discourse, or discursive practices. How do we present and deploy knowledge in society? How does knowledge relate to power? How is power invested in particular institutions, theories, or ideologies? The Archaeology of Knowledge (1974) explores the conditions that allow discourses to develop. This concept of discourses includes not only texts, terminologies, images, and concepts, but also cultural practices and artifacts such as maps, calculations, and experiments. Discourses collect in "fields," intersecting formations or strands of knowledge. ⁴³ Discourses are powerful because they represent what is asserted as truth by the people and institutions who control language, and reality can't exist outside these discursive frameworks.

Through this work, Foucault became particularly interested in the ways that society seeks to control, manage, and monitor human bodies, what he calls "the political technologies of the body." ⁴⁴ In Discipline and Punish: The Birth of the Prison (1995), Foucault traces the history of the development of prisons genealogically. We may think from our cultural perspective that prisons have always been around, but they've only existed a few hundred years. Foucault looks at the eighteenth century, when penal systems began to move away from punishments such as whipping or branding to reform as their primary goal. ⁴⁵ This necessitated the building of prisons where the bodies of offenders would not be

punished, but regulated, controlled, and reformed so that they would learn not to transgress again.

Foucault also broke new ground in his willingness to look at sexuality as a social construct, rather than innate or natural, and as an instrument of the regimes of power (see also Chapter 3). The first volume of his History of Sexuality (also published as The Will to Knowledge) opens by questioning the widely accepted belief that our post-Victorian culture represses sexuality. ⁴⁶ On the contrary, Foucault argues, our culture engages in discourses that actively produce sexuality and sexed subjects. This is because sexuality is a key "transfer point" for relations of power in multiple directions and between many partners: men and women, young and old, priests and laity, etc. ⁴⁷ He argues that since the eighteenth century, the web of knowledge/power relations centered on sexuality has relied on four essential strategies: the "hysterization" of women's bodies, the "pedagogization" of children's bodies, the socialization of procreative behavior, and the psychiatrization of perverse behavior. ⁴⁸

Structuralism, post-structuralism, and art history

Both structuralism and post-structuralism have been enormously influential within art history, especially as their development has coincided with an interest in semiotics and issues of social context. For example, French art historian Hubert Damisch has used structuralist approaches in his work on Renaissance art, suggesting that the strict linear perspective of Renaissance painting is countered by the use of clouds and other hazy atmospheric effects. ⁴⁹ In some ways, elements of structuralist thought have long been present in art history— Heinrich Wölfflin's use of binary oppositions to perform visual analysis (linear/painterly, open/closed forms) is a good example. ⁵⁰

Post-structuralism, in particular, has required a different way of thinking about works of art, representation, and, especially, mimesis (the imitation of reality). As we've seen, post-structuralist theorists of language have argued that there is no obvious or necessary connection between language and what it refers to: such relationships are cultural, based on human choices and conventions. Post-structural theorists and art historians have extended such arguments to the visual arts. For example, Camera Lucida: Reflections on Photography (1982), by Roland Barthes, is an eloquent meditation on portrait photography and the relationship between the photograph as signifier and the sitter as signified. Barthes

notes the peculiar way in which we do not separate the photographic representation from the person represented.⁵¹ As Keith Moxey says in The Practice of Theory: Poststructuralism, Cultural Politics, and Art History (1994), visual forms are not mimetic, they are not a means by which the artist captures the qualities of the real world; instead, visual forms are value-laden interpretations of the world which vary from culture to culture and period to period.⁵²

Although art history has traditionally taken a single artist's work, a period, or a culture as its focus, post-structuralism points out the artificiality of those interpretive frames, even though they may seem natural or inevitable. It may be more provocative to trace a particular motif or a practice such as iconoclasm, or to group artists or images in new ways, as Barthes did in Sade, Fourier, Loyola, which makes some unexpected connections among these three very distinctive thinkers.⁵³ In post-structuralist art history, instead of simply cataloguing an artist's "influences" to see what works from the past or present interest her, the focus shifts to asking why she's choosing particular artists and images—asking what she is seeking to do in reusing and reworking visual images in her present context, and tracing the effects of these choices on the viewer.

Foucault's ideas about power, the political technologies of the body, sexuality, and the nature of history have had a strong impact on art-historical practice. Although Foucault is primarily associated with literature, philosophy, and history, he did write about art (and wasn't one to pay too much attention to disciplinary boundaries anyway).⁵⁴ One approach is to examine art's institutions—such as museums or art galleries—just as Foucault examines mental hospitals and prisons (see also Chapter 3).⁵⁵ Nicholas Mirzoeff draws on Foucault's work to trace the "body-scape"—the body as a cluster of multiple, flexible signs—to explain how different versions of the ideal figure have been created in art.⁵⁶

Practicing structuralist and post-structuralist art history

This photograph (Figure 5.5) was taken for the French physician Jean-Martin Charcot (1825–1893), who studied nervous illnesses. Charcot worked at the famous Salpêtrière hospital for poor women in Paris, and Freud, among others, studied with him. Under Charcot's direction, patients identified as hysterics were methodically photographed, providing skeptical colleagues with visual proof of hysteria's symptoms. These images provided the

material for the multivolume album Iconographie photographique de la Salpêtrière (1877–1880). The photographs are highly staged, and it is questionable to what degree the women depicted in them performed according to Charcot's expectations.⁵⁷

- ▶ What does this image tell us about the disciplining of the human body through the medical profession and the medicalization of madness? What does this image tell us about concepts of hysteria, of mental illness, at this time? What are the institutional and social contexts—the insane asylum, the medical profession, gender and class relations—of the image? (Foucault is an obvious reference point here.)
- ▶ What are the binary concepts at work here (sanity/insanity, hysteria/calm, genuine/performed, hysteria/arousal, etc.)? How is the implied viewer, the reader of the Iconographie—whom we might expect to be a white, heterosexual, professional man of the late nineteenth century—implicated in the construction of these binaries?
- ► What conventions (structures) of photography do we see at work here? How does the photographer—or the sitter, for that matter—challenge or restructure those conventions? What role did photography play in the creation of the category of hysteria?
- What narratives of power and ideology, what discursive practices, inform this image?
- ▶ Do the photographs reveal a tension between the idea, or diagnosis, of hysteria, and the particular patient's hysteria? This could be read as a tension between the langue and parole of hysteria, or between monologia (the authority of the physician)

5.5 Attitudes passionnelles, Iconographie photographique de la Salpêtrière, pl. XXIII.

- and heteroglossia (the multiple conditions experienced, and expressed, by the patients).
- ► Through techniques such as hypnosis, electroconvulsive therapy, and genital manipulation, Charcot instigated the hysterical symptoms in his patients, who often came to hate his treatments. Does any sense of this emerge in this image? Is the subject's resistance evident?

Deconstruction

[Deconstruction] is not the exposure of error. It is constantly and persistently looking into how truths are produced. Gayatri Chakravorty Spivak, "Bonding In Difference:

Interview with Alfred Arteaga" (The Spivak Reader, 1995)

Deconstruction is a word that is used—and misused—frequently. It often appears, inappropriately, as a synonym for "analyze" or "interpret," as in "Let's deconstruct this painting." As the Spivak quote above suggests, the term can also be wrongly used to mean finding out hidden "errors." Tossing around the word deconstruction may make some people feel intellectually hip, but it actually indicates a serious lack of engagement with this very specific, and complex, theoretical construct.

The French-Algerian philosopher Jacques Derrida (b. 1930) coined the term deconstruction to indicate a theoretical project that explores how knowledge and meaning are constructed.⁵⁸ He adapted the term deconstruction from Martin Heidegger, who used several different terms (including destruction and retrieve) to indicate his complex relationship to philosophy's past. Heidegger felt that he was simultaneously critical of Continental philosophy and deeply attached to it. So, too, is Derrida deeply attached to the text and yet critical of it. Derrida points out that even though we typically think of language as conveying meaning, language can simultaneously convey both the presence and the absence of meaning.⁵⁹ That is, what any given statement tries not to say may be as important as what it does say. The shifting play of signs makes this tension between meaning and non-meaning possible (see Chapter 2). Deconstruction starts from the idea, articulated by a number of post-structuralist thinkers, that structures are not some kind of deep truth waiting to be uncovered, but are themselves cultural constructs created through discourse. There is no objective, universal way to achieve knowledge or to claim truth.

In 1967 Derrida laid out his central ideas with the publication of three important books: Speech and Phenomena, Writing and Difference, and Of Grammatology. Like other post-structuralists, Derrida challenges the metaphysical certainty that the speaking subject puts forth a consistent, intentional, and rational point of view, and a unified meaning that directly refers to a pre-existent reality. For Derrida, deconstruction is a necessary strategy of reading because the idea of rationality is so deeply embedded in Western thinking and language—and yet completely unacknowledged.60 In this early work especially, Derrida challenged the binary oppositions (nature/culture, man/woman) that are accepted as customary and foundational in a given context. By examining these basic structures of the argument, Derrida exposes them as human constructions, rather than the essential truths they pretend to be: "the reading must always aim at a certain relationship, unperceived by the writer, between what he commands and what he does not command of the patterns of the language that he uses."61 We can then ask why these constructs were put into play in the first place. Why might a text construct culture as superior to nature? Or men as superior to women?

A key idea for Derrida is différance. Although Derrida insists that différance is not a word or a concept, its usage over time in effect makes it seem like both. Différance is a (mis)spelling of the French word différence, which is roughly equivalent to the English "difference." Différance, however, refers to the idea that signifiers and signifieds are not identical: they differ from each other, there is a space between them.⁶² Signs not only differ, they also defer (différer) to many other signs as part of the endless chain of signifiers. The differing and deferring of signs means that every sign repeats the creation of space and time. In the end, there can be no ultimate truth, because truth can only exist by virtue of difference: it can't be absolute or universal because it can't be outside time and space (which are both essential to the creation of meaning). Any truth is therefore contingent, relational, and partial. Signs only signify, or create meaning, via difference (just as in Lacanian psychoanalysis, the Self exists only because of its relationship to the Other). If a word signifies, it signifies by differing, and what it differs from becomes a trace—an inevitable, absent part of its presence.63 In this view, culture becomes a network of relations: differences, displacements, traces, deferrals.

Although Derrida insists that deconstruction doesn't provide a methodological program for analyzing texts, in the three early works cited above he developed a practice of close reading that has been influential among cultural critics in many fields. Derrida's later works, such as The Truth in Painting (1978) and The Post Card (1980), often experiment with new relationships of theme and form rather than the systematic treatment of language and interpretation. ⁶⁴

Art history and deconstruction

Much of what Derrida has to say about texts or textual representations can also be adapted to visual representations. For Derrida, art is critically important, for it is capable of challenging the metaphysical foundation of our civilization. Works of art may be able to point a way out of logocentrism because they transcend the logic of sameness, they foreground the play of différance. The work of art itself deconstructs the quest for presence and truth, or truth as presence (remember that Western philosophy's traditional goal has been the pursuit of Truth). If deconstruction challenges the dangerous idea that we can know the world with any clarity—much less express and act on what we know with any clarity—then visual arts are a prime example of this indeterminacy, of the open play of signifiers.

Derrida has written several books that deal directly with the visual arts. The Truth in Painting's most celebrated essay examines art historian Meyer Schapiro's response to Heidegger's essay "The Origin of the Work of Art" (1935), which addresses van Gogh's painting of two shoes.65 "This equipment," Heidegger wrote, "belongs to the earth, and it is protected in the world of the peasant woman . . . Van Gogh's painting is the disclosure of what the equipment, the pair of peasant shoes, is in truth . . . This entity emerges into the unconcealment of its being . . . "66 For Heidegger, the image of these battered shoes evokes, and brings into being, the world of the peasant; but Schapiro attacks this as a dangerous sentimentalism of a kind that the Nazis employed so ruthlessly. He goes on to argue that these were not peasant shoes but the shoes of the urbanite Van Gogh himself. Derrida argues that because Heidegger had ties to the Nazis, Schapiro's analysis was an act of revenge—and restitution.

For Derrida, this exchange raises a host of interesting questions. To whom does the painting belong? Why did Schapiro feel compelled to return it—restitute it—to its "rightful" discourse?

What is restituted in a painting anyway? Does mimesis—the representation of the shoes in this case—restore the shoes to us? If a painting renders something, in the sense of representation, does it then also render it to its owner (the viewer, painter, or subject)? In this way, the problem of mimesis parallels the problem of ethics. Derrida goes on to question why Heidegger and Schapiro both assume that the painting represents a pair of shoes, rather than simply two shoes. To respect the work of art is to avoid jumping to conclusions, but as soon as we assert that this painting represents a pair of shoes (a right and a left shoe that go together), Derrida declares, we have already started to arraign the artwork.

And yet this kind of "arraigning" of the artwork, which Derrida finds so problematic, is fundamental to art-historical practice. From Vasari to Panofsky, art historians have focused on explanation—the idea that the work of art is logical and comprehensible, that it is mimetic and represents reality. In the spirit of deconstruction, some art historians have deconstructed the binary oppositions of the discipline itself by emphasizing art's resistance to interpretation, a resistance that art history would be all too happy to push to the margins (after all, if art really can't be explained, then there wouldn't be any need for art historians).

Art historian Stephen Melville has grappled with the implications of deconstruction for the study of visual objects, noting that "The question of the object in and for deconstruction . . . is a question not about what the object is, but about how or, even more simply, that it is."67 Melville is concerned that once deconstruction recognizes itself in the object, it must be careful not simply to replace it with a discursive representation that reduces the object to a "mere" theoretical construct. That is, the threat that the object is but a construct of theory surfaces once theory attains self-recognition in the object. If objects are objects, it is because they resist (object to) theory on some level. At the same time, however, the "interdisciplinary framing of the object" is not an imposition on the object but "a not wholly proper effect of the object itself." The object's effects stem not from its essence, but from its relations with the subject of art history: the object prefigures its own historiographical and theoretical accounts.

Practicing deconstructive art history

Derrida's rejection of the idea that deconstruction can be applied programmatically to the study of visual or textual representations hasn't stopped any number of scholars from trying it. In this section, I'll try to be mindful of Derrida's objections while developing lines of questioning informed by the processes of deconstruction.

Edmonia Lewis (circa 1840s—circa 1890) was an extraordinary person, a woman of African-American and Native-American descent who had a passion for art, and particularly sculpture. In spite of the many obstacles she faced, she was able to train professionally as a sculptor. For many years she kept a studio in Rome, often selling her work to wealthy Americans traveling abroad.

- ► What are the binary oppositions at work in this sculpture (Figure 5.6) (male/female, black/white, enslaved/free)? If the sculpture represents freedom, for example, how does slavery also exist here as a trace?
- How does this sculpture navigate the binary terms man/woman? Which term is prioritized? Which is subordinate? How is this established visually? How does this hierarchical pairing exist in relation to other hierarchical pairs supposedly challenged by the sculpture (white/black, free/enslaved)? Does the prioritizing of male over female undermine other readings of the sculpture? How stable are these oppositions?

5.6 Edmonia Lewis, Forever Free, 1867. Marble. Howard University Art Gallery, Washington, D.C.

- Also here, as a trace, are the crude racist representations of Africans and African Americans that circulated widely in the nineteenth century; you could say that the image defers or refers (différer) to them even in their absence. Edmonia Lewis draws on the conventions and materials of classical sculpture to counter this, to endow these figures with dignity. And yet—does that not simply justify the canon of aesthetics that defines blackness as ugly in the first place? Does Lewis's representational strategy successfully challenge the underlying hierarchy of white over black aesthetics? What does this image say about the (im)possibility of making a non-racist image in the nineteenth century?
- Also implicit here are the ideas of Black Artist and Woman Artist and Black Woman Artist. How does the virtuosity of this piece speak to those statuses? Like hermeneutics, or any of the other stances discussed in this chapter, deconstruction is often combined with other theoretical approaches, and both feminism and critical race theory may help you here.

5.7 Installation view of Parthenon Marbles in the British Museum, London, looking toward the East Pediment figures.

A deconstructive reading of the Parthenon sculptures (Figure 5.7) might address issues pertaining to their interpretation and ownership:

▶ In presenting the Parthenon (Elgin) marbles as great masterworks and as "our" heritage, the British Museum celebrates Greek culture as a universal human value, and as the wellspring of Western civilization. What is the logic of those binaries—past/present, civilized/savage, universal/particular, apex/nadir, ours/theirs, Western/non-Western? What gets pushed to the margins in constructing this argument?

► Greece has formally asked for the Parthenon sculptures to be repatriated, arguing that they were taken out of the country illegally in the early nineteenth century. The British Museum denies the validity of the claim, and points out that one of the Museum's three founding principles is that the collections should be "held in perpetuity in their entirety." If deconstruction is ultimately concerned with truth claims, politics, and justice, how might a deconstructive reading of the Greek and British arguments help illuminate the situation?

Postmodernism as condition and practice

Postmodernism is an important contemporary critical and creative movement. But before we can really delve into postmodernism, we have to ask: what is modernism?

Defining modernism(s)

In art history, we may use the terms modernism or modernist to designate a time period, an artwork or group of artworks, a culture, or an approach to the interpretation of culture. The beginnings of modernism, in the art world, are usually located in France in the 1850s with the work of such artists as Gustave Courbet and Edouard Manet and the writer Charles Baudelaire, and modernism is generally recognized as coming to full flower in the first half of the twentieth century

Modernist artists and writers found the inspiration for their art in the ever-changing present, in the dazzling spectacle of the city, and in the modern world. They deliberately rejected the idea that they should look to past traditions of art, as the academies taught. This break with the past meant that modern artists had to invent forms, compositions, media, and signs that would be adequate to express the novel and breakneck pace of the modern world. So when Manet decided to paint a female nude, he didn't produce a sentimental, soft-focus image of a pseudo-Greek goddess; rather, he painted a vigorous modern woman, a prostitute—complete with bouquet-bearing servant, a joke of a cat, and a challenging stare. In a similar tradition-breaking spirit, in the early twentieth century Marchel Duchamp signed a urinal "R. Mutt" and hung it on a gallery wall; Wassily Kandinsky delved into abstract form; and the Surrealists delved into the unconscious.

Along with modernism, the notion of the avant-garde comes into play—the idea of being self-consciously at the cutting edge, of

creating and seeking out the new, of attacking the established institutions of art and culture. Duchamp made the urinal precisely to shock the art-viewing public, consciously rejecting past traditions of representation and striving toward something that was more direct, honest, and fundamentally more legitimate. Artists worked to create new forms and media—new images, and new social orders, to be built on the ruins of the old. And yet, in spite of its revolutionary aims, in many ways this modernist movement displaced one authority with another, as one overarching view of culture and cultural production displaced another.

At the same time, modernism became associated with a particular way of telling the history of art, a particular narrative of art history. It was a unitary, totalizing narrative—one that emphasized the figure of the heroic (male) artist, the centrality of Europe (and, much later) American cultural production, one that traced a history of art from the ancient world to the present. Art history has been so preoccupied with European and American modernism that it has often overlooked modernist phenomena elsewhere. The modernist movement unfolded very differently in Africa, Asia, the Pacific, and Latin America than it did in Europe or the United States. Modernism didn't just happen in Europe, and it didn't just happen there first and then export itself whole to other parts of the world (in spite of the mechanisms of colonialism). There were modernist practices both distinct from and in dialogue with Western modernism.

Adding the "post" to modernism

Does the "post-" in postmodern mean "after" modernism, "in light of" modernism—or both? Does postmodernism offer a critique of capitalism, or is it the cultural expression of capitalism's ascendancy? When did postmodernism start, anyway?

The word itself first appeared in the 1930s, and gained currency in literary criticism in the 1950s and 1960s, but it didn't really take hold until the seventies and eighties as a way of talking about forms of literature, music, and visual arts that departed from modernist conventions. The term first came into wide use to describe architecture that found its inspiration not only in Modernist structures but in an eclectic array of buildings and motifs from the past. In painting, sculpture, and other media, postmodernism is associated with a rejection of the rigid truths and hierarchies of modernism; an interest in the past traditions that modernism rejected;

5.8 James Stirling, Neue Staatsgalerie, 1977-83. Stuttgart.

Stirling's art-gallery building for the city of Stuttgart combines classical references, in its proportions and use of windows and columns, with playful elements such as bright colors and undulating walls. The museum, Stirling once wrote, is a place "in which the styles of different eras are brought together as in a giant collage—so why shouldn't the building itself also be such a collage of architectural quotations?" Despite the building's innovative architectural forms, Douglas Crimp criticized it for perpetuating an outmoded and reactionary model of the museum's function.

pastiche, the varied mixture of elements and motifs; and a return to figurative imagery. Good examples are New York City's AT&T (now Sony) Building (1984), designed by architects Philip Johnson and John Burgee (b. 1933), James Stirling's Neue Staatsgalerie (1977–83, Figure 5.8) in Stuttgart, or Kenzo Tange's Tokyo City Hall (1991).

The term postmodern proliferated so quickly that you might understandably think of postmodernism only as a trendy style of architecture or interior design. But cultural critic Hal Foster argues that postmodernism is not just an artistic style but a condition of life in a media-saturated global village, in the context of the shifting class and culture formations of post-industrial societies. It constitutes a major challenge to ways of thinking about the world that have their origin in Enlightenment theories of rationality and progress. Foster's influential anthology The Anti-Aesthetic (1983) contains not only his own very useful overview of postmodern theory, but also key essays by Jurgen Habermas, Jean Baudrillard, Frederic Jameson, Rosalind Krauss, and others.⁶⁸ These critics explore postmodernism's critique of the central truths of modernism and they challenge dichotomies such as center/periphery, civilized/primitive, high art/low art, culture/nature, image/reality, innovation/tradition. As Huyssen points out in "Mapping the Postmodern" (1984), postmodern theory and cultural practice no longer automatically privilege the first term in such pairs.⁶⁹ There are, however, less optimistic views of postmodernism. The American literary critic Fredric Jameson (b. 1934), in Postmodernism, Or The Cultural Logic of Late Capitalism (1991), links postmodern culture to a new wave of American military and economic domination—"in this sense," he argues, "as throughout class history, the underside of culture is blood, torture, death, and terror."⁷⁰

Challenging master narratives

One of the major works of postmodern theory is the French philosopher Jean-François Lyotard's The Postmodern Condition: A Report on Knowledge (1979). Lyotard (b. 1924) argues that Western civilization's master narratives—those overarching truths that claim to explain everything-no longer work. He asserts that grand, totalizing theories such as humanism don't help us understand the constant flux of culture, its endless processes of synthesizing and resynthesizing forms and practices. No single explanation for culture is possible—culture can't be reduced, for example, to economic determinism alone, as some Marxists would have it, or psychic determinism, as some psychoanalysts might hold. Instead, Lyotard and others ask us to examine culture as a process rather than a thing, and they emphasize the social contexts that shape that process. Lyotard argues that, most of all, we must identify the master narratives that shape our culture and society, those narratives that conceal as much as they reveal, and that work to oppress as much as to enable human action. History and culture are not single narratives, in this view, but conversations which struggle to come to terms with the relations of power.⁷¹

In particular, postmodernists such as Lyotard reject the idea that the European tradition sets a universal standard for judging historical, cultural, or political truth. No tradition can speak with authority and certainty for all of humanity. Instead, a wide range of traditions can be valued for their particular ways of viewing the world. Traditions are not valued for their claims to truth or authority, but for the ways in which they serve to liberate and enlarge human possibilities. In this way, postmodernism, feminism, queer theory, and post-colonialism have much to say to each other, for, in challenging the primacy of Western culture, postmodernism opens a space for the politics of race, gender, sexuality, class, ethnicity, etc. Postmodern theorists share with Marxist theorists of

ideology the perspective that culture is just as important as economics in shaping human existence and identity, and is just as much a site of struggle.

Just as postmodernism decenters Western culture, so too it decenters the Western idea of the subject. One of the key master narratives challenged by postmodernism is the idea of the single, unified, whole subject speaking from one place with a sense of authority. Postmodernism shares the post-structuralist concept of the subject as fragmented and contradictory, and challenges the idea that human consciousness or reason are powerful forces shaping human history. The postmodern subject is fragmented, decentered, speaking from a particular place with only his or her own authority from a particular viewpoint. Andreas Huyssen reasons that postmodernism does not argue for the death of the subject, like post-structuralism, so much as work toward new theories and practices of speaking, writing, and acting subjects. Instead of celebrating (or negating) the individual subject, the emphasis is on how codes, texts, images, and other cultural artifacts and practices shape subjectivity.

Fragmentation, pastiche, and the simulacrum

Any number of discursive practices are related to postmodern art and culture. I want to treat three ideas here that are key for art history—fragmentation, pastiche, and the simulacrum.

As we've noted, postmodernism is often associated with pluralistic thought—the idea that there's no single correct way of seeing the world. In this context, the fragmentation of the subject replaces the alienation of the subject that characterizes modernism. So in modernism the subject feels alienated from the world around her-but at least, she has a way of knowing both herself and the world and recognizing the gulf that separates her from it. According to Fredric Jameson, the fragmentation of the subject develops because of the new ways of living in the world and occupying space that have developed in late capitalism. Whether we're talking about the architectural space of a building or the conceptual space of global relations, late capitalism has transcended the ability of the individual human body to locate itself, to organize its immediate surroundings perceptually, and to map its position in the vast, multinational network of communication and capital in which we're all caught. Late capitalism aspires to this hyperspace, an unprecedented vastness of scale.

Late capitalism is also marked by a focus on the recycling of old images and commodities, and postmodern art and theory challenge the very idea of originality, the very notions of progress and of the continual remaking of civilization. In this spirit, artist Cindy Sherman (b. 1954) posed herself in photographs modeled deliberately on film-stills, and her contemporary Sherrie Levine (b. 1947) simply rephotographed photographs by other artists. Jameson cites the artist Andy Warhol's work as a prime example of a world transformed into images of itself.

Postmodernism is concerned with the investigation of images in a number of realms, and in Simulacra and Simulations (1981) the French philosopher Jean Baudrillard (b. 1929) explores the simulacrum, the copy without an original. 72 Baudrillard points out that in the mass media there is no signified attached to the signifier: there is no reality, no thing that the signifier reproduces or represents. In this way, the simulacrum—the image—becomes the reality. Postmodern cultural critics have made a minor industry of analyzing such celebrities as Madonna, who are all image: between the PR machine, the make-up artist and image consultants, the studio remixes, the video manipulation, etc., who's actually there when it comes to Madonna? The emergence of the simulacrum threatens the very foundations of Western thought, which since the time of Plato has made a distinction between the original and the copy, the latter being inferior or of less value.

What's more, Baudrillard argues that there's no way of getting away from simulacra, because of mass media. Simulacra are everywhere, and they determine our reality, how we live and behave. They provide us with codes or models that tell us what to do, and we're passive before this onslaught. Baudrillard says that when the image is more "real" than any other "reality," where there is only surface but no depth, only signifiers with no signifieds, only imitations with no originals, we are in the realm of hyperreality. One of the best examples of such a hyperreality is Disneyland, which is a minutely created "reality" of things that don't exist in the "real world."

Modernism, postmodernism, and art history

Among its various other meanings, the term modernist can be used to describe a particular way of telling the history of art—especially modern art. Modernist art history is based on the kind of totalizing narrative that postmodernism critiques. In this view, art history focuses on Europe, especially urban centers such as Rome,

Paris, and Berlin. It proceeds according to a model of rationality and progress—all of art's history is a march toward the (inevitable) present. The rest of the world is largely ignored, and the focus is on male artists who are trained to produce high art: painting, sculpture, and architecture.

Postmodernist art historians have worked to replace this single master narrative with the practice of multiple histories of art. In particular, in telling the histories of modern art, the emphasis is on modernisms rather than the singular modernism, as art historians work to incorporate both regional and multi-national perspectives, as well as issues of race, class, gender, and sexuality. There is new attention to the distinctive modernisms of Asia, Africa, the Pacific, and Latin America, as well as a fuller range of visual arts, including "high" and "low" art. Good examples are Okwui Enwesor's exhibition catalogue, In/Sight (1996), which focuses on photography in twentieth-century Africa, and Enwesor and Olu Oguibe's edited volume Reading the Contemporary: African Art from Theory to Marketplace (2000).⁷³ Art historians also critically interrogate the foundational beliefs and practices of modernism—as in Rosalind Krauss's essay "The Originality of the Avant-Garde: A Postmodernist Repetition" (1081), in which she examines the beliefs about originality and masculine individualism that underlie the idea of the avantgarde.74

For art historians, postmodernism has prompted a reevaluation of the history of the discipline and our relationship to the art and art history of the past. A provocative analysis of this turn in art history was presented by German art historian Hans Belting (b. 1935) in The End of the History of Art? (1983).75 Belting argues that art history had experienced a split in the nineteenth century, when modernist artists turned away from the past. As a result, he says, we've developed two different ways of telling the histories of art, one for the pre-modern period and another for the modern period. Belting contends that art historians must bring these two approaches together, rejecting the idea of "art for art's sake" in favor of an awareness that art shapes and is shaped by cultural practices. In this way art historians will deconstruct the old binary oppositions between art and life, image and reality. Belting goes on to suggest that art historians must also take an interest in contemporary art, which, unlike modernist art, is grounded in intense historical and cultural awareness and no longer pretends to a totalizing narrative. We may not share Belting's faith in contemporary art, but his point is worth considering. At the same time as Belting's work was published in English, American art historian Donald Preziosi (b. 1941), in Rethinking Art History: Meditations on a Coy Science (1989), argued that the crisis art history experienced in the 1970s and 1980s was nothing new. The questions raised by post-structuralism, postmodernism, and by critical theory generally, could be traced to the very foundations of art history as an academic discipline.⁷⁶

Practicing postmodernist art history

Yinka Shonibare was born in London, of Nigerian descent. As an artist, he challenges easy binaries of geography, race, and artistic practice, exploring the power dynamics of colonialism. In this installation, Shonibare depicts a nuclear family of astronauts dressed in printed textiles. We often think of such textiles as quintessentially African, but these were actually designed and produced in the Netherlands and Asia. Practicing a postmodernist art history in relation to this piece might mean critiquing master narratives, and being sensitive to ideas of pastiche and the simulacrum at work here.

▶ Vacation (Figure 5.9) raises the idea of the future and Africa's place in the future. Where is the future located? And who is there? It's jarring to see "African" textiles in this context instead of some kind of high-tech NASA fabrics. What does this tell us about the contradiction between the idea of Africa and the idea of the future, at least for Westerners? Does Africa belong to the past and not the future? Are there any ways of bringing these two terms, Africa and future, together?

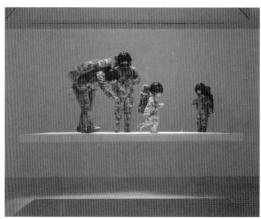

5.9 Yinka Shonibare, Vacation, 2000. Mixed media installation. Stephen Friedman Gallery, London.

- There's a tension here between the idea of the nuclear family on vacation and astronauts at work. Is this a futurist astronaut family, like the Jetsons? Can astronaut families go on vacation? In what kind of future world? Have the astronauts "gone native" by wearing African textiles, like a vacationing family? Does this question assume they're not African? Can this family be African? Some would argue that the nuclear family is an artifact of Western industrial capitalism, as opposed to the extended family, which is found in much of rural Africa and which we think of as "authentically" African.
- ▶ Do Baudrillard's ideas help you interpret this piece? To what extent are the figures here simulacra? Do they "represent" a signified?
- Questions of pastiche arise in this work as well—what are the multiple and seemingly disparate sources that Shonibare draws on?
- ► How might you interpret this image in relation to the intersections of postmodern and postcolonial theory?

Conclusion

Is postmodernism over? Are post-structuralism and deconstruction just passing intellectual fads? Is hermeneutics largely irrelevant now? How you answer such questions depends on what you think the nature and significance of theory is. If you think it's just a way of describing a particular style of analysis (or a window or chair, for that matter), then, yes, while remnants of postmodernism or post-structuralism may linger, as intellectual movements they may easily become passé. However, if you think of structuralism and post-structuralism, postmodernism, hermeneutics, or deconstruction as discourses that raise important questions about how we live and think, then they continue to be of vital interest.

A place to start

Hermeneutics

- Dilthey, William. "The Development of Hermeneutics," Dilthey: Selected Writings, transl. H.P. Rickman. Cambridge: Cambridge University Press, 1979.
- Gadamer, Hans Georg. Truth and Method, transl. Joel Weinsheimer and Donald Marshall. New York: Crossroad, 1989.
- Heidegger, Martin. Being and Time, transl. John Macquarrie and Edward Robinson. Oxford: Blackwell. 1962.
- Heidegger, Martin. "The Origin of the Work of Art," (1935), Basic Writings. New York and London: Routledge, 1993.

Structuralism and post-structuralism

- Barthes, Roland. Camera Lucida: Reflections on Photography. New York: Noonday Press, 1982.
- Foucault, Michel. The Archaeology of Knowledge. New York: Pantheon, 1982.
- Lévi-Strauss, Claude. The Savage Mind. Chicago, University of Chicago Press, 1966.
- Moxey, Keith P.F. The Practice of Theory: Poststructuralism, Cultural Politics, and Art History. Ithaca: Cornell University Press, 1994.

Deconstruction

- Brunette, Peter, and David Wills, eds. Deconstruction and the Visual Arts: Art, Media, Architecture. Cambridge: Cambridge University Press, 1994.
- Derrida, Jacques. The Truth in Painting, transl. by Geoff Bennington and Ian McLeod. Chicago: University of Chicago Press, 1987.
- Kamuf, Peggy. A Derrida Reader: Between the Blinds. New York: Columbia University Press, 1991.

Postmodernism

- Baudrillard, Jean. Simulacra and Simulations (1981), transl. Sheila Faria Glaser. Michigan: University of Michigan Press, 1994.
- Belting, Hans. The End of the History of Art? (1983), transl. by Christopher S. Wood. Chicago and London: University of Chicago Press, 1987.
- Foster, Hal, ed. The Anti-Aesthetic: Essays on Postmodern Culture. Seattle: Bay Press, 1983. Huyssen, Andreas. "Mapping the Postmodern," New German Critique, 33 (Fall 1984): 5–52.
- Jameson, Frederic. Postmodernism, or the Cultural Logic of Late Capitalism. Durham: Duke University Press, 1991.
- Lyotard, François. The Postmodern Condition: A Report on Knowledge (1979), transl. by Geoff Bennington and Brian Massumi. Minneapolis: University of Minnesota Press, 1984.

Chapter 6 Writing with theory

I think I did pretty well, considering I started out with nothing but a bunch of blank paper. Steve Martin

At this point, you may be wondering how to work with theory in the context of your training as an art historian. How do you learn to think as a theorist? How do you learn to write with theory? Or actually get to a point where Marxist, feminist, or psychoanalytic theories might help you in developing a research project? Unfortunately, there's no easy answer here—your skills as a writer and researcher, your expertise in art history, your own intellect and interests, will determine how you learn to write with theory. Working with theory is very much about the maturation of your own thought processes, your emergence as an independent thinker.

In this chapter, I'll provide some basic suggestions for approaching theory and the challenge of integrating theory into your work as an art historian, but be aware that you will have to find your own path. Some of these suggestions may work beautifully for you, others, not at all. I've included examples of student writing, only lightly edited for grammar and clarity, to illustrate the points I make here. These are all papers produced for actual courses and will give you real-life examples of students rising to the challenge of writing with theory.

The kind of paper you're probably writing now

Students in upper-level art-history courses are typically writing papers that present a mix of formal, iconographic, and contextual analysis. I'm not sure most students could even identify the theo-

 Michelangelo, Prophet Zechariah, Sistine Chapel Ceiling, 1508–1512.
 Vatican.

retical underpinnings of their approach; often, they're simply modeling their work on a pastiche of techniques they see their professors using in class, or kinds of analysis they've seen in textbooks or other readings.

This paper, written by a student for a survey of Italian Renaissance art, presents a typical mix, emphasizing iconographic analysis supported by some basic formal analysis and contextual information (Figure 6.1). In the following excerpt I've underlined iconographic passages, bolded contextual analysis, and italicized the formal analysis to help you understand what's here:

In May 1508 Michelangelo began his work on the Sistine Chapel in Rome. Pope Julius II had commissioned him to redecorate the entire ceiling of the chapel. The Pope initially suggested that the ceiling should depict the twelve apostles; however, he agreed to allow Michelangelo to decide his own theological program after the sculptor had rejected the Pope's original idea (Hibbard, 105). Michelangelo replaced the twelve apostles with twelve figures of both Hebrew prophets and pagan sibyls. Christian theologians interpreted these figures as seers who foresaw the coming of Jesus Christ. Throughout the ceiling, prophets and sibyls sit on carved thrones next to one another, each holding a scroll or book. Some appear contemplative, others fearful; the figures are consumed by their knowledge of the future and grasp their scriptures as if to suggest to the viewer that the truth, no matter how it is told, is too powerful for humankind to bear.

This essay focuses on the significance of the prophet Zechariah, the first seer depicted in Michelangelo's schema.

Zechariah sits on his throne, positioned right above the entrance door for the congregation. The placement of Zechariah is important because some of the themes derived from the book of Zechariah in the Old Testament can be interpreted in other scenes and figures on the ceiling. By examining some of these themes, the viewer is able to understand why this prophet begins the succession of prophets and sibyls, culminating with the figure of Jonah, who sits at the other end of the ceiling above the altar. Some important motifs include the coming of Christ and the suffering of humankind . . .

The figure of Zechariah is also a symbol of the patron of Michelangelo's artistic endeavor, the Pope. In the Old Testament Zechariah prophesies the foundation of the church of the Lord and the coming of the servant of God: "Behold, the man whose name is the branch: for he shall grow up in his place, and he shall build the temple of the Lord". (Zech. 6:13). Della Rovere, the family name of Pope Julius II, translates as "oak tree" in English, and therefore the image of Zechariah also conflates messages about the religious authority of the papacy with the secular authority of the Della Rovere family in Rome (Hibbard, 109). Thus the figure of Zechariah sends the message that the Catholic Church has its roots in the time of Jesus Christ, when he decreed that the church (i.e. the Pope) would be His vicar on earth . . .

Although Zechariah may symbolize the coming of Christ, the Lord and Savior to his people, this message is shadowed by the catastrophic images depicted in the scene of the Deluge, depicted next to the figure, and by the scene of man's sin in the Drunkenness of Noah. Zechariah's face is shadowed and dark; his intense expression does not seem to reflect the elation one might have in rejoicing at the coming of the Messiah. This is because the book of Zechariah also prophesies apocalyptic destruction: "And this shall be the plague with which the Lord will smite all of the peoples . . . their flesh shall rot . . . their eyes shall rot in their sockets, and their tongues shall rot in their mouths" (Zech. 14:12). It also makes reference to the four chariots (Zech. 6:1), a theme interpreted in the New Testament as the four chariots of the Apocalypse (Revel. 6:5-8). Zechariah's placement immediately next to the panel depicting the Drunkenness of Noah emphasizes that Zechariah prophesies not only the coming of Christ, but also the catastrophes and sufferings that will befall humanity . . .

This paper presents some effective iconographic analysis, but in a fairly unstructured and unsystematic way. The third paragraph, for example, mixes iconographic, formal, and contextual analysis, without really providing in-depth analysis in any of them. The issue of the Della Rovere family deserves its own paragraph and a more extended consideration of how the family relates to the figure of Zechariah via the conflation of Zechariah's metaphoric "branch" with "oak," the meaning of the name Della Rovere. I don't want to suggest that it's a bad paper; in fact, overall it's thoughtful, carefully observed, and generally well written (and of course remember that you're not seeing the whole piece here). None the less, systematizing the inquiry in theoretical terms would help the writer develop her arguments fully and give the paper a tighter organization: the points don't lead into each other, and the paragraphs aren't interconnected. This organization should be reflected in a more dynamic—and specific—topic sentence than "This essay focuses on the significance of the prophet Zechariah, the first seer depicted in Michelangelo's schema."

In revising this paper, the writer has any number of options. For example, she could have followed Panofsky's method for iconographic analysis, as discussed in Chapter 2. This means deliberately proceeding from pre-iconographic analysis (interpretation based on purely visual analysis and practical experience) to iconographic analysis (connection to literary sources) to iconological interpretation (addressing the meaning of the image in its historical context). Elements of all these aspects of analysis are present in the paper, but following Panofsky's method, and looking to his work as a model, might help deepen the analysis. A paragraph of pre-iconographic analysis—that is, a paragraph of thorough formal analysis—would be effective if inserted between the first and second paragraphs. It would establish some of the important visual elements in the image, and actually make it easier to write the subsequent iconographic and iconological analysis, because the reader would already have a sense of the essential visual elements.

Of course, there are limits to Panofsky's method, too, and the writer could use the figure of Zechariah to explore these limits—for example, by turning to reception theory in order to think about some issues of viewer and audience not raised in an iconographic analysis. Semiotics might also be helpful here, especially considering the placement of the figure on the ceiling (Meyer Schapiro's famous essay on the frame would be relevant). The author could also explore issues of intertextuality both within the

work—in the ways in which the different parts of the ceiling and the different narratives relate to each other—and between this work and others of the period. In this way, the figure of the prophet Zechariah would provide an opportunity to think about the interrelation of iconographic, iconological and semiotic methods. The politics surrounding the Della Rovere family and its artistic patronage could also be explored further via materialist or Marxist analysis.

Please keep in mind that I'm offering alternative, theoretically informed ways to develop research topics and write papers not because they'll necessarily get you better grades. In fact, your theoretical readings will probably make the writing process more difficult initially, and the paper you write may suffer. But, this is about your intellectual and personal growth: it is a way of encountering the world, for those who are seriously committed to engaging with art history as an academic discipline and as a process of interpretation. And taking a risk in writing one of your research papers now, when you have a highly trained expert in your professor helping you develop your ideas, is a good opportunity.

Ideally, working with theory enables you to think more deeply and critically about your research topic and better prepares you to analyze arguments in the literature, synthesize different perspectives, evaluate arguments, and develop your own interpretation with subtlety, rigor, and imagination. In this way working with theory is important for those students who want to go on in academic life, but it is also good training for anyone seeking to think critically and express complex thoughts and arguments in writing. Ultimately, the process isn't about the paper but about thinking critically; the special ways in which you grapple with theoretical ideas by trying to write with them will, perhaps, deepen not only your understanding but your commitment to particular ideas and ways of interpreting images.

Learning how to write with theory

Several strategies may help you learn how to write theoretically. The first is obvious but important: read a lot of theory, and a lot of art history. This will not only help you familiarize yourself with a variety of different theoretical approaches, but will also give you models: pay attention to what you are reading not only for content but also for the style and structure of the argument. Eventually, you'll develop particular interests within critical theory, but you'll

also have a good, basic knowledge of a wide range of theories so that if a research topic you're working on has a good "fit" with a particular theoretical approach, you'll have some basic idea of where to turn in order to pursue this line of questioning.

As you read theoretical works, think about how the material you're reading might relate to an analysis of the visual arts. What kinds of issues does it make you consider—what kinds of questions does it make possible? When the theoretical work comes from outside art history (as with psychoanalytic or Marxist theory), be sure to read some art historians who work from these theoretical perspectives as a model for your own work. When reading theoretically informed art history, be sure to pay attention to the way the author structures the arguments. How is the author using theory to generate questions? How does her analysis produce theoretical insights? What's the interplay between theory and practice in her work? Is the theory driving the argument or does it seem extraneous? Is the theoretical apparatus convincing, or are there logical flaws in the argument?

In addition to your own reading, your art history department may offer courses on theory and methodology. Courses such as these are enormously useful in getting you grounded in theoretical approaches: you'll work quickly and efficiently, with the guidance of a knowledgeable instructor and the help of a group of peers who are working through similar issues. Plus, you'll almost certainly have the opportunity to write a great deal. Check other departments. A Political Science department may offer an introductory course on Marxism, an English department may offer a course in semiotics, or Sociology a course on theories of race. One of my students took a Philosophy course in logic that helped her enormously in learning how to structure arguments. Within these contexts, you may be able to arrange with the professor to write a paper with an art-historical focus, which will help you apply the insights gained to your own field.

If you can't find such courses, you can always gather together a group of art-history students who are also interested in theory to form a theory reading group. The group can set a reading list, meeting once a week or every two weeks to discuss particular readings. You may also want to function as a writing group, discussing your various research projects and critiquing each others' papers. Ask a faculty member to advise you on a reading list, or even supervise your work as an independent study.

The place of theory in research

If you're interested in writing with theory, you can't leave theory aside until you sit down at the computer to write your first draft. Working with theory has to be part of the entire process of producing the paper. As you develop interests in theory, this work will go on continually, even as particular research projects come and go.

Which comes first?

So which comes first, the theory or the research topic? This is one of those chicken-or-egg questions that doesn't have a definitive answer. In fact, it depends—partly on your research topic, partly on the nature of your interests, partly on your knowledge of theory.

I'll generalize very broadly here by saying that when you first start working with theory you will probably start from the material first, since that is how you're used to working. That is, you will decide to research a particular artist, image, or issue (be it Faith Ringgold's story quilts, the Woman of Willendorf, or nineteenthcentury French art criticism), and then you will go out and find an appropriate theoretical framework to help you develop your interpretation. As you keep working with theory, reading more widely and becoming more conversant with different theories, you'll find yourself developing certain interests or commitments to particular theoretical frameworks. This will then begin to guide the kind of research you do. So, if you're interested in the kinds of issues raised by reception theory, you're not very likely to work on small ceramic pots from Ancient Rome that were originally used for storage and rarely seen—although someone working from materialist or Cultural Studies perspectives might well find them interesting. If you go on in art history, and as you mature as a scholar, you may become a specialist in a more narrow range of theoretical approaches to which you make important contributions.

As you're researching your topic, you'll start to develop a point of view, a distinctive interpretation that you want to present. This is where you should be using theory to generate questions about your topic, to guide your research and push it in new directions. The sample questions presented in Chapters 2 through 5 of this book should give you some idea of how to formulate theoretically driven questions during your research. At every level, there's a to-ing and fro-ing between the empirical research and the theoretical work.

Your research on the topic will prompt you to turn to a particular theoretical construct; reading in that theory will yield questions that send you back to your subject; and so on.

In the end, you may not end up using a lot of what you read. For example, if you're pursuing a psychoanalytic framework, you may read very widely about "the mirror stage," but in the end refer only to Jacques Lacan's original essay on the subject ("The Mirror Stage as Formative of the Function of the I as Revealed in Psychoanalytic Theory," 1949) and an article about the mirror stage and film theory by Kaja Silverman (The Acoustic Mirror, 1988). Other readings you did on the idea of the mirror stage by David Carrier and others—although interesting, valuable, helpful in expanding your mind—may not in the end help you develop your particular argument. You shouldn't feel that this is wasted time; not only is it inevitable to discard some material in the development of your ideas, but what you've read may prove to be helpful in the future, in some other research project.

How do you know which theory (or theories) to use?

Although some topics will lend themselves more easily to one mode of theoretical inquiry than to another, there's no one right or wrong theory or line of questioning to take with a particular subject. There is, however, a sense of "fit" between a subject and the theoretical framework you use to address it; the "fit" isn't sitting out there, waiting to be discovered—it comes from you, in how you think and write and work with the visual arts. Be aware that if the process of researching and writing seems difficult, and you feel like you're constantly hitting dead ends in your analysis, then the fit may not be right. This is a good time to take the problem to your instructor and work through your ideas.

Sometimes there's a good fit between your subject and your theoretical framework because the artists themselves were interested in that theory. This is often especially true of modern and contemporary art, where artists may be actively engaged with many kinds of theories. For example, many Surrealist artists in the 1920s and 1930s were deeply interested in Marxism and psychoanalysis, and these theoretical frameworks often provide a productive approach to the analysis of their work. There's a similar kind of fit in the following introductory paragraph from a student research paper, which uses Donna Haraway's famous essay "A Cyborg Manifesto" published in Simians, Cyborgs and Women: The Reinvention of

6.2 Lee Bul, Cyborg, 1999. Aluminum wire, stainless steel, polyethylene resin, polyurethane sheet. Kukje Gallery, Seoul, Korea.

Women (1991) to analyze contemporary Korean artist Lee Bul's Cyborg figures (Figure 6.2):

Lee Bul's cyborg figures highlight various feminist debates over the implications technology has for women and their socio-political placement within society and its various institutions (specifically, the new, technologically induced ones, such as the internet, virtual reality, and biomedical engineering). Donna Haraway's landmark essay "A Cyborg Manifesto" (1991) has been crucial to outlining the doctrine/dogma of cyborg theory from a socialist-feminist standpoint . . . I would like to discuss the positive aspects of Haraway's work for feminist epistemology-how the female cyborg can be used as a [means] for understanding the myths that surround gender, specifically the idea that gender is a unified holistic identity while also engaging with her work critically to point out how her vision fails to recognize some of the realistic operational tactics of technology. Haraway's utopian vision, although precise in rendering the contradictory postmodern condition of women, fails to recognize [that] and indicate how-when the existent mechanisms [power dynamics] [and gender stereotypes] still underlie the technological apparatuses constituting the cyborg woman—we can move beyond the gendered stereotypes still pervading representations of women. Lee Bul's cyborg women address just this problem, in exploring how

technology and science are invested with the same patriarchal ideologies of sexism, racism, and ageism that saturate the larger culture.

This student focuses on the direct relationship between the sculptures and feminist cyborg theory, both of which address the problem of sexism in technology and science through the figure of the cyborg. She takes care to interpret Lee Bul's figures and Donna Haraway's essay together and in relation to each other, giving us insight into both. Notice that it isn't just a question of applying Haraway's essay to the interpretation of the figures, as if the theory provided a program for interpretation that was already whole and complete in itself. Rather, the interpretation and questioning go both ways: Haraway's essay helps this student interpret Lee Bul's figures, and vice versa.

That kind of direct connection isn't always present, though, and isn't necessary. For the most part, male Surrealist artists of the 1020s and 1030s couldn't accurately be described as feminists, and yet feminist analyses of their work—which includes many images of women's bodies—are often very insightful. This issue can be especially difficult when dealing with non-Western or ancient art. where the theoretical framework you're using may feel very foreign to the material in some sense, or distant from it, in that the art was generated in a very different cultural context. But remember that any theoretical framework is imported, in some sense, because the way you use it is particular to you and your way of thinking. Just because a theoretical framework wasn't available at the time an artwork was created or an art practice was current, doesn't mean that it isn't an effective mode of analysis. Michelangelo, after all, wasn't familiar with Panofsky's iconographic method, yet that's still a productive way to approach his work. You can remember that people in Michelangelo's time performed similar kinds of analysis. and every culture has traditions for analyzing and interpreting visual works. You're looking for insight within the context of art history, within a specific disciplinary frame; you're not making the only or final statement about the worth of an object, artist, or artistic practice.

Working with theory does, at the same time, require an awareness of your own position in relation to the material you're studying. Why are you interested in the material? What do you hope to accomplish in studying it? What are the relations of power that

shape your study? How do gender, class issues, or the legacy of colonialism shape access to education and information in relation to your topic?

Writing the paper

Writing theoretically informed art history is challenging—it will stretch you intellectually and creatively. Be sure to get the help you need during the writing process. Ask your instructor for advice about your research topic and discuss with her the theoretical perspectives that interest you. She can probably provide background information, references, and insights to help you in your work. I know students hesitate to visit professors during office hours—I did too as an undergraduate. But as a professor myself, I can say that talking with students about their research is one of the most important and enjoyable things that I do. I will also note here that although I am a very strong supporter of writing centers, they may not be able to help you with this kind of theoretical, disciplinespecific writing project unless they are staffed by professionals as well as peer editors. As a more long-term strategy, take advanced writing courses, especially courses in expository writing or advanced writing of research papers. One of the real regrets I have about my own undergraduate education is that I didn't take writing courses beyond the required first-year course.

Writing is a process of thinking, and your argument will probably be rather different at the end of the first draft than it was when you started. Even though outlining is an important part of organizing your thoughts and developing your argument, don't lock yourself into an outline as an inflexible program. Also, free yourself from the expectation that you'll be generating brilliant, high-level theory from the beginning: the first draft of any particular project will most likely be very rough, with all sorts of incomplete arguments and gaps in your supporting materials, and the first theoretical papers you write will probably be very rough. Remember that even widely admired art historians with many years of experience may still struggle with theoretical ideas.

Crafting a theoretically driven argument

Your research is done and you're outlining and preparing the first draft of your paper: this is a critical point at which to remember to integrate theory fully into the argument; theory shouldn't be separate or introduced later, but should shape the analysis you present

at every step. If you find that you're writing some formal analysis followed by a generalized contextual analysis and then introducing a theory, you need to go back and rethink your outline.

Integrating theory

I'll briefly discuss here some of the common pitfalls that students encounter when crafting theoretically driven arguments.

Descriptive writing Just as you don't want to write descriptive art history—art history that's not fundamentally interpretive—neither do you want descriptive theory. You're not just summarizing a theoretical argument, you're engaging with it—using it, extending it, challenging it. One of the worst things you can do is to just plunk a mass of undigested theory-writing at the beginning of the paper (maybe in an effort to look intellectually sophisticated or more on top of your subject than you actually are) and then leave it there, completely unconnected to anything else you're writing about subsequently. Also, beware of long quotes from theoretical sources, because writing these often indicates that you haven't fully digested the perspectives they represent.

Losing the focus on art Your argument has a problem when there are pages and pages of theoretical writing in which the artworks drop out completely. At that point, ask yourself whether you're writing about the theory or about your proposed subject. Maybe in the end what you want to write is a paper about Antonio Gramsci's theory of hegemony, but if you've set out to write about David's portraits of Napoleon then you have to figure out some way to bring these two subjects together. Often, the works of art become the key to better, more interesting theorizing. The following excerpt from the paper about Lee Bul's Cyborg figures (quoted above) attempts to perform this kind of interconnected analysis of theory and artwork:

It is here that we should keep in mind Lee Bul's Cyborg Blue, which can arguably be regarded as a visual representation of Foucault's notion of the body as a "site of power." For Foucault, the material body becomes a site of conflict, where the apparatuses of power continuously disperse its regulatory investments. We are presented with simulated models and eroticized categories of identity that our bodies must correspond to. Understood in terms of Haraway's Cyborg vision, it is these particular structures of thought and identity—hitherto understood as unified and fixed—which have so suppressed our fluid and unstable subjectivities.

The student is juxtaposing Foucault and Haraway in an interesting way, and Cyborg Blue is the nexus of her argument, but she doesn't give us the visual analysis of Cyborg Blue to support and develop these ideas. She has to show us how it represents Foucault's notion of the body as a "site of power" in relation to Cyborg image and theory: it's not enough just to say that it does. Incorporating the visual and contextual analysis of Cyborg Blue would, I think, also require her to pursue her provocative ideas about "simulated models and eroticized categories" in greater detail and specificity.

Supporting your points/providing evidence

This raises the issue of the importance of providing supporting evidence to prove your point. Don't just list supporting materials, as if their relevance is self-evident; instead, explain how the evidence supports your point of view. In the following excerpt from a paper, a student juxtaposes an installation work by Pepón Osorio, En La Barbería No Se Llora (No Crying Allowed in the Barbershop) with Gilles Deleuze's ideas about empiricism, memory, and difference, as a way of coming to new understandings of both artist and philosopher (Figure 6.3):

6.3 Pepón Osorio, En La Barbería No Se Llora (No Crying Allowed in the Barbershop), 1994. Real Art Ways, Hartford, CT.

In Difference and Repetition, Deleuze discusses the syntheses of time, of memory, and imagination that are part of the mechanisms that support empiricism. He states that "The active syntheses of memory and understanding are superimposed upon and supported by the synthesis of the imagination" (1994: 71). Deleuze sees the active syntheses of memory and understanding as antagonistic to true empiricism, [even] if they are generally conceived as being the basis for it. The passive synthesis of imagination gives rise to the active syntheses mentioned above. Deleuze's idea of the relationship between imagination and memory provides a better way of understanding En La Barbería No Se Llora, which could fit the categorization of a "memory project," as they are typically called in the art world. It would seem that the installation has as much to do with Osorio's, and the community's, imaginations as with their memories per se. The installation is, after all, art, not a business, and the space was used as a community forum. Furthermore, as discussed above, the installation lacks verisimilitude. [An earlier paragraph explored how the installation was not a faithful reproduction of a Puerto Rican barbershop so much as an exuberant, exaggerated reimagining of one.] But it does involve the kind of imagination that can best be described in terms of play . . .

When writing, be sure to qualify what you say: you want to develop a nuanced argument. Also, you may want to take the time to refute obvious counterarguments: argue against yourself, acknowledging possible weaknesses in your interpretation and presenting evidence to counter potential criticism.

Creativity, imagination, and truth

These qualities belong to scholarly writing, to theory, and to art history as much as they do to fiction or poetry. And they apply equally to researching, crafting an argument, and writing. All writing, whether it engages historical facts or not, is about telling the truth, or bearing witness in some sense, and all writing emerges from the writer's unique way of seeing the world. It requires imagination, as well as courage, to write something better than the safe, dutiful scribing students usually produce in search of a good grade.

Notes

Introduction

- For students interested in the historiography of art history, a good place to start is Vernon Hyde Minor, Art History's History (Upper Saddle River, NJ: Prentice Hall, 2001). See also Donald Preziosi, ed., The Art of Art History: A Critical Anthology (Oxford:
- Oxford University Press, 1998) and Eric Fernie, ed., Art History and Its Methods: A Critical Anthology (London: Phaidon, 1995).
- 2 This method was first developed by F.P. Robinson, Effective Study (New York: Harper and Row, 1970).

Chapter 1 Thinking about theory

- Anne D'Alleva, "Tattoo as Crime and Punishment in Nineteenth-Century Tahiti," forthcoming.
- Terry Eagleton, Literary Theory: An Introduction (Minneapolis: University of Minnesota Press, 1983): 115.
- 3 Michel Foucault, Power/Knowledge: Selected Interviews and Other Writings, 1972–1977 (New York: Pantheon Books, 1980) provides a useful introduction to these issues in Foucault's work.
- 4 See, for example, bell hooks, Yearning: Race, Gender, and Cultural Politics (Boston: South End Press, 1990) and Outlaw Culture: Resisting Representation (New York: Routledge, 1994).
- 5 Audre Lorde, "The Master's Tools Will Never Dismantle the Master's House," in Sister Outsider: Essays and Speeches (Crossing Press, 1984): 110–13.
- 6 bell hooks, "Postmodern Blackness," in Yearning, 23.
- 7 For an introduction to Auguste Comte's

- positivism, see Gertrud Lenzer, ed. Auguste Comte and Positivism: The Essential Writings (New Brunswick, NJ: Transaction, 1998).
- For a discussion of nineteenth-century historians of art in the German-speaking world, see Michael Podro, The Critical Historians of Art (New Haven, CT: Yale University Press, 1982).
- g Eagleton, vii-viii.
- 10 Gilles Deleuze and Claire Parnet, Dialogues, transl. by Hugh Tomlinson and Barbara Habberjam (New York: Columbia University Press, 1087): vii.
- 11 Ibid. See also Constantin V. Boundas, "Translator's Introduction," in Gilles Deleuze, Empiricism and Subjectivity: An Essay on Hume's Theory of Human Nature, transl. Constantin V. Boundas (New York: Columbia University Press, 1991): 1–20.
- 12 Albert Wendt, "Tatauing the Post-Colonial Body," Span 42–43 (April–October 1996): 15–29.

Chapter 2 The analysis of form, symbol, and sign

- For an assessment of formalism and contemporary art history, see David Summers, "'Form', Nineteenth-Century Metaphysics, and the Problem of Art Historical Description," Critical Inquiry 15 (Winter 1989): 372–93.
- Immanuel Kant, "Of the Faculties of the Mind that Constitute Genius," Critique of Judgement (1790) on Eserver.org Accessible Writing (Iowa State University, accessed November 2003), http://eserver.org/ philosophy/kant/critique-of-judgement.txt.
- 3 Heinrich Wölfflin, Principles of Art History: The Problem of the Development of Style in Later Art (1915), quoted in Donald Preziosi, ed., The Art of Art History: A Critical Anthology (Oxford: Oxford University Press, 1998): 118. See also Marshall Brown, "The Classic Is the Baroque: On the Principle of Wölfflin's Art History" Critical Inquiry 9 (December 1982).
- 4 Laurie Schneider Adams, The Methodologies of Art:

- An Introduction (New York: Icon Editions, 1996): 212–15.
- 5 Roger Fry, Vision and Design (Oxford: Oxford University Press, 1981): 167. Fry's friend and associate Clive Bell (1881–1964) popularized the idea of significant form in his book Art (1914), which argued that form, independent of content, was the most important element in a work of art.
- 6 Henri Focillon, The Art of the West, vol. 2: Gothic, ed. Jean Bony (London: Phaidon, 1963): 3.
- 7 Clement Greenberg, "Modernist Painting" in John O'Brian, ed. Clement Greenberg: The Collected Essays and Criticism, vol. 3 (Chicago: University of Chicago Press, 1986–1993): 86.
- 8 Art historian and critic Michael Fried also wrote important formalist criticism in the 1960s which departed from and extended Greenberg's work in interesting ways. The extensive introduction to his anthology of criticism provides an

- autobiographical account of formalist criticism. Art and Objecthood: Essays and Reviews (Chicago: University of Chicago Press, 1998): 1–74.
- 9 Rosalind Krauss, "In the Name of Picasso" in The Originality of the Avant-Garde and Other Modernist Myths (Cambridge: MIT Press, 1985): 37.
- 10 Ibid.: 24.
- 11 Ibid.: 25. For a provocative discussion of this essay in relation to the work of T.J. Clark, see Jonathan Harris, The New Art History: A Critical Introduction (London: Routledge, 2001): 47–56.
- 12 Winckelmann is an important figure in the development of art history. See Alex Potts, Flesh and the Ideal: Winckelmann and the Origins of Art History (New Haven: Yale University Press, 1994).
- 13 Erwin Panofsky, Meaning in the Visual Arts (Harmondsworth: Penguin, 1970): 205.
- 14 Adrienne Kaeppler "Genealogy and Disrespect: A Study of Symbolism in Hawaiian Images," RES 2 (1982): 82–107.
- 15 Michael Ann Holly, Panofsky and the Foundations of Art History (Ithaca, NY: Cornell University Press, 1984): 130-57.
- 16 Ernst Cassirer, The Philosophy of Symbolic Forms, 4 vols. (New Haven: Yale University Press, 1953–96).
- 17 Jan Białostocki, Stil und Ikonographie: Studien zur Kunstwissenschaft (Cologne: DuMont, 1981); see also Willem F. Lash, "Iconography and Iconology," The Grove Dictionary of Art Online (Oxford: Oxford University Press, accessed November 2002) http://www.groveart.com.
- 18 Harris op. cit. under 11 above: 6. Harris's
 Introduction is a useful guide to the emergence of
 the "new" art history (1–34). Harris notes that the
 term began to circulate in the early 1980s to
 describe recent and current trends in the discipline.
 See also O.K. Werckmeister, "Radical Art History,"
 Art Journal (Winter 1982): 284–91; Norman Bryson,
 Calligram: Essays in New Art History from France
 (Cambridge: Cambridge University Press, 1988).
- 19 T.J. Clark, "The Conditions of Artistic Creativity", Times Literary Supplement (May 24, 1974): 561–62; Svetlana Alpers, The Art of Describing: Dutch Art in the Seventeenth Century (Chicago: University of Chicago Press, 1983): xviii–xx.
- 20 "To a remarkable extent the study of art and its history has been determined by the art of Italy and its study. This is a truth that art historians are in danger of ignoring in the present rush to diversify the objects and the nature of their studies." Alpers, op. cit.: xix.

- 21 Eddy de Jongh, "Realism and Seeming Realism in Seventeenth-Century Dutch Painting", in Wayne Franits, ed. Looking at Seventeenth-Century Dutch Art: Realism Reconsidered (Cambridge: Cambridge University Press, 1997): 21–56.
- 22 Lash, op. cit. under 17 above.
- Mieke Bal and Norman Bryson, "Semiotics and Art History," Art Bulletin 73 (June 1991).
- 24 Ferdinand de Saussure, Course in General Linguistics, transl. Roy Harris, eds Charles Bally and Albert Sechehaye (London: Duckworth, 1983).
- 25 Charles Sanders Peirce, Peirce on Signs: Writings on Semiotics by Charles Sanders Peirce, ed. James Hooper (Chapel Hill: University of North Carolina Press, 1991): 141–43, 253–59.
- 26 Rosalind Krauss, "Notes on the Index: Seventies Art in America" in Annette Michelson et al., eds., October: The First Decade (Cambridge, MA: MIT Press, 1987): 2–15, 14.
- 27 Roman Jakobson, "Closing Statement: Linguistics and Poetics", in Thomas Sebeok, ed., Style in Language (Cambridge, MA: MIT Press, 1960): 350–77.
- 28 Umberto Eco, A Theory of Semiotics (Bloomington: Indiana University Press, 1979).
- 29 Giovanni Morelli, Italian Painters, quoted in Eric Fernie, Art History and Its Methods: A Critical Anthology (London: Phaidon, 1995): 106–15.
- 30 Carlo Ginzburg, "Morelli, Freud, and Sherlock Holmes: Clues and Scientific Method," History Workshop Journal 9 (Spring 1980): 282.
- 31 James Elkins, Why Are Our Pictures Puzzles? On the Modern Origins of Pictorial Complexity (London: Routledge, 1999): 258.
- 32 Julia Kristeva, Semiotike (Paris: Editions du Seuil, 1969): 146. See also Julia Kristeva, The Kristeva Reader, ed. Toril Moi (New York: Columbia University Press, 1986).
- 33 Valentin Voloshinov, Marxism and the Philosophy of Language, transl. Ladislav Matejka and I.R. Titunik (Cambridge, MA: Harvard University Press, 1986): 105. For a good introduction to these issues, see David Chander, "Denotation, Connotation, and Myth," Semiotics for Beginners (accessed November 2002) http://www.aber.ac.uk/ media/Documents/ S4B/semo6.html.
- 34 Roland Barthes, S/Z transl. Richard Miller (Oxford: Blackwell, 1974): 9.
- 35 Louis Marin, "Toward a Theory of Reading in the Visual Arts: Poussin's 'The Arcadian Shepherds'" in Preziosi, The Art of Art History: 269.
- 36 Mieke Bal, Reading 'Rembrandt': Beyond the Word-Image Opposition (Cambridge: Cambridge

- University Press, 1991); Bryson, Word and Image, Marin, op. cit.
- 37 Ernst Gombrich, Art and Illusion: A Study in the Psychology of Pictorial Representation (Princeton, NJ: Princeton University Press, 1960): 9.
- 38 Bal. op. cit.: 47.
- 39 W.J.T. Mitchell, "Word and Image," Critical Terms for Art History (Chicago: University of Chicago
- Press, 1996): 49. Mitchell's image is inspired by the writing of the eighteenth-century philosopher G. E. Lessing, Laocoon: An Essay Upon the Limits of Painting and Poetry (1776).
- 40 Bal, op. cit.: 25-59.
- 41 Mitchell, "Word and Image": 48.
- James Elkins, On Pictures and the Words that Fail Them (Cambridge: Cambridge University Press, 1998).

Chapter 3 Art's contexts

- Isaiah Berlin, "The Pursuit of the Ideal," in Henry Hardy, ed., The Proper Study of Mankind: An Anthology of Essays (New York: Farrar, Straus & Giroux, 2000): 1. See also Isaiah Berlin, The Power of Ideas, ed. Henry Hardy (Princeton, NJ: Princeton University Press, 2002). Berlin himself was influenced by the work of the Russian philosopher and revolutionary Alexander Herzen (1812–1870), who wrote about the history of social and political ideas.
- Jerome Pollitt, Art and Experience in Classical Greece (Cambridge: Cambridge University Press, 1972): 48.
- 3 "Critical Marxism" in Tom Bottomore et al, eds., The Dictionary of Marxist Thought (Oxford: Blackwell Publishers, 1992).
- 4 Karl Marx, Capital: A Critique of Political Economy, vol. 1, translated by Ben Fowkes (New York: Penguin, 1992): 293–306.
- Karl Marx and Friedrich Engels, The Communist Manifesto; With Related Documents, ed. John Toews (New York: Bedford/St. Martin's, 1999): 65.
- 6 Marx and Engels first articulated this idea in The German Ideology, written in 1845–1846; Marx developed it in A Contribution to the Critique of Political Economy in 1857–1858.
- 7 Antonio Gramsci, Selections from the Prison Notebooks, transl. Geoffrey N. Smith and Quintin Hoare (New York: International Publishers Co., 1971): 12.
- 8 Ibid.
- 9 Louis Althusser, "ideology and Ideological State Apparatuses (Notes Towards an Investigation)," Lenin and Philosophy and Other Essays (New York: Monthly Review Press, 1971): 127–86.
- 10 Karl Marx and Friedrich Engels, The German Ideology in Collected Works, 1845–1847, vol. 5 (New York: International Publishers Co., 1976): 394.
- 11 Karl Marx, Grundrisse: Foundations of the Critique of Political Economy, transl. Martin Nicolaus (New York: Penguin, 1993): 110.
- 12 Georg Lukács, History and Class Consciousness,

- transl. Rodney Livingstone (London: Merlin Press, 1971): 83.
- 13 Terry Eagleton, The Ideology of the Aesthetic (Oxford: Blackwell, 1990): 323–24.
- 14 Theodor Adorno, Minima Moralia: Reflections from a Damaged Life (London: NLB, 1974): 146–47.
- Theodor Adorno, Culture Industry (London: Routledge, 2001): 58–60.
- 16 Walter Benjamin, "The Work of Art in the Age of Mechanical Reproduction," Illuminations (New York: Schocken Books, 1969): 240–41.
- 17 Ibid.: 243.
- **18** Guy Debord, The Society of the Spectacle (Detroit: Black and Red, 1983): 1.
- 19 Ibid.: 12.
- 20 Michael Baxandall, Painting and Experience in Fifteenth-Century Italy: A Primer in the Social History of Pictorial Style (Oxford: Oxford University Press, 1988): 2.
- T. J. Clark, Image of the People: Gustave Courbet and the 1848 Revolution (London: Thames & Hudson, 1973): 10–11.
- 22 Michael Camille, The Gothic Idol: Ideology and Imagemaking in Medieval Art (Cambridge: Cambridge University Press, 1989): xxv. See also Jonathan Harris, The New Art History (London: Routledge, 2001): 175–78.
- 23 Carol Duncan, "The Art Museum as Ritual" in Donald Preziosi, ed., The Art of Art History (Oxford: Oxford University Press, 1998): 478.
- 24 Annie E. Coombes, Reinventing Africa: Museums, Material Culture, and Popular Imagination in Late Victorian and Edwardian England (New Haven: Yale University Press, 1992): 2.
- 25 Alice Rossi, The Feminist Papers: From Adams to De Beauvoir (Boston: Northeastern University Press, 1988) presents a useful selection of primary texts.
- 26 On the Women's Movement in the United States, see Ruth Rosen, The World Split Open: How the Modern Women's Movement Changed America (New York: Penguin, 2001).

- 27 Linda Nochlin, "Why Have There Been No Great Women Artists?" Women, Art, and Power and Other Essays (Boulder: Westview Press, 1989): 158–64.
- 28 Ibid.: 156.
- 29 Griselda Pollock and Rozsika Parker, Old Mistresses: Women, Art, and Ideology (London: Pandora Press, 1981): xviii.
- 30 Patricia Matthews in Mark Cheetham et al., eds., The Subjects of Art History: Historical Objects in Contemporary Perspective (Cambridge: Cambridge University Press, 1998). An earlier, but still helpful, assessment of the field is Thalia Gouma-Peterson and Patricia Mathews, "The Feminist Critique of Art History," Art Bulletin 69 (1987): 326–57.
- 31 Alice Walker, "In Search of Our Mothers' Gardens," In Search of Our Mothers' Gardens: Womanist Prose (Harcourt, 1983): 239.
- 32 Patricia Mainardi, "Quilts—The Great American Art," in Norma Broude and Mary D. Garrard, eds., Feminism and Art History: Questioning the Litany (New York: Harper & Row, 1982); Rozsika Parker, The Subversive Stitch: Embroidery and the Making of the Feminine (London: Women's Press, 1984); Pollock and Parker, Old Mistresses, op. cit.
- 33 Norma Broude and Mary D. Garrard, "Introduction: Feminism and Art History," Feminism and Art History: Questioning the Litany (New York: Harper & Row, 1982): 2.
- 34 Norma Broude and Mary D. Garrard, "Introduction: The Expanding Discourse," The Expanding Discourse: Feminism and Art History (New York: Icon Editions, 1992): 1–25.
- 35 Norma Broude and Mary D. Garrard, eds., The Power of Feminist Art: The American Movement of the 1970s; History and Impact (New York: Harry N. Abrams, 1994).
- 36 Mary D. Garrard, Artemisia Gentileschi: The Image of the Female Hero in Italian Baroque Art (Princeton, NJ: Princeton University Press, 1991).
- 37 Griselda Pollock, Differencing the Canon: Feminist Desire and the Writing of Art's Histories (New York and London: Routledge, 1999): 106–15.
- 38 Gayatri Chakravorty Spivak notes that the subject is "part of an immense discontinuous network ('text' in the general sense) of strands that may be termed politics, ideology, economics, history, sexuality, language, and so on. (Each of these strands, if they are isolated, can also be seen as woven of many strands.) Different knottings and configurations of these strands, determined by heterogeneous determinations which are themselves dependent upon myriad

- circumstances, produce the effect of an operating subject." See "Subaltern Studies: Deconstructing Historiography," In Other Worlds: Essays in Cultural Politics (London: Methuen, 1987): 204.
- 39 Pollock, op. cit. under 37 above.
- 40 Freida High W. Tesfagiorgis, "In Search of a Discourse and Critique/s that Center the Art of Black Women Artists' in: Theorizing Black Feminisms: The Visionary Pragmatism of Black Women, ed. Stanlie M. James and Abena P. A. Busia (London: Routledge, 1993): 228.
- 41 Janet Price and Margrit Shildrick, eds., Feminist Theory and the Body: A Reader (London: Routledge, 1999).
- 42 Amelia Jones, Body Art/Performing the Subject (Minneapolis: University of Minnesota Press, 1998): 22–4.
- 43 Joanna Frueh, Monster/Beauty: Building the Body of Love (Berkeley: University of California Press, 2000): 64.
- 44 Deborah Willis and Carla Williams, The Black Female Body: A Photographic History (Philadelphia: Temple University Press, 2002).
- 45 Diana Fuss, Essentially Speaking: Feminism Nature and Difference (London: Routledge, 1990): xi.
- 46 Sylvia Arden Boone, Radiance from the Waters: Ideals of Feminine Beauty in Mende Art (New Haven: Yale University Press, 1990); Ruth Phillips, Representing Woman: Sande Masquerades of the Mende of Sierra Leone (Los Angeles: Fowler Museum of Cultural History, UCLA, 1995).
- 47 Eve Kosofsky Sedgwick, Tendencies (Durham: Duke University Press, 1993): 18.
- 48 David Halperin, Saint Foucault: Towards a Gay Hagiography (New York: Oxford University Press, 1997): 62.
- 49 Adrienne Rich, "Compulsory Heterosexuality and the Lesbian Continuum," Blood, Bread, and Poetry: Selected Prose, 1979–1985 (New York: Norton, 1980): 23–75.
- 50 Teresa de Lauretis, "Queer Theory: Lesbian and Gay Sexualities. An Introduction," différences: A Journal of Feminist Cultural Studies (1991): vii—xviii; "Habit Changes," différences: A Journal of Feminist Cultural Studies 6 (1994): 296–313. Halperin also investigates the terms on which "queer" can continue to be a politically useful concept: see Halperin, op. cit.: 112–15.
- 51 Michel Foucault, The History of Sexuality: An Introduction (New York: Vintage, 1990): 43.
- 52 Judith Butler, Gender Trouble (New York: Routledge, 1999).
- 53 Ibid.: 25.

- 54 Judith Butler, Bodies that Matter: On the Discursive Limits of "Sex" (New York: Routledge, 1993): 232; see also 93–120.
- 55 Ibid.: 105-06.
- 56 Jonathan Weinberg, "Things are Queer," Art Journal (1996).
- 57 Laura Cottingham, "Notes on Lesbian," Art Journal (Winter 1996).
- 58 Natalie Boymel Kampen, "Introduction," Sexuality in Ancient Art (Cambridge: Cambridge University Press, 1996): 1.
- 59 Stuart Hall, "Encoding/decoding," in Stuart Hall et al., eds, Culture, Media, Language: Working Papers in Cultural Studies, 1972–79 (London: Hutchinson, 1980): 128–39; see also Daniel Chandler, "Encoding/Decoding," Semiotics for Beginners (http://www.aber.ac.uk/media/Documents/S4B/semo8c.html, consulted November 2003).
- 6o Gayatri Chakravorty Spivak, A Critique of Postcolonial Reason: Toward a History of the Vanishing Present (Cambridge: Harvard University Press, 1999): 1–3.
- 61 Stuart Hall, "Cultural Identity and Diaspora", in Jonathan Rutherford, ed., Identity: Community, Culture, Difference (London: Lawrence and Wishart, 1990): 224.
- 62 Stuart Hall, "Cultural Identity and Cinematic Representation," in Houston Baker, Jr., Manthia Diawara, and Ruth Lindeborg, eds., Black British Cultural Studies. A Reader (Chicago: University of Chicago Press, 1996): 213.
- 63 Bill Ashcroft, Gareth Griffiths and Helen Tiffin, The Empire Writes Back (London: Routledge, 1989): 2.
- 64 Frederick Cooper and Ann Laura Stoler, eds., Tensions of Empire: Colonial Cultures in a Bourgeois World (Berkeley: University of California Press, 1997).
- 65 Edward Said, Orientalism (New York: Random House, 1979): 3.
- 66 Aijaz Ahmad, In Theory: Classes, Nations, Literatures (London: Verso, 1994); Bernard Lewis, "The Question of Orientalism," Islam and the West (Oxford: Oxford Press, 1994): 99–118.
- 67 Homi K. Bhabha, The Location of Culture (London: Routledge, 1994): 85–92.
- 68 Hall, op. cit. under 61 above: 225.
- 69 Hall, op. cit. under 61 above: 226.
- 70 Eleanor M. Hight and Gary D. Sampson, eds., Colonialist Photography: Imagining Race and Place (London: Routledge, 2002).
- 71 Bernard Smith, European Vision and the South Pacific (New Haven: Yale University Press, 1985).
- 72 See, for example, Thomas R. Metcalf, An Imperial

- Vision: Indian Architecture and Britain's Raj (Oxford: Oxford University Press, 2002).
- 73 Nestor García Canclini, Hybrid Cultures: Strategies for Entering and Leaving Modernity (Minneapolis: University of Minnesota Press, 1995); Olu Oguibe and Okwui Enwezor, eds. Reading the Contemporary: African Art from Theory to the Market Place (London: Institute of International Visual Arts, 1999).
- 74 Henry Louis Gates, Jr., The Signifying Monkey: A Theory of African-American Literary Criticism (Oxford: Oxford University Press, 1989).
- 75 David C. Driskell, Two Centuries of Black American Art (Los Angeles: Los Angeles County Museum of Art, 1976); Sharon F. Patton, African-American Art (Oxford: Oxford University Press, 1998).
- 76 Ranajit Guha, "On Some Aspects of the Historiography of Colonial India," in Ranajit Guha and Gayatri Chakravorty Spivak, eds, Selected Subaltern Studies (Oxford: Oxford University Press, 1988): 37–44.
- 77 Gayatri Chakravorty Spivak, "Introduction," Selected Subaltern Studies, 13.
- 78 Ibid.
- 79 Nicholas Mirzoeff, An Introduction to Visual Culture (London: Routledge, 1999).
- 8o Johanna Drucker, "Who's Afraid of Visual Culture?," Art Journal 58, no. 4 (Winter 1999): 37–47; James Elkins, The Domain of Images (Ithaca: Cornell University Press, 1999).
- 81 Norman Bryson, Michael Ann Holly and Keith Moxey, eds, Visual Culture: Images of Interpretation (Middletown: Wesleyan University Press, 1994).
- 82 "Visual Culture Questionnaire," October 77 (Summer 1996): 25–70.
- 83 In 1974, T. J. Clark pointed out that the kinds of issues art historians engaged by turning to critical theory could also be found in the work of key nineteenth- and early twentieth century-art historians; see "The Conditions of Artistic Creativity," Times Literary Supplement (May 24, 1974): 561–62.
- 84 Jonathan Crary, Techniques of the Observer: On Vision and Modernity in the 19th Century (Cambridge: MIT Press, 1992); Barbara Maria Stafford and Frances Terpak, Devices of Wonder: From the World in a Box to Images on a Screen (Los Angeles: Getty Center for Education in the Arts, 2001).
- 85 For information on the repatriation of Native
 American objects, see Tamara L. Bray, ed., The
 Future of the Past: Archaeologists, Native Americans and
 Repatriation (London: Garland, 2001).
- 86 Pollock, op. cit. under 37 above: 26.

Chapter 4 Psychology and perception in art

- Terry Eagleton, Ideology: An Introduction (London: Verso, 1991).
- 2 Sigmund Freud, Civilization and its Discontents, transl. Jean Rivière (New York: J. Cape & H. Smith, 1930).
- Freud, Totem and Taboo (London: Routledge, 2001).
- Freud, "Der Moses des Michelangelo". Imago, 3/1 (Feb. 1914): 15–36.
- Freud, "Leonardo da Vinci and a Memory of His Childhood." Standard Edition of the Collected Psychological Works of Sigmund Freud, vol XI, transl. James Strachey (London: Hogarth Press, 1957).
- 6 C.G. Jung et al., Man and His Symbols (Garden City: Doubleday, 1964).
- 7 Eagleton, The Ideology of the Aesthetic (Oxford: Oxford University Press, 1990).
- 8 For an overview of the work of Horney and Deutsch, see Janet Sayers's book Mothers of Psychoanalysis: Helene Deutsch, Karen Horney, Anna Freud, Melanie Klein (New York: W.W. Norton, 1992).
- o Ibid
- Nancy Chodorow, Feminism and Psychoanalytic Theory (New Haven: Yale University Press, 1991).
- Simone de Beauvoir, The Second Sex, trans. H. M. Parshley (New York: Bantam Press, 1952).
- 12 Kate Millett, Sexual Politics (Garden City: Doubleday, 1970).
- 13 Judith Butler, Gender Trouble: Feminism and the Subversion of Identity (New York & London: Routledge, 1990).
- 14 Meyer Schapiro, "Leonardo and Freud: An Art Historical Study." Journal of the History of Ideas, 17 (1956): 303–39.
- 15 Melanie Klein, "Infantile Anxiety Situations Reflected in the Work of Art and in the Creative Impulse." International Journal of Psychoanalysis, 10: 436–43.
- 16 D. W. Winnicott, "The Use of an Object," International Journal of Psychoanalysis, 49 (1969): 591–99.
- 17 For an overview of Jakobson's work and a selection of his writings, see Linda Waugh and Monique Monville-Burston, eds, On Language: Roman Jakobson (Cambridge, MA: Harvard University Press, 1990).
- 18 Jacques Lacan, "The Ethics of Psychoanalysis." The Seminar series, Book VII, ed. Jacques-Alain Miller (New York: Norton, 1992).
- 19 Lacan, "The Four Fundamental Concepts of Psychoanalysis." The Seminar series, Book XI, ed. Jacques-Alain Miller. New York: Norton, 1977.
- 20 Julia Kristeva, Tales of Love, transl. Leon Roudiez (New York: Columbia University Press, 1987).

- 21 Kristeva, "Motherhood According to Bellini," in Desire in Language, transl. by Leon Roudiez (New York: Columbia University Press, 1980).
- 22 For a full analysis of Irigaray's views, see Margaret Whitford, ed., The Irigaray Reader (Cambridge: Blackwell, 1991).
- 23 Hélène Cixous, "Laugh of the Medusa," in The Rhetorical Tradition, ed. Patricia Bizzell and Bruce Herzberg (Boston: Bedford Books, 1990). See also Cixous' Coming to Writing, and Other Essays, ed. Deborah Jansen (Cambridge, MA: Harvard University Press, 1991).
- 24 Jane Gallop, Reading Lacan (Ithaca: Cornell University Press, 1985).
- 25 Freud, The Psychopathology of Everyday Life, ed. Adam Phillips (New York: Penguin, 2003).
- 26 Noam Chomsky, Current Issues in Linguistic Theory (The Hague: Mouton, 1964); a useful introduction to Chomsky is John Lyons's Noam Chomsky (Harmondsworth: Penguin, 1978).
- 27 Richard Wollheim, Painting as an Art (Princeton: Princeton University Press, 1987).
- 28 The Selected Melanie Klein, ed. Juliet Mitchell (Toronto: Penguin Books Canada, 1986).
- 29 The Critical Writings of Adrian Stokes, ed. L. Gowing, 3 vols (London: Thames and Hudson, 1978); and Adrian Stokes, The Invitation in Art, with a preface by Richard Wollheim (London: Tavistock Publications, 1965).
- 30 Suzanne Preston Blier, African Vodun: Art, Psychology, and Power (Chicago: University of Chicago Press, 1995).
- 31 Rosalind Krauss, The Optical Unconscious (Boston: MIT Press, 1997).
- 32 Mieke Bal, Looking In: The Art of Viewing (London: Taylor & Francis, 1999): 239–58.
- 33 Lacan, op. cit. under 19 above.
- 34 Laura Mulvey, "Visual Pleasure and Narrative Cinema." Screen, 16/3 (1975): 6–18.
- 35 bell hooks, "The Oppositional Gaze: Black Female Spectators," Black Looks: Race and Representation (Boston: South End Press, 1992); Reel to Real: Race, Sex, and Class at the Movies (New York: Routledge, 1996).
- 36 Alois Riegl, The Group Portraiture of Holland, transl. E. M. Kain (New York: Getty Publications, 1999).
- 37 Ernst Kris, Psychoanalytic Explorations in Art (New York: International Universities Press, 1952).
- 38 Freud, "Jokes and Their Relation to the Unconscious." Standard Edition of the Collected Psychological Works of Sigmund Freud, vol VIII, transl. James Strachey (London: Hogarth Press, 1957).

- 39 Harold Bloom, The Anxiety of Influence: A Theory of Poetry (Oxford and New York: Oxford University Press, 1973).
- 40 Bryson, Tradition and Desire: From David to Delacroix (Cambridge and New York: Cambridge University Press, 1984).
- 41 See E.H. Gombrich, Art and Illusion: A Study in the Psychology of Pictorial Representation (Princeton: Princeton University Press, 1961) and The Image and the Eye (Oxford: Oxford University Press, 1982).
- 42 Rudolf Arnheim, Art and Visual Perception (Berkeley: University of California Press, 1954); Visual Thinking (Berkeley: University of California Press, 1969); The Dynamics of Architectural Form (Berkeley: University of California Press, 1977); The Power of the Center (Berkeley: University of California Press, 1982).
- 43 Norman Bryson, Michael Ann Holly, and Keith Moxey, eds. Visual Theory: Painting and Interpretation (New York: HarperCollins, 1991).
- 44 Ingarden's views are surveyed in Jeff Mitsherling's

- Roman Ingarden's Ontology and Aesthetics (Ottawa: University of Ottawa Press, 1997).
- Wolfgang Iser, The Act of Reading: A Theory of Aesthetic Response (Baltimore: John Hopkins University Press/London and Henley: Routledge and Kegan Paul, 1978).
- 46 Hans Robert Jauss, Toward an Aesthetic of Reception, transl. Timothy Bahti (Minneapolis: University of Minneapolis Press, 1982).
- 47 Stanley Fish, Surprised by Sin: The Reader in Paradise Lost (Cambridge, MA: Harvard University Press, 1998).
- 48 Roland Barthes, The Pleasure of the Text, transl. Richard Miller (New York: Farrar, Straus & Giroux, 1975).
- 49 Wolfgang Kemp, "The Work of Art and its Beholder: The Methodology of the Aesthetics of Reception," in The Subjects of Art History: Historical Subjects in Contemporary Perspective, ed. M.A. Cheetham, M.A. Holly, and K Moxey (Cambridge: Cambridge University Press, 1998): 180–96.

Chapter 5 Taking a stance toward knowledge

- Wilhelm Dilthey, "The Development of Hermeneutics," Dilthey: Selected Writings, transl. H.P. Rickman (Cambridge: Cambridge University Press, 1979).
- 2 For an assessment of Heidegger's work and its relationship to Nazism, see Charles Bambach, Heidegger's Roots: Nietzsche, National Socialism, and the Greeks (Ithaca: Cornell University Press, 2003).
- 3 Martin Heidegger, Being and Time, transl. John Macquarrie and Edward Robinson (Oxford: Blackwell, 1962): 32.
- 4 Martin Heidegger, Poetry, Language, Thought, transl. A. Hofstadter (New York: Harper and Row, 1971): 207–08.
- 5 Martin Heidegger, "Traditional Language and Technological Language," transl. Wanda Torres Gregory, Journal of Philosophical Research 23 (1998): 120–45.
- 6 Heidegger, Poetry, Language, Thought: 44.
- 7 Ibid.: 43.
- 8 Ibid.: 68-70.
- 9 Hugh J. Silverman, ed., Gadamer and Hermeneutics (New York: Routledge, 1991): 1.
- 10 Hans Georg Gadamer, Truth and Method, transl. Joel Weinsheimer and Donald Marshall (New York: Crossroad, 1989): 477.
- 11 Ibid.: 302-07.
- 12 Ibid.: 265-71.
- 13 Heidegger, op. cit. in 3 above: 98.
- 14 Today there is a large literature on American quilts

- generally and African-American quilts specifically. Important early challenges to these media hierarchies came from the novelist and essayist Alice Walker in her essay "In Search of Our Mothers' Gardens" In Search of Our Mothers' Gardens: Womanist Prose (New York: Harcourt Brace and Company, 1984): 231–43, and from art historian Patricia Mainardi, "Quilts: The Great American Art" in Feminism and Art History: Questioning the Litany, ed. Norma Broude and Mary D. Garrard (New York: Harper & Row, 1982): 331–46.
- 15 Heidegger, op. cit. in 3 above: 153.
- 16 Oskar Bätschmann, "A Guide to Interpretation: Art Historical Hermeneutics" in Compelling Visuality: The Work of Art In and Out of History, wed. Claire Farago and Robert Zwijnenberg (Minneapolis, University of Minnesota Press, 2003): 179–210; Einführung in die kunstgeschichtliche Hermeneutik: die Auslegung von Bildern (Darmstadt: Wissenschaftliche Buchgesellschaft, 1984).
- 17 Gottfried Boehm, Was ist ein Bild? (Munich: Wilhelm Fink, 1994).
- 18 Mieke Bal, Quoting Caravaggio: Contemporary Art, Preposterous History (Chicago: University of Chicago Press, 1999): 100 n. 1.
- 19 Claude Lévi-Strauss, Structural Anthropology, transl. Claire Jacobson and Brooke Grundfest Schoepf (Harmondsworth: Penguin, 1972): 203–04.
- 20 Ibid.: 211. The work of the Russian Formalist critic

- Vladimir Propp (1805–1070) on Russian folktales strongly influenced Lévi-Strauss's views; see Vladimir Propp, The Morphology of the Folktale, transl. Laurence Scott (Austin: University of Texas Press, 1968).
- 21 Saussure, op. cit. in ch. 2 note 24 above: 127.
- 22 Roland Barthes, Mythologies, transl. Annette Lavers (New York: Hill and Wang, 1984): 129, 131.
- 23 Mary Douglas, Purity and Danger: An Analysis of the Concepts of Pollution and Taboo (New York: Routledge, 2002): 44-45.
- 24 Claude Lévi-Strauss, The Savage Mind (Chicago: University of Chicago Press, 1966).
- 25 Saussure, op. cit. in ch. 2 note 24 above: 115, 120-22.
- 26 Claude Lévi-Strauss, Totemism, transl. Rodney Needham (Boston: Beacon Press, 1963).
- Roman Jakobson first developed this distinction in relation to phonology: "The general meaning of a marked category states the presence of a certain (whether positive or negative) property A; the general meaning of the corresponding unmarked category states nothing about the presence of A, and is used chiefly, but not exclusively, to indicate the absence of A." Selected Writings II: Word and Language. (The Hague: Mouton, 1971): 136.
- 28 Daniel Chandler, Semiotics: The Basics (London: Routledge, 2001): 112.
- 29 Roland Barthes, Image-Music-Text (London: Fontana/Collins, 1977): 143.
- 30
- Nanette Salomon, "The Art Historical Canon: Sins of Omission" in Donald Preziosi, ed., The Art of Art History: A Critical Introduction (Oxford: Oxford University Press, 1998): 345. Feminist art historians such as Salomon, Griselda Pollock, and Linda Nochlin have incisively critiqued art history's focus on the individual genius and the artist's intentions (see Chapter 3); Michael Baxandall, on the other hand, argues that the physical art object compels art historians to see it as the result of purposeful activity, and to attempt to come to grips with the ideas of its maker-see Patterns of Intention: On the Historical Investigation of Pictures (New Haven: Yale University Press, 1985).
- op. cit. in 29 above: 148.
- Julia Kristeva, Desire in Language: A Semiotic Approach to Literature and Art (New York: Columbia University Press, 1980): 69. Kristeva suggests that a horizontal axis connects the author and reader of a text while a vertical axis connects the text to other texts.
- 34 Jonathan Harris, The New Art History: A Critical Introduction (London: Routledge, 2001): 277.

- Mikhail Bakhtin, The Dialogical Imagination, ed. Michael Holquist (Austin: University of Texas Press, 1981): 270-71.
- 36 Ibid.
- 37
- 38 Julia Kristeva, "The System and the Speaking Subject," The Kristeva Reader, ed. Toril Moi (New York: Columbia University Press, 1986): 24-33.
- Norman Bryson, "Art in Context," The Point of Theory: Practices of Cultural Analysis, Mieke Bal and Inge E. Boer, eds. (New York: Continuum, 1994): 66-74.
- 40 Michel Foucault, "Nietzsche Genealogy, History" in The Foucault Reader, ed. Paul Rabinow (New York: Pantheon Books, 1984): 76-100.
- Michel Foucault, The Archaeology of Knowledge (New York: Pantheon, 1982): 21ff.
- 42 Michel Foucault, The History of Sexuality, Volume 1: An Introduction, transl. Robert Hurley (New York: Vintage Books, 1990): 102.
- 43 Foucault, The Archaeology of Knowledge, 31ff.
- Michel Foucault, Discipline and Punish: The Birth of the Prison (New York: Vintage, 1995): 24-27.
- Ibid .: 3-31. 45
- 46 Foucault, op. cit. in 42 above.
- 47
- Ibid.: 140. For an introduction to sexuality studies 48 and an assessment of Foucault's contributions to the field, see Joseph Bristow, Sexuality (London: Routledge, 1997).
- Hubert Damisch, A Theory of /Cloud/: Toward a History of Painting, transl. Janet Lloyd (Palo Alto: Stanford University Press, 2002).
- See Heinrich Wölfflin, Principles of Art History: The Problem of the Development of Style in Later Art, transl. M.D. Hottinger (New York: Dover, 1950), and Donald Preziosi, The Art of Art History: A Critical Anthology (Oxford: Oxford University Press, 1998):
- Roland Barthes, Camera Lucida: Reflections on Photography (New York: Noonday Press, 1982): 5-6.
- Keith P.F. Moxey, The Practice of Theory: Poststructuralism, Cultural Politics, and Art History (Ithaca: Cornell University Press, 1994).
- Roland Barthes, Sade, Fourier, Loyola, transl. Richard Miller (Berkeley: University of California Press, 1989).
- Perhaps his most famous writings about art are the analysis of Las Meninas that opens The Order of Things and his essay on Magritte, This is Not a Pipe (Berkeley: University of California Press, 1989). On Foucault, post-structuralism, and art history, see Craig Owens, "Representation, Appropriation,

- and Power" in Beyond Recognition: Representation, Power, and Culture (Berkeley: University of California Press, 1994): 88-113.
- Eilean Hooper-Greenhill, Museums and the Shaping of Knowledge (London: Routledge, 1992), and Tony Bennett, The Birth of the Museum: History, Theory, Politics (London: Routledge, 1995) both engage Foucault's work in framing their arguments.
- 56 Nicholas Mirzoeff, Bodyscape: Art, Modernity, and the Ideal Figure (London: Routledge, 1995): 3.
- See Georges Didi-Huberman, Invention of Hysteria: Charcot and the Photographic Iconography of the Salpêtrière, transl. Alisa Hartz (Cambridge: MIT Press, 2003).
- 58 Although Derrida is the scholar popularly associated with the development of deconstruction, I want to note here that a number of important thinkers have contributed to its development. For example, the literary critic Paul de Man (1919-1983), who emigrated from Belgium to the United States after the Second World War, played a crucial role in introducing Derrida's work to the United States. His collection of essays, Allegories of Reading (1979), focuses on the ways in which texts inadvertently reveal their own reflexivity, an awareness of themselves as rhetorical systems, and thereby undermine their own claims to authority. Like Derrida, de Man is interested in those moments of aporia, or contradiction, within the text. Gayatri Chakravorty Spivak has made important contributions to deconstruction not only through her translation of Derrida's work, but also through the ways in which she connects deconstruction with feminism, post-colonialism, and Marxism. For a broader overview of deconstruction, see Martin McQuillan, ed., Deconstruction: A Reader (New York: Routledge, 2001). For an accessible assessment of Derrida's work, see Julian Wolfreys, Deconstruction: Derrida (St. Martin's Press, 1998). For Spivak, see The Spivak Reader: Selected Works of Gayatri Chakravorty Spivak, ed. Donna Landry and Gerald MacLean (London: Routledge, 1995).
- Peggy Kamuf, A Derrida Reader: Between the Blinds (New York: Columbia University Press, 1991): 4. 60
- Jacques Derrida, Of Grammatology, transl. Gayatri

- Chakravorty Spivak (Baltimore: Johns Hopkins University Press, 1976): 158.
- Ibid .: 53. 62
- 63 Ibid.: 65.
- Kamuf, op. cit. in 59 above: 5. 64
- Meyer Schapiro, "The Still Life as Personal Object: A Note on Heidegger and Van Gogh" in his Selected Papers: Theory and Philosophy of Art (New York: George Braziller, 1994).
- Martin Heidegger, "The Origin of the Work of Art" (1935) in his Basic Writings (New York and London: Routledge, 1993).
- Stephen Melville's views on deconstruction can be found in "Philosophy Beside Itself: On Deconstruction and Modernism," Theory and History of Literature, 27 (1986) and in "The Temptation of New Perspectives," The Art of Art History: A Critical Anthology, ed. Donald Preziosi (Oxford: Oxford University Press, 1998).
- Hal Foster, ed. The Anti-Aesthetic: Essays on Postmodern Culture (Seattle: Bay Press, 1983).
- 69 Andreas Huyssen, "Mapping the Postmodern," New German Critique, 33 (1984): 5-52.
- Fredric Jameson, Postmodernism, or the Cultural Logic of Late Capitalism (Durham, Duke University Press,
- François Lyotard, The Postmodern Condition: A Report on Knowledge (1979), transl. by Geoff Bennington and Brian Massumi (Minneapolis: University of Minnesota Press, 1984).
- 72 Jean Baudrillard, Simulacra and Simulations (1981), transl. Sheila Faria Glaser (Michigan: University of Michigan Press, 1994).
- Enwesor, Okwui, et al. In/Sight, exh. cat. (New York: Harry N. Abrams, 1996); Enwesor, Okwui, and Olu Oguibe. Reading the Contemporary: African Art from Theory to Marketplace (Boston: MIT Press, 2000).
- 74 Rosalind Krauss, "The Originality of the Avant-Garde: A Postmodern Repetition," October, 18 (1981): 47-66.
- 75 Hans Belting, The End of the History of Art? (1983), transl. by Christopher S. Wood (Chicago and London: University of Chicago Press, 1987).
- 76 Donald Preziosi, Rethinking Art History: Meditations on a Cou Science (New Haven: Yale University Press, 1989).

Acknowledgments

If the idea of the "death of the author" recognizes the power of readers in creating a text, we have yet to create an adequate framework for acknowledging the many people—in addition to the one wielding the pen—who shape a book long before it even finds its readers.

At Laurence King Publishing, Kara Hattersley-Smith first believed that what was once a chapter of Look! The Fundamentals of Art History should grow and stand alone as its own book. The resourceful Lesley Henderson has seen this project through several difficult moments, for which I am very grateful. Lee Greenfield and Susan Bolsom also contributed their expertise in essential ways. Thanks are due to Elisabeth Ingles, the project manager, Charlotte Rundall for copy-editing, Sally Nicholls for picture research, Gordon Lee for proofreading, and Andrew Lindesay for design. Two sets of anonymous readers delivered tough-minded criticism, and I thank them for the time and effort they put into that difficult task.

Many others contributed to this project in ways both indirect and direct. This book reflects numerous discussions I have had with teachers, students, colleagues, and friends, from my graduate school days to the present. Several students at the University of Connecticut—including Michelle Craig, Carina Andreika, and Meghan Dahn—allowed me to publish excerpts from their papers here, for which I thank them. Meghan Dahn also helped to compile references, and gave the manuscript a thorough reading from a student's point of view. Gary Morris generously provided both friendship and practical support, which helped realize this book. Aroha nui to Shigeyuki Kihara for allowing me the honor of discussing her work in the introduction.

And, finally, there is family. My parents, sisters, and nephew have all shown tremendous enthusiasm for my work, even when it means I spend too much time at my computer. My partner Cathy Bochain has taken this book, with its pleasures and anxieties, to heart. Nathaniel Hawthorne once wrote that "The only sensible ends of literature are, first, the pleasurable toil of writing; second, the gratification of one's family and friends; and, lastly, the solid cash." To my mind—having long since given up on the idea of solid cash—if family and friends and students find this book worthwhile, then that's my best reward.

Index

Figures in **bold** refer to illustration captions

Abstract Expressionism 19-20 abstract art 102 Adorno, Theodor 52-3, 60, 77 aesthetics of reception 115 African-Americans 64-5, 80-1, 108; quilts 63, 126, 126-7, 165; sculpture 147, 147-8 Ahmad, Aijaz 79 AIDS 70, 71 alienation 153 allegories 23 Alpers, Svetlana 25, 55 Althusser, Louis 51 anxiety of influence 110, 118 archetypes, Jungian 93 architecture 80, 115, 150-1, 151 Aristotle 43 Arnheim, Rudolf 112 authorship 135-6 avant-garde 53, 54, 149, 155

Baca, Judith: The Great Wall of Los Angeles ... 58, 58-60 Baker, Josephine 65 Bakhtin, Mikhail 136-7 Bal, Mieke 38-9, 43, 44, 102, 106, 128 Balzac, Honoré de 52 Barbie (doll) 22, 82 Barthes, Roland 36, 113, 114-15, 132-3, 135-6, 140 Bate, W. Jackson 110 Bätschmann, Oskar 127 Baudelaire, Charles 149 Baudrillard, Jean 151, 154, 157 Baxandall, Michael 54-5 Beauvoir, Simone de 61, 94 Bellori, Giovanni Pietro 21 Belting, Hans 24, 155-6 Benjamin, Walter 53, 104 Berlin, Isaiah 47 Bhabha, Homi 79 Białostocki, Jan 24 binary oppositions 79, 133-4, 140, 142, 144, 146, 147, 155 Blier, Suzanne P. 102, 103-4 Bloom, Harold 110, 118 bocio figures, Fon 103, 103-4 body, the 64, 65, 141

body art, feminist 65
Boehm, Gottfried 127–8
Boone, Sylvia Arden 69
Boucher, François 74
Bourgeois, Louise 88; Maman 118, 118–19
Brettell, Richard 56
Broude, Norma 63–4
Bryson, Norman 37, 39, 44, 110, 112, 118, 137
Bul, Lee: Cyborg figures 167, 167–8, 170–1
Burgee, John 151
Butler, Judith 72–3, 95

Camille, Michael 44, 55 capitalism 49, 50, 52-3, 54, 60, 81, 150, 153-4, 157 Caravaggio 106, 128 Carrier, David 166 Cassatt, Mary 62, 66 Cassirer, Ernst 23 Césaire, Aimé 76 Charcot, Jean-Martin 141-3, 142 Charioteer of Delphi 47, 48 Chodorow, Nancy 94 Chomsky, Noam 102 Cixous, Hélène 64, 101 Clark, T.J. 25, 55 codes 32-6, 41, 114 collages 20, 105-6 "collective unconscious" 93 colonialism 77, 78-9, 80, 81, 150 commodity fetishism 52 Comte, Auguste 10 connotation 35-6, 40 Coombes, Annie E. 56, 84 Cottingham, Laura 73 Courbet, Gustave 55, 149 Cox, Renée 65 Crary, Jonathan 82 creativity 96, 109-10 Crimp, Douglas 151 critical theory 6 Crow, Thomas 56 cultural hegemony 50-1 Cultural Studies 76-7, 78, 87; and postcolonialism 77-8, 83-6 culture(s)/cultural meaning 22, 23, 33, 46, 78, 92, 114; and feminism 64, 66, 68; and postmodernism 152, 153; and semiotics 33, 34–5; and structuralism 131, 132–3

Damisch, Hubert 140 David, Jacques-Louis 110; The Consecration of the Emperor Napoleon . . . 56-8, 57 Davis, Whitney 74 Debord, Guy 53-4, 58 deconstruction 64, 143-9, 158 deixis 37, 42 Deleuze, Gilles 12-13, 171-2 Demuth, Charles 74; Three Sailors Urinating 74-6, 75 denotation 35-6, 40 Derrida, Jacques 14, 137, 143-7 Desperately Seeking Susan 108 Deutsch, Helene 94 différance 144, 145 Dilthey, Wilhelm 123, 125 discourse(s) 8-9, 139 Douglas, Mary 133 dreams 88, 91, 97 Driskell, David 81 Duchamp, Marcel 48, 104, 105; Fountain 149, 150 Duncan, Carol 55-6 Durga defeating Mahisha 25, 26, 26-7, 28 (10th-c.), 27, 27-8 (19th-c.) Dutch art 25, 55, 109

Eagleton, Terry 8–9, 11, 89, 94
Eco, Umberto 34
ego, the 90–1, 96, 98, 101
Eisenman, Stephen F. 56
ekphrasis 88
Electra complex 90, 94
Elkins, James 34, 44
empiricism 12–13
Engels, Friedrich 48, 49–50,
51–2
Enlightenment, the 60, 47, 151
Enwesor, Okwui 155
Ernst, Max 104, 105–6
essentialism 66, 100

Fanon, Franz 8o femininity 62, 64, 73 feminisms/feminist theory 5, 6, 28, 58, 60-1, 87; and art history 61-70; and Freud 94-5, 100-1; and Lacan 99-100, 101; and technology 167-8 films 53, 107-8, 166 Fish, Stanley 114 focalizers 115, 116 Focillon, Henri 19 formalism 11, 17-20, 23, 44, 45, 104 "forms of address" 115, 116 Foster, Hal 151 Foucault, Michel 7, 8, 9, 72, 138-40, 141, 170-1 fragmentation 153 Frankfurt School 6, 52 Freud, Sigmund 34, 47, 88-92,102, 106, 109, 121, 141; on art 92-4; critics 94-5, 100-1; and Lacan 96, 97, 98, 99, 100 Fried, Michael 104 Friedan, Betty 61 Frueh, Johanna 65 Fry, Roger 18-19 Fuss, Diana 66

Gadamer, Hans-Georg 124-5, 126, galleries, art 55, 141 Gallop, Jane 101 Garrard, Mary 63-4, 67 Gates, Henry Louis, Jr. 81 Gauguin, Paul 56 Gay and Lesbian Studies see LGBTI Studies gaze, the 64, 65, 88, 106-8, 116-17, 120, 131 gender identity 70, 72-3, 78 Gender Studies 70, 71 Gentileschi, Artemisia 62, 64; Judith and her Maidservant Slaying Holofernes 66-8, 67 Gestalt psychology 109, 112, 127 Ginzburg, Carlo 34 Gogh, Vincent van: Shoes 145-6 Gombrich, Ernst 24, 39, 109, 110-11, **111**, 112 Gothic style 19, 55 Gould, Stephen J. 10 Gramsci, Antonio 50-1, 58, 81 Greek art/sculpture 47, 48, 52, 101, 140, 148, 148-9

Greenberg, Clement 19–20, 104, 137 Greer, Germaine 94

Habermas, Jurgen 151

Hall, Stuart 1, 77, 78, 80, 84 Halperin, David 71-2 Haraway, Donna: "A Cyborg Manifesto" 166-9, 170-1 Harmsworth History of the World, The 83,83-4Harris, Bertha 70 Harris, Jonathan 136 Hartley, Marsden 74 Haskell, Francis 100 Hauser, Arnold 54 Hawai'ian people 23, 80 Hawthorne, Nathaniel: The Scarlet Letter 8 Heidegger, Martin 123-4, 125, 127, 143, 145, 146 Henderson, Linda 48 Hensley, Marie: Quilt 126, 126-7 hermeneutics 122-5, 137, 158; and art history 127-31; "hermeneutic circle" 125-7 Hesse, Eva 104 heteroglossia 136-7, 142 Himid, Lubaina 64 history (Foucault) 138-9 "history of ideas" 46-8 "Holmes, Sherlock" 14, 34 homosexuality 72, 93, 95, 108; see LGTBI Studies; Queer Theory hooks, bell 9, 28, 29, 65, 108 Horace 43 Horkheimer, Max 52-3 Horney, Karen 94 Hours of Jeanne d'Evreux, The (Pucelle) 39-43, 41 humanism 91, 135, 152 Huyssen, Andreas 151-2, 153 hybridity 14, 15, 79, 80 hyperreality 154

iconography/iconology 6, 17, 20–1, 24–5, 39, 44, 45, 160–2; and hermeneutics 127; Panofsky's 21–3, 162; practice of 25–8, 43; and semiotics 29 id, the 90, 91 identity 78 ideologies 50–1, 55–6, 77; of gender 62, 64 illusionism 20, 111
indexes 30, 31
Ingarden, Roman 113
Ingres, Jean-Auguste-Dominique
110; Oedipus and the Sphinx 92
intertextuality 35, 37, 41–2, 136,
162–3
Irigaray, Luce 64, 100–1
Iser, Wolfgang 113–14, 116

Jakobson, Roman 32, 33, 38, 97,

Jameson, Frederic 151, 152, 153–4
jargon 8
Jauss, Hans Robert 114
Johnson, Philip 151
Jones, Amelia 65
Jongh, Eddy de 25
Jung, Carl 93

Kafka, Franz 8
Kampen, Natalie 74
Kandinsky, Wassily 149

Kafka, Franz 8
Kampen, Natalie 74
Kandinsky, Wassily 149
Kant, Immanuel 18, 51
Kemp, Wolfgang 115–16
Kihara, Shigeyuki: performance
piece 14–15, 15
Klein, Melanie 96, 99, 100, 102,
105, 105
Krauss, Rosalind 20, 32, 102,
104–5, 118, 151, 155
Krautheimer, Richard 24
Kris, Ernst 109–10
Kristeva, Julia 35, 37, 64, 100, 136,
137
Kruger, Barbara: Your Gaze Hits the
Side of My Face 107, 107

Lacan, Jacques 96-9, 110, 115, 121, 144, 166; on art 99; critics 99-102; on the gaze 106-7; L-Schema diagram 105, 105 language 9, 97, 98, 123-4, 135; heteroglossic and monologic 136-7, 142; and semiotics 37, 39; and structuralism 131, 132 Lauretis, Teresa de 72 Lee, Anthony 60 Leonardo da Vinci 43, 93-4, 95; Mona Lisa 94, 95 lesbian art 64-5; see LGBTI Studies Lévi-Strauss, Claude 97, 132, 133, 134 Levine, Sherrie 154

Lewis, Bernard 79 Lewis, Edmonia 147; Forever Free 147, 147–8 LGBTI Studies 70–1, 72, 73–6, 87 Libeskind, Daniel: model for new World Trade Center 129, 129–30 Lorde, Audre 5, 9 Lukács, Georg 52 Lyotard, Jean-François 152

Mainardi, Patricia 63 Man, Paul de 14 Manet, Édouard 149; Olympia 116-18, 117, 149 Marin, Louis 37-8, 39, 42 Martin, Henry Byam: Tahitian Woman 7, 7 Marx, Karl 48, 49-50, 51-2, 89 Marxism/Marxist theory 5, 6, 19, 48-9, 87, 152, 164, 166; and art 51-4, 56-60; and ideology 50-1 masks, African 66, 68-70, 69 materialist art history 54-6, 57-60 Mathews, Patricia 63 Melville, Stephen 146 Mende masks 66, 68-70, 69 Merleau-Ponty, Maurice 36 metaphors 97, 102, 124, 134 methodology 13 metonymy 97 Michelangelo Buonarroti 168; Moses 92-3; Prophet Zechariah 160, 160-3 Millet, Kate 94 mimesis 140, 146 "mirror stage" 98, 100, 106, 117, 166 Mirzoeff, Nicholas 141 Mitchell, W.J.T. 43-4 modernism/modernist art 19-20, 104, 149-50, 153, 154-5 monologia 136-7, 142 Montaigne, Michel de 122 Morelli, Giovanni 34 Morimura, Yasumasa: Futago 116-18, 117 Moxey, Keith 141 Mukarovsky, Jan 36 Mulvey, Laura 107-8 mural art 58, 58-60 museums 55-6, 115, 137, 141; and repatriation of artworks 84-6, 148-0 myths 106, 132, 133

Neshat, Shirin 120; Fervor **119**, 120 nihilism 123 Nochlin, Linda 61–2 "normal"/"normative" 71

object relations theory 96
Oedipus complex 90, 92, 94, 100
Oguibe, Olu 155
Oppenheim, Dennis 32
"optical unconscious" 104–5, 118
Orientalism 79, 80
Orozco, José Clemente 60
Osorio, Pepón: En La Barbería No Se
Llora 171, 171–2

Panofsky, Erwin 22, 23, 24, 25, 124, 162 parapraxes 102, 103 Parker, Rozsika 62, 63 Parthenon/Parthenon marbles 130, 148, 148-9 Partisan Review 19 pastiche 153, 157 pathographical method 95 Patton, Sharon 81 Peirce, Charles Sanders 30-1, 31, 33, 102, 125-6 penis envy 90, 94-5 phallocentricity 99, 101 Phillips, Ruth 69 photography 31, 53, 65, 80, 118, 140, 141-3, 154 Picasso, Pablo 20, 56 Plekhanov, Georgi 48 Pliny: Natural History 21 Pollitt, Jerome 47, 48 Pollock, Griselda 62, 63, 64, 67, 68, Pollock, Jackson 104 positivism 10 postcolonialism/postcolonial theory 77-8, 81, 87, 120; and race 78-81 postmodernism 35, 149, 150-2, 157, 158; and art history 155-7 post-structuralism 25, 35, 136-8, 153, 157, 158; and art history 140-3; and feminisms 64 Poussin, Nicolas: The Arcadian Shepherds 37-8, 38, 42 power 7, 77, 81, 139, 141 Preziosi, Donald 156 Proust, Marcel: Swann's Way 5, 6,

13

psychoanalysis/psychoanalytic theory 5, 6, 14, 18, 20, 88–9, 166; and art 109, 110, 120, 121; and art history 102–6, 116–20, 164; and feminism 64, 94–5, 99–101; see also Freud; Jung; Lacan psychology of art 109–12 Pucelle, Jean: The Hours of Jeanne d'Eureux 39–43, 41

Queer Theory 6, 70, 71–2, 74, 87 quilts, African-American 63, **126**, 126–7, 165

race 64-5, 83-6; see also culture(s) racism 9, 10, 127; and postcolonial theory 78-81 Rand, Erica 82 Raphael 110, 118 reader-response theory 113-16 "reading" works of art 39 Rear Window 108 reception theories 14, 22, 33, 88, 116-20, 127; psychology of art 109-12; reader-response 113-16 Rembrandt van Rijn 55 Renaissance art 18, 24, 25, 54-5, 135, 140, 160 repatriation (artworks) 84-6 Rich, Adrienne 72 Riegl, Alois 18, 82, 109 Ringgold, Faith 165 Rivera, Diego 60

Said, Edward 79, 80 Saussure, Ferdinand de 30, 30, 32, 33, 36, 97, 102, 131, 132, 134, 135 Saxl, Fritz 24 Schapiro, Meyer 36-7, 40, 95, 145, 146, 162 schemata 111, 113, 116 science 10, 12, 48 Sedgwick, Eve Kosofsky 71 "Self" and "Otherness" 80, 84, 97-8, 101, 120, 144 semiotic drift 34 semiotics 6, 8, 17, 20, 22, 25, 28-32, 44, 45, 97; and art history 36-43; signs and codes 32-6 Serrano, Andrés 128

sexuality 74, 138, 139-40; of Christ 24; and psychoanalysis 90, 94-5, 100-1; see also homosexuality; LGBTI Studies Sherman, Cindy 118, 154 Shonibare, Yinka 156; Vacation 156, 156-7 significant forms 23 signifiers and signified 30, 31, 36, 42, 97, 99, 115, 135, 137, 144, 154 signs 28-9; and codes 32-6; and deconstruction 144; Peircean 30-1, 31, 33-4; Saussurean 29-30, 30 Silverman, Kaja 166 simulacra 153, 154 Situationist International 54 Smith, Bernard 80 "social history of art" 54 Spivak, Gayatri 81, 143 Stafford, Barbara Maria 82 Steinberg, Leo 24 Stirling, James: Neue Staatsgalerie, Stuttgart 151, 151 Stokes, Adrian 96, 102 structuralism 6, 131, 136, 158; and art history 140, 141-3; and binary oppositions 133-4, 140; and culture 131, 132-3

Subaltern Studies 81, 120
"subject effect" 64
subjectivity 77
superego, the 90, 91
Surrealism 149, 166, 168
symbols 23, 25; see
iconography/iconology

Tahitian judicial courts 7, 7
Tange, Kenzo 151
Tansey, Mark: Derrida Querying
De Man 14
tattooing 7, 7, 8
Tel Quel (journal) 35
Tesfagiorgis, Freida High 65
theory: and anti-theoretical
positions 10–11; definitions
5–7, 11–12, 16; as discourse
8–9; and facts 12; and
methodology 13; and research
13–14, 165–9
traditions 152
transferences 103

unconscious, the 89, 91, 93, 95, 97, 101, 102, 115, 149; "optical" 104–5, 118 Utamaro, Kitagawa: Geisha with

Samisen 130-1, 131

Vasari, Giorgio 21 Visual Culture Studies 82 Voloshinov, Valentin 36

Walker, Alice 60, 63 Wallach, Allan 55-6 Warburg, Aby 21-2 Warhol, Andy 154 Weems, Carrie Mae 128 Weinberg, Jonathan 73, 74, 76 Wells, H.G. 8 Wendt, Albert 15 Wilke, Hannah 65 Williams, Carla 65 Williams, Raymond 76, 77, 78 Willis, Deborah 65 Winckelmann, Johann J, 21, 73 Winnicott, D.W. 96 Wittkower, Rudolf 24 Wölfflin, Heinrich 2, 18, 22, 110, Wollheim, Richard 96, 102, 111 Wollstonecraft, Mary 60-1 Woolf, Virginia 17, 43, 61 word and image 43-4, 45 World Trade Center 129, 129-30

Zuni War God figures 84-6

Photo credits

Collections are given in the captions alongside the illustrations. Sources for illustrations not supplied by museums or collections, additional information, and copyright credits are given below. Numbers are figure numbers.

1.2 Photo courtesy of Shigeyuki Kihara. 1.3 Courtesy of the Gagosian Gallery, New York. 2.1 Photo © Michael D. Gunther/www.artandarchaeology.com 2.3 Redrawn by Advanced Illustration Ltd. 2.4 Redrawn by Advanced Illustration Ltd. 2.5 Photo © Photo Josse, Paris. 3.1 Photo Hirmer Fotoarchiv. 3.2 Photo © Photo Josse, Paris. 3.4 © Studio Quattrone, Florence. 3.6 Reproduced in W. Davis (ed.), Gay and Lesbian Studies in Art History, New York, Hawthorne Press, 1994, p.237. 4.1 Photo Werner Forman Archive. 4.4 Courtesy Mary Boone Gallery, New York. 4.6 Photo © Photo Josse, Paris. 4.7 Courtesy of the artist and Luhring Augustine, New

York. 4.9 Photo by Larry Barns. Courtesy Barbara Gladstone. 5.1 Gift of the Friends of the Philadelphia Museum of Art and partial gift of the Lindsey Family. 5.2 Photo taken in 1991. Photo AKG-Images. 5.3 Photo © Jock Pottle for Studio Daniel Libeskind. 5.7 Photo The British Museum. 5.8 Photo AKG-Images. 5.9 Courtesy Stephen Friedmann Gallery, London, and the Israel Museum, Jerusalem. Gift of the New York Contemporary Art Acquisition Committee of American Friends of the Israel Museum. 6.1 Photo AKG-Images. 6.2 Photo Rhee Jae-yong. Courtesy the artist and Kukje Gallery, Seoul. 6.3 Photo John Groo/Real Art Ways.